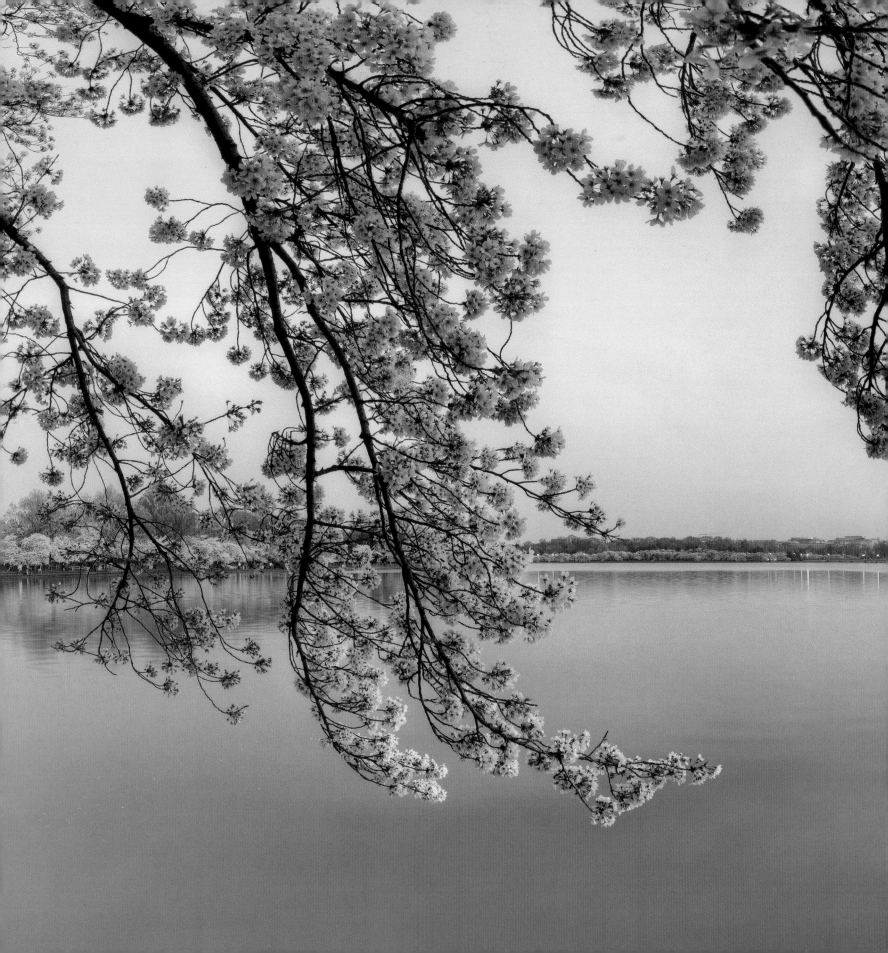

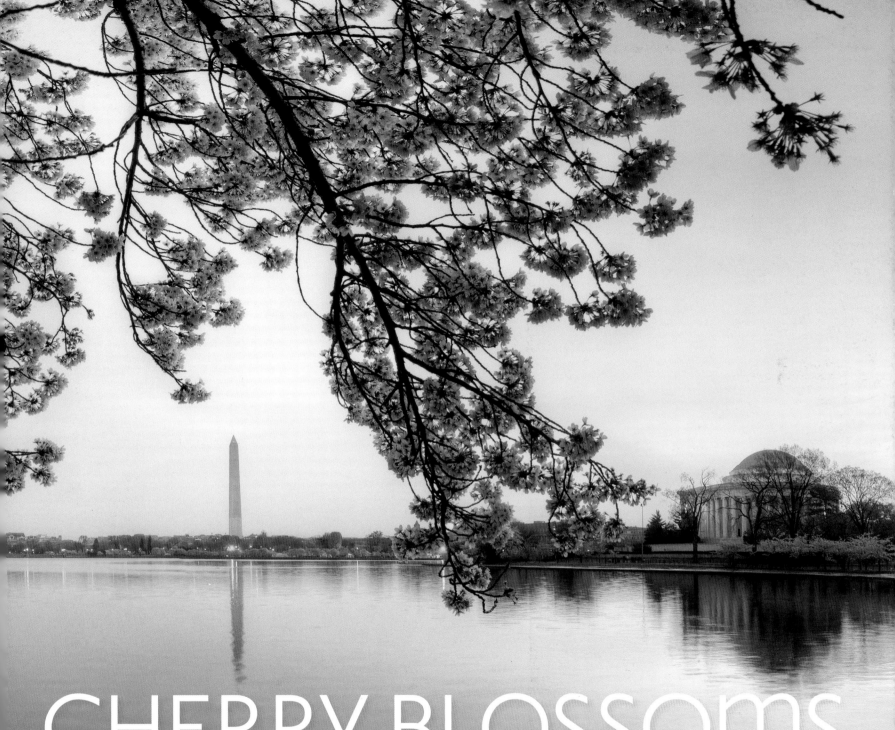

CHERRY BLOSSOMS

THE OFFICIAL BOOK OF THE NATIONAL CHERRY BLOSSOM FESTIVAL

ANN McCLELLAN PHOTOGRAPHS BY RON BLUNT

NATIONAL GEOGRAPHIC

WASHINGTON, D.C.

NATIONAL
FESTIVAL

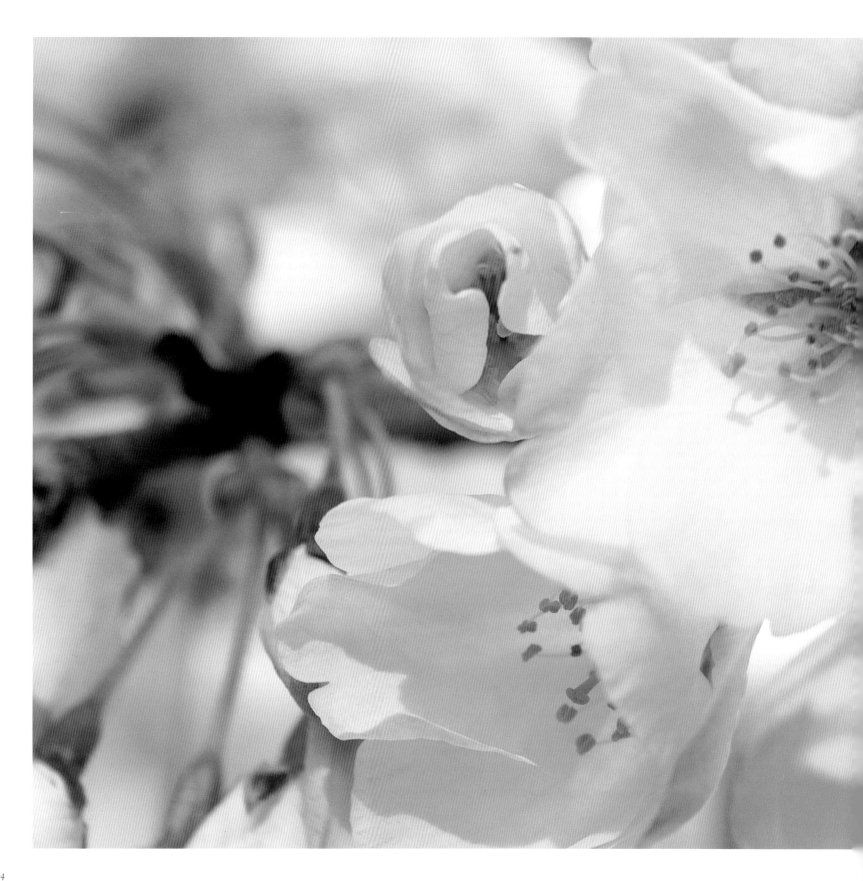

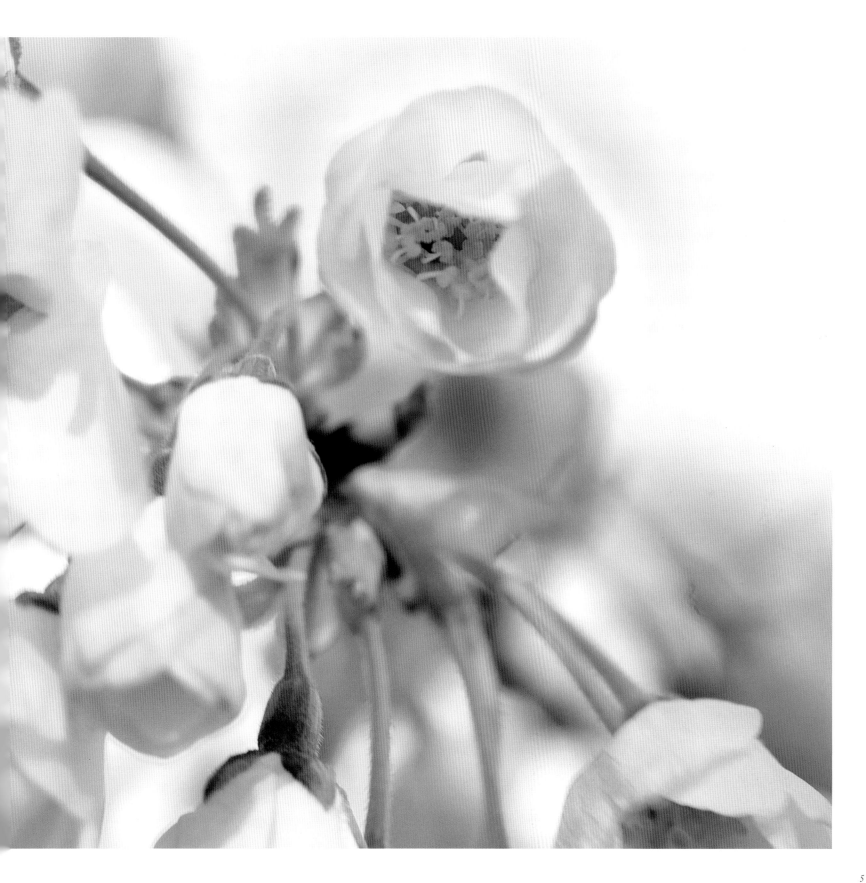

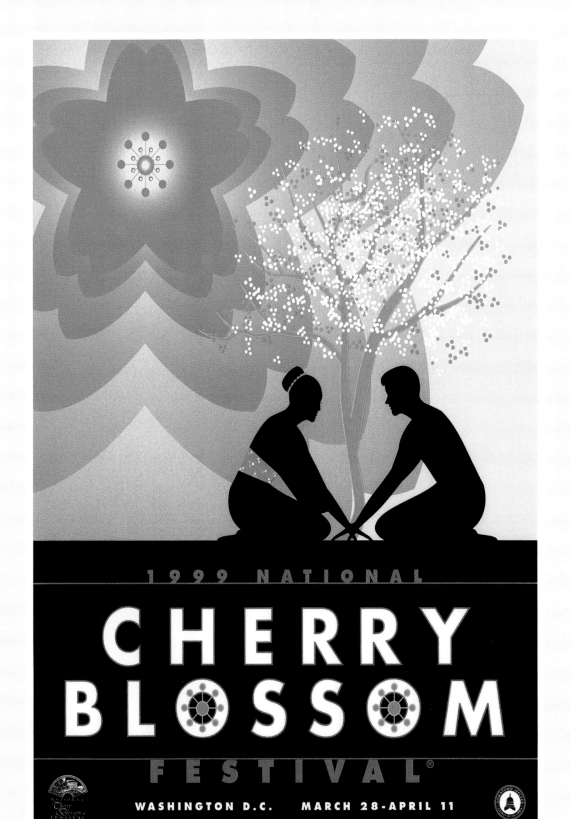

DEDICATION

To THE MILLIONS OF VISITORS to the National Cherry Blossom Festival and its celebration of spring and the gift of trees, creating memories to cherish. And to the thousands of supporters and volunteers who dedicate their time and resources to make the Festival possible each year.

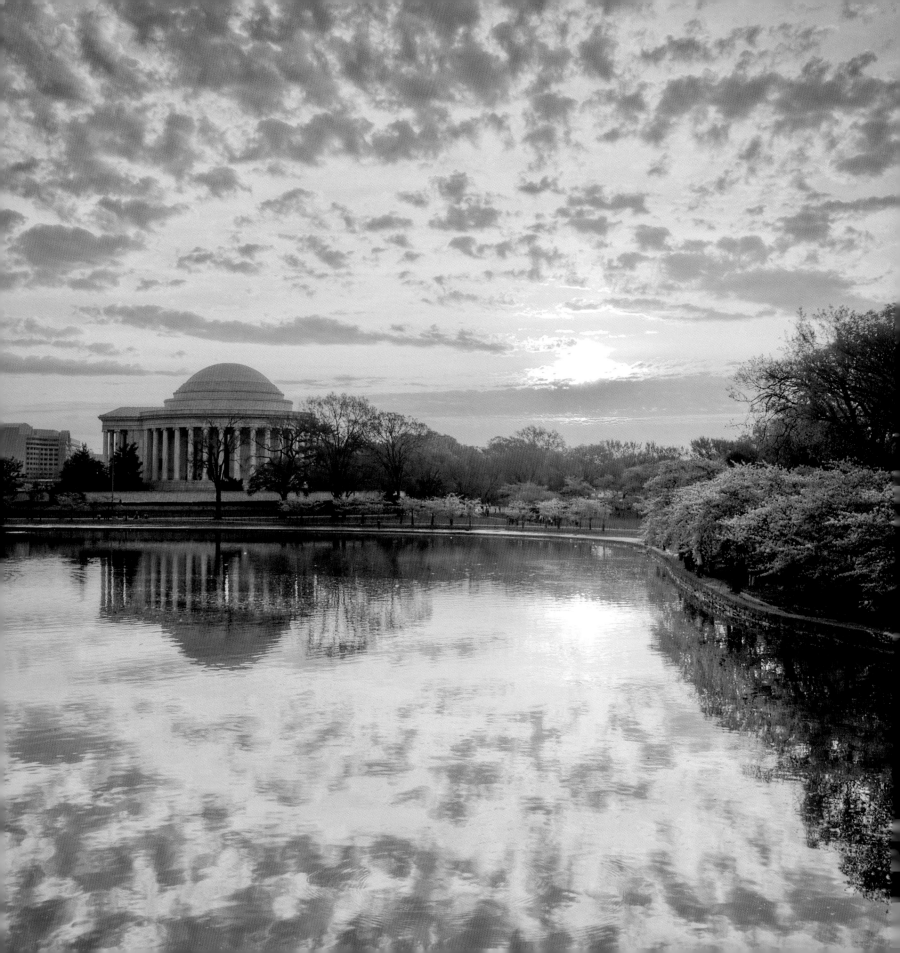

CONTENTS

OPPOSITE: *This image was a finalist in the "landscape" category of the Festival's 2011 photo contest.*
FOLLOWING PAGES: *Older cherry blossom trees arch their blooming branches toward the Tidal Basin.*
PAGES 14-15: *Ballerinas, dressed in petal pink, dance at an Opening Ceremony.*

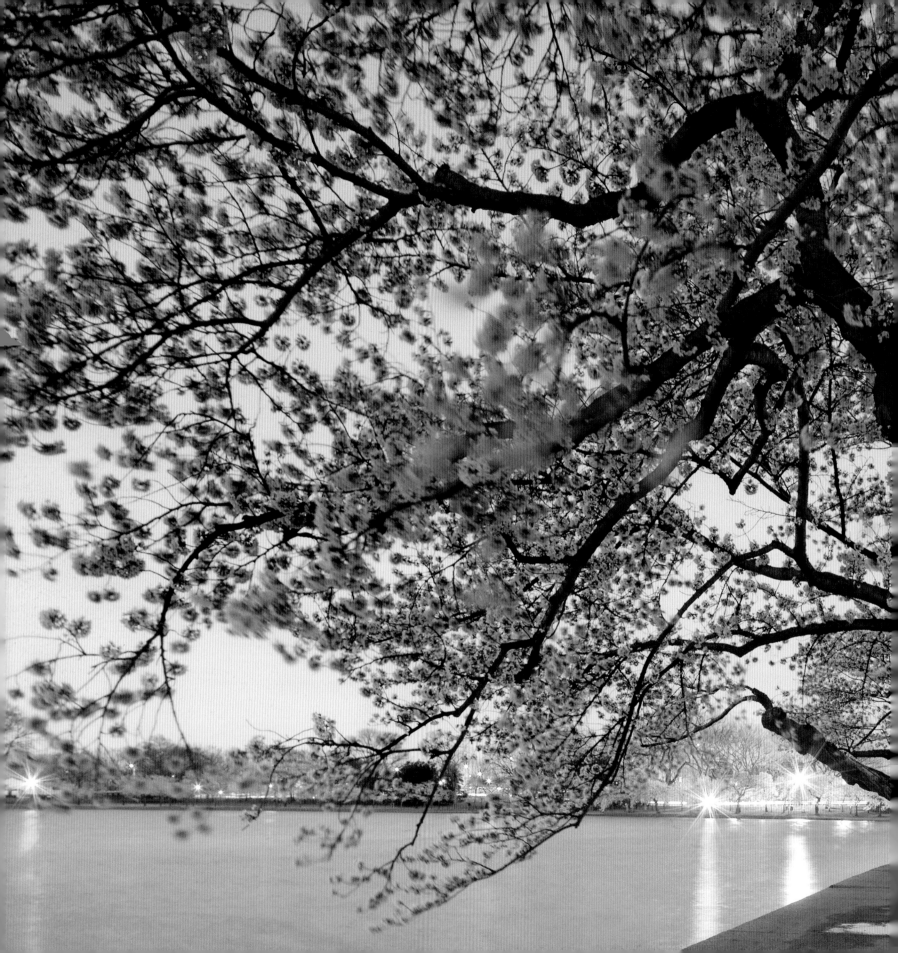

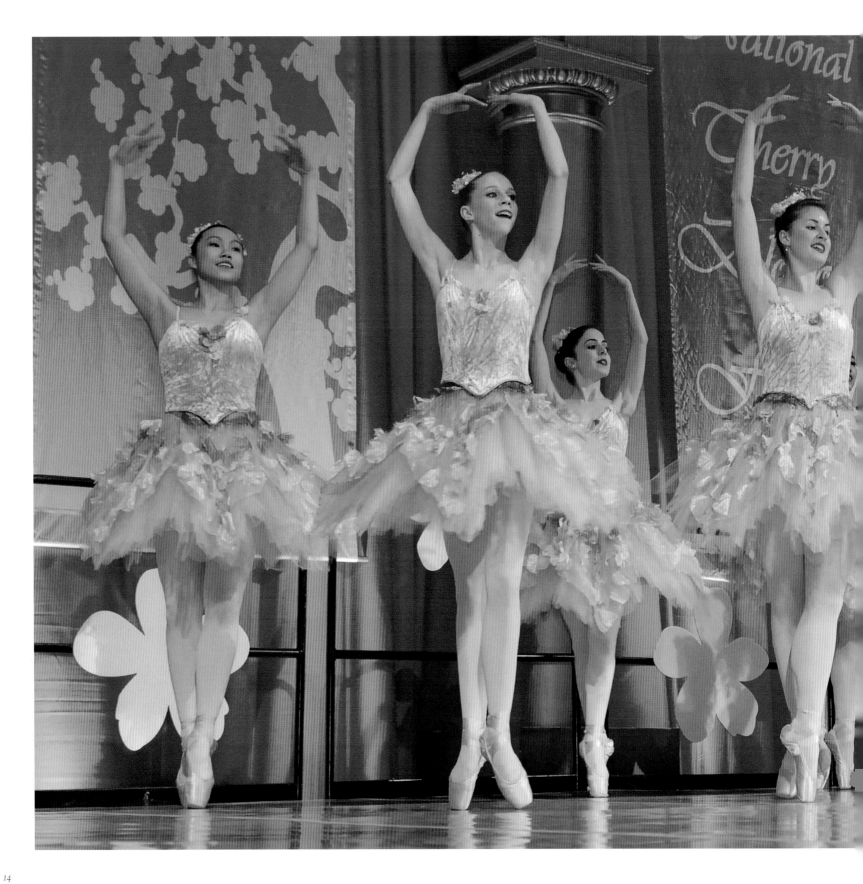

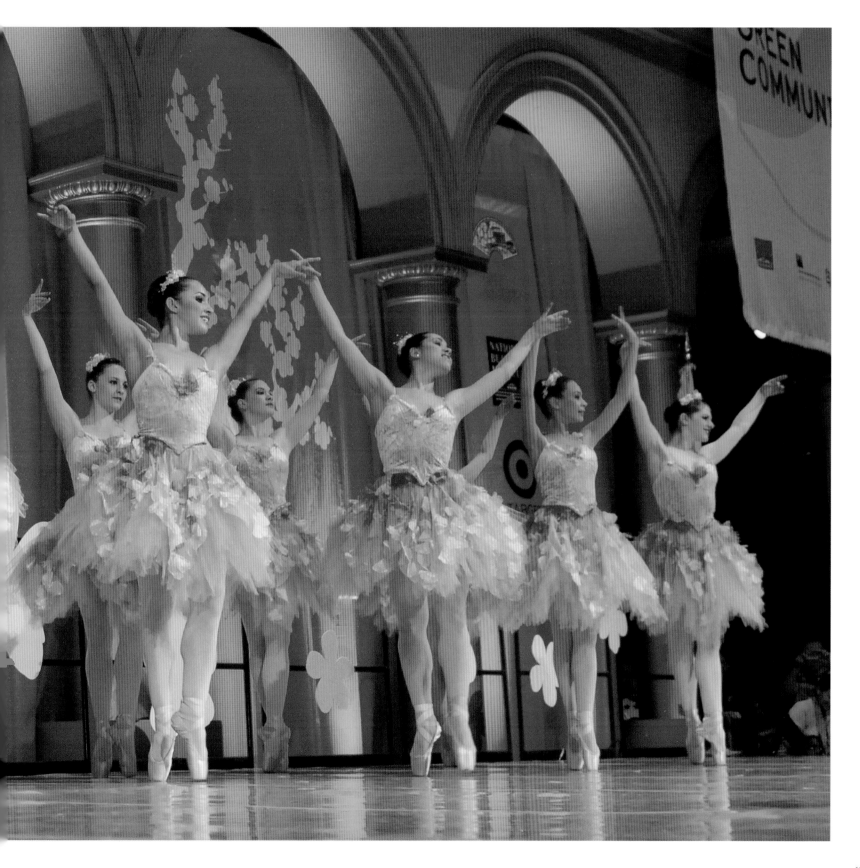

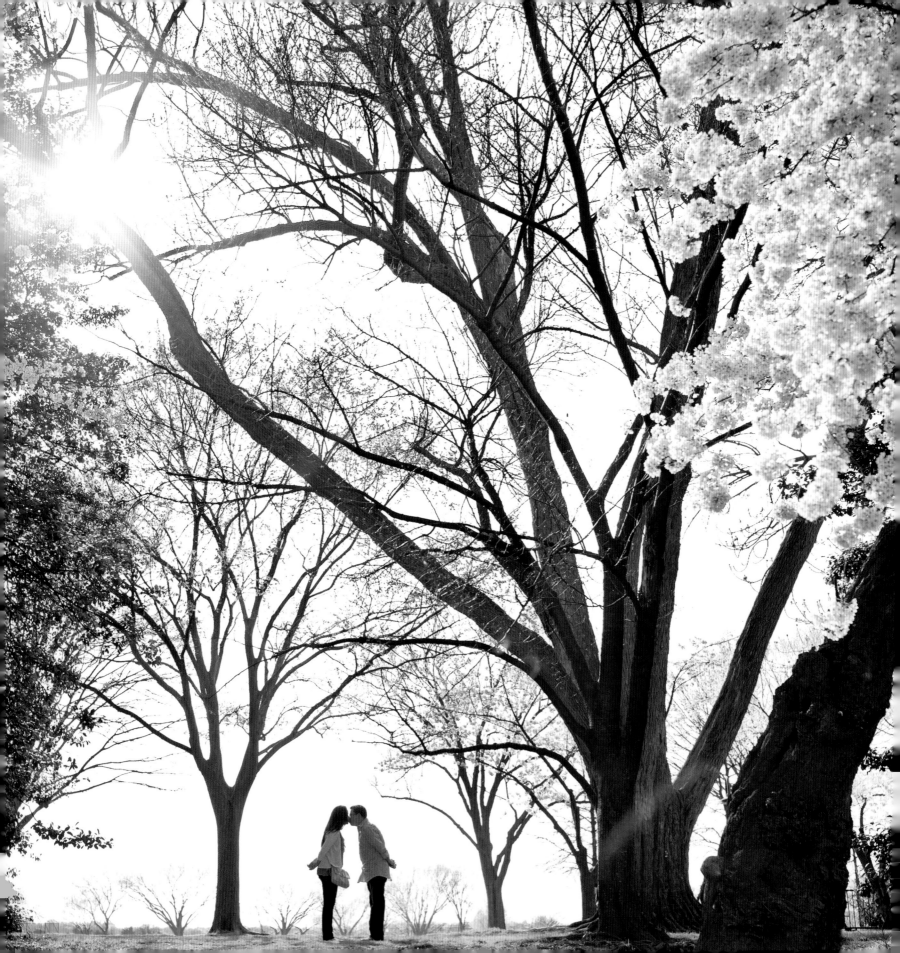

INTRODUCTION

WHAT STARTED AS A ONETIME GIFT OF 3,000 CHERRY BLOSSOM TREES from Tokyo to Washington, D.C., more than a century ago is now an annual tradition: the National Cherry Blossom Festival, the nation's greatest springtime celebration. This book tells the story of the journey, of how the gift of trees has become what it is today, a multiweek, event-filled extravaganza held dear to so many and attended by more than a million people each year. As president of the Festival, I meet people from all walks of life who have deep personal connections to the trees, often celebrating family milestones under the blossoms. I am honored to play a role in this celebration that inspires so many people and will continue to create cherished memories for generations to come. Through this book, I hope you discover something you may not have known about the Festival. As you peruse these pages, experience the Festival's joys and thrills through the years, from the fun and casual events to the deeply symbolic moments that join individuals and nations. The profound personal connections created and reinforced through Festival events are more than just a symbol of international friendship; they truly bridge cultural divides. That remains—even after 100 years—the power of this gift of trees. May that be true for our descendants hundreds of years from now. Few things endure an entire century, but the cherry blossoms remain. The National Cherry Blossom Festival is deeply gratified to produce and coordinate the celebration of these treasured trees that have solidly stood throughout the changes of nations, through upheaval and uncertainty, through reconciliation and renewal. We thank all our partners; supporters; board members and staff; volunteers; the National Park Service, stewards of the trees; and the Embassy of Japan, for all they do to make the Festival possible every year. And we thank you for joining us in the nation's capital, in person or in spirit, to celebrate nature's perennial springtime gifts. ▪

Diana Mayhew
President, National Cherry Blossom Festival

OPPOSITE: *An award-winning shot in the Festival's 2011 photo contest "people" category captures a memorable moment.*
FOLLOWING PAGES: *Confetti showers swirling dancers and their "flower girls" during a Festival parade.*

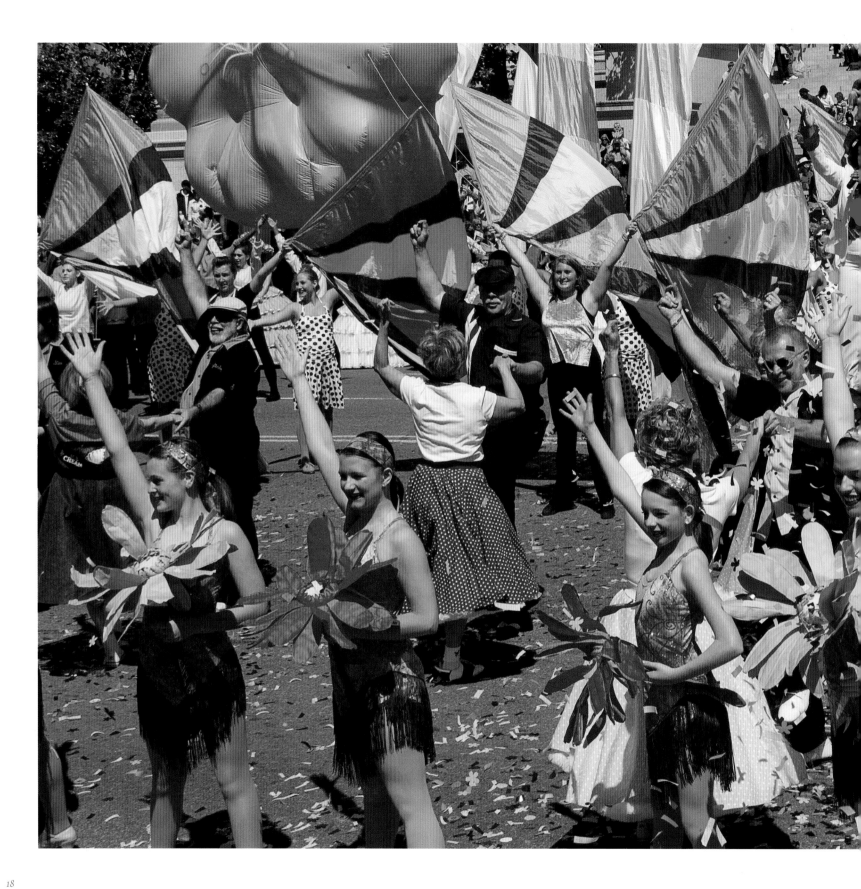

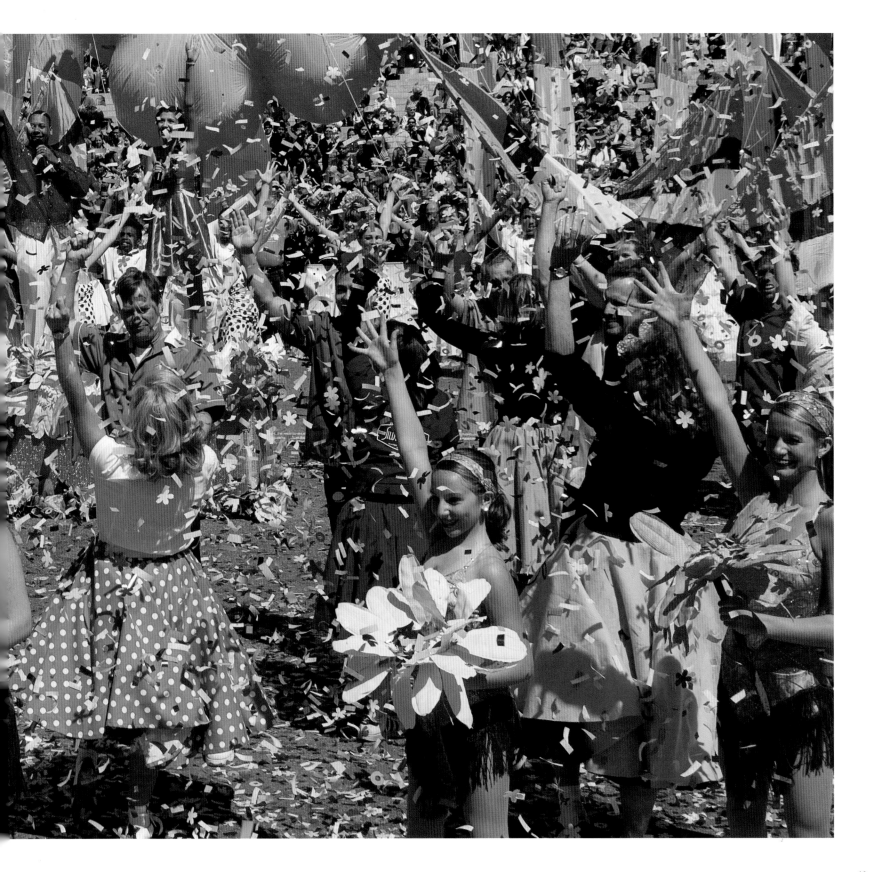

CHAPTER ONE

STARTING
WITH A GIFT OF TREES

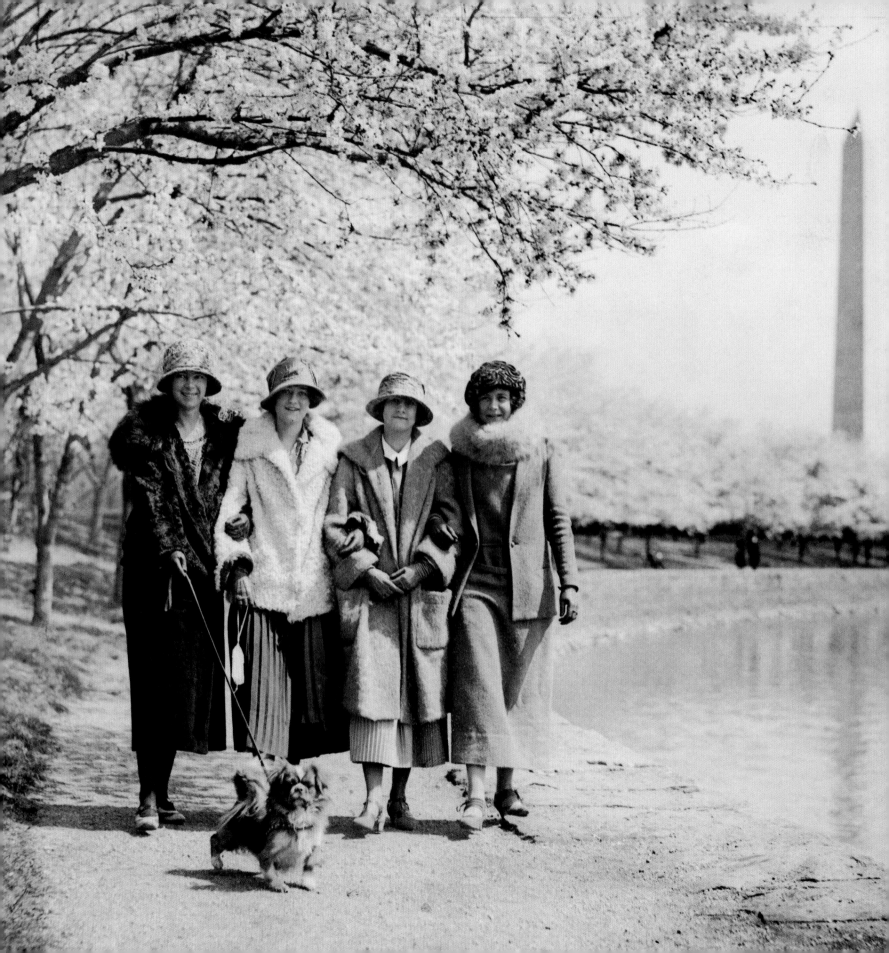

A Gift of
Beauty and Friendship

A T ONE TIME, THERE WERE NO CLOUDS of pink and white cherry blossoms around the Tidal Basin. In fact, there was no Tidal Basin. It was only after draining and dredging the marshy area in the late 19th century that the land was reclaimed, and the once swampy area now boasts monuments and memorials to many U.S. Presidents and other heroes. ∞ On the other side of the globe, Commodore Matthew Perry negotiated the Treaty of Kanagawa with Japan in 1854, opening the possibility of commercial interactions with the Asian nation that had been closed to foreigners for more than 200 years. Following Perry, Japan negotiated treaties with other nations, leading to its "discovery" as a source of beautiful art, furniture, textiles, ceramics, and plants, including cherry blossom trees.

The cherry blossoms' blooming in Japan has inspired celebrations with poetry, music, picnicking, and dancing under the blossoms for more than 1,000 years.

Travelers to Japan lucky enough to see the flowering cherry trees in bloom have come away enchanted and inspired to import the trees to their homelands. One such traveler was an intrepid woman and Wisconsin native named Eliza Scidmore. Scidmore became a society reporter in Washington, D.C., a job that allowed her access to the social leaders of her day. She traveled extensively, wrote books, and was the first female board member of the National Geographic Society. She visited Japan often in the late 19th century because her brother served in the American Foreign Service there and their mother lived with him.

Another U.S. traveler who visited Japan was David Fairchild, a plant explorer. He traveled around the world seeking plants that would enhance the United States' ability to meet its own needs and to advance its commercial interests. Eliza Scidmore and her acquaintances David and Marian Bell Fairchild agreed the trees would do well in Potomac Park. The Fairchilds had

Four debutantes stroll beneath the blossoms, 1923.

already imported more than 25 varieties of trees as a test on their estate, "In the Woods" in Bethesda. They were so enthused about their success with the trees that, on Arbor Day in 1908, they gave 150 trees to be planted in every public schoolyard in the city.

Helen Herron Taft, who would later become First Lady, also visited Japan. She and her children stayed there for several months in 1900, en route to join her husband William Howard Taft in Manila where he was serving as commissioner and then governor-general of the Philippines. She arrived in Japan after cherry blossom season, so she only saw photos of the blossoms, but she embraced Japanese aesthetic and style.

Eventually, William Howard Taft and his family returned to the United States, and he was elected President, taking office in March 1909. As First Lady, one of Helen Taft's first endeavors was improving Potomac Park—then an undeveloped area including a carriage "speedway"—by re-creating a pleasant waterside gathering spot modeled after Luneta Park (now Rizal Park) in Manila.

Shortly after Taft's Inauguration, Fairchild wrote to Colonel Spencer Cosby, the new superintendent of public buildings and grounds, enclosing four color images

of cherry trees blooming in Japan. Fairchild and his wife offered "to present the Speedway with 50 selected Japanese flowering cherry trees . . . The location lends itself peculiarly to the fairylike effects which these trees produce near watersides." Cosby showed the pictures to Mrs. Taft, won her approval, and accepted the Fairchilds' offer.

Japanese officials learned of Mrs. Taft's interest in flowering cherry trees. They seized the opportunity to demonstrate Japan's gratitude to the United States for its role in brokering the Treaty of Portsmouth, which had ended the Russo-Japanese War of 1904–1905 and inducted Japan as a full-fledged member of the international community after its centuries of isolation. According to Eliza Scidmore, Dr. Jokichi Takamine, world-famous chemist and discoverer of adrenaline, also played an important role in the funding of the trees and their arrival.

Tokyo's Mayor Yukio Ozaki corresponded with U.S. government officials about the gift, signing the document that consigned the November 1909 shipment of 2,000 trees to the *Kaga Maru,* the freighter that brought the trees across the Pacific free of charge.

After their arrival in Seattle, the trees were shipped by railway across the continent in climate-controlled cars,

The Festival's artwork in 2004 by Jerry Arnold highlighted the Washington Monument.

arriving in Washington on January 6, 1910. David Fairchild was one of the first to inspect the trees. He observed that the trees' root systems were so severely pruned that the tops would have to be cut back commensurately. Closer inspection by other Department of Agriculture experts revealed that the trees were infested with root gall worm (root-knot nematode), fungus diseases, and other insect pests. The secretary of agriculture insisted that the trees be destroyed, and President Taft reluctantly agreed. According to official records, all but six of the 2,000 trees were burned.

A flurry of tactful diplomatic correspondence followed with the result that the Japanese decided to replace the trees with 3,000 new ones, specially grown in virgin soil. These trees, along with an additional 3,000 destined for New York's Riverside Park, were shipped aboard the *Awa Maru* from Yokohama on February 14, 1912.

Mayor Ozaki's accompanying letter to Colonel Cosby says: "As for the first lot of trees which we sent you three years ago, we are more than satisfied that you dealt with them as you did, for it would have pained us endlessly to have them remain a permanent source of trouble. The present trees have been raised under the special care of scientific experts and are reason-

ably expected to be free from the defects of their predecessors."

The new trees arrived in Washington, D.C., on March 26, 1912, and the Department of Agriculture experts immediately began to inspect them, finding, to everyone's relief, that "the trees seem singularly free from injurious insects or plant diseases." On March 27, First Lady Helen Taft planted the first tree and invited Viscountess Chinda, wife of the Japanese ambassador, to plant the second. The Japanese ambassador, Colonel Cosby, and Eliza Scidmore were the only witnesses.

Within five years, the trees were achieving full bloom and became the highlight of spring in the capital. The first commemoration of their arrival was held in 1927, with dancing, singing, and Washington schoolchildren reenacting the original tree planting. Since that time, the springtime celebration has evolved and grown into an annual festival, with only a brief hiatus during World War II. In recent decades, the Festival has showcased diverse arts and culture, including highlights from Japan, and has included a parade, cooking events, and sports. Many First Ladies have served as honorary chair of the National Cherry Blossom Festival. They have participated in tree plantings, the opening ceremony, and many other Festival events. ▪

ABOVE: *Festival items and marketing materials featured Ann Marie Williams's art in 2006.*
FOLLOWING PAGES: *Japanese people have enjoyed cherry blossom viewing for more than 1,000 years.*

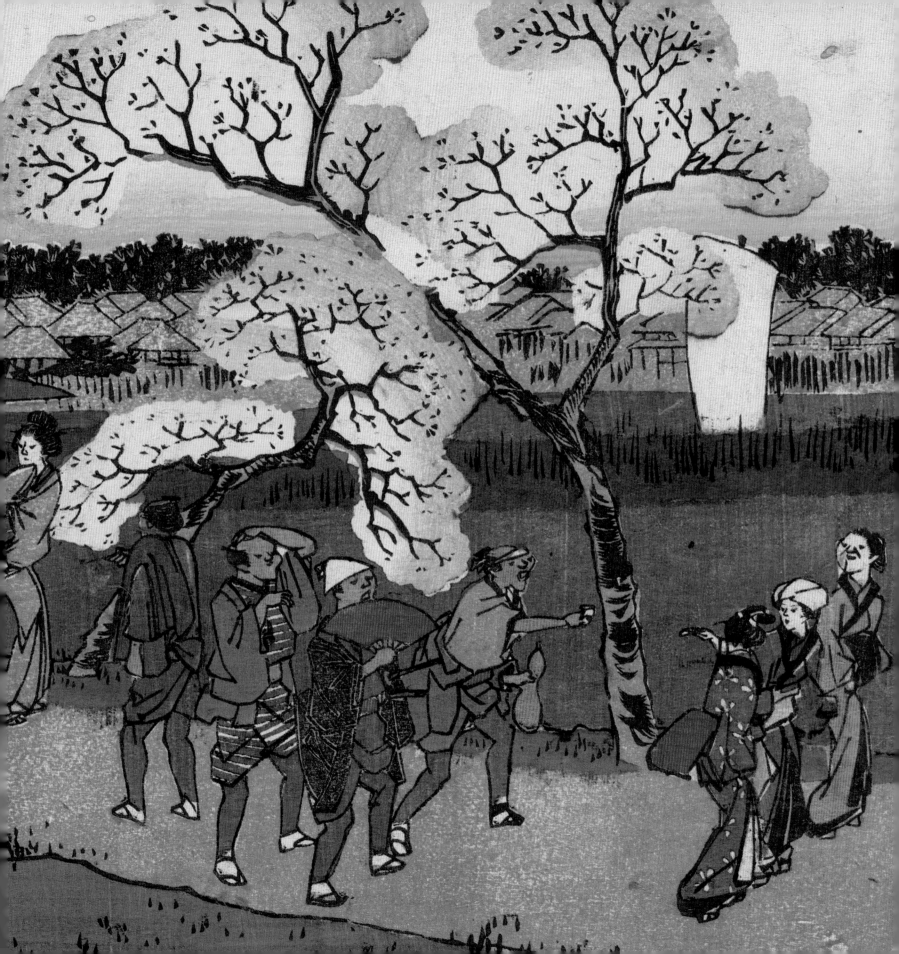

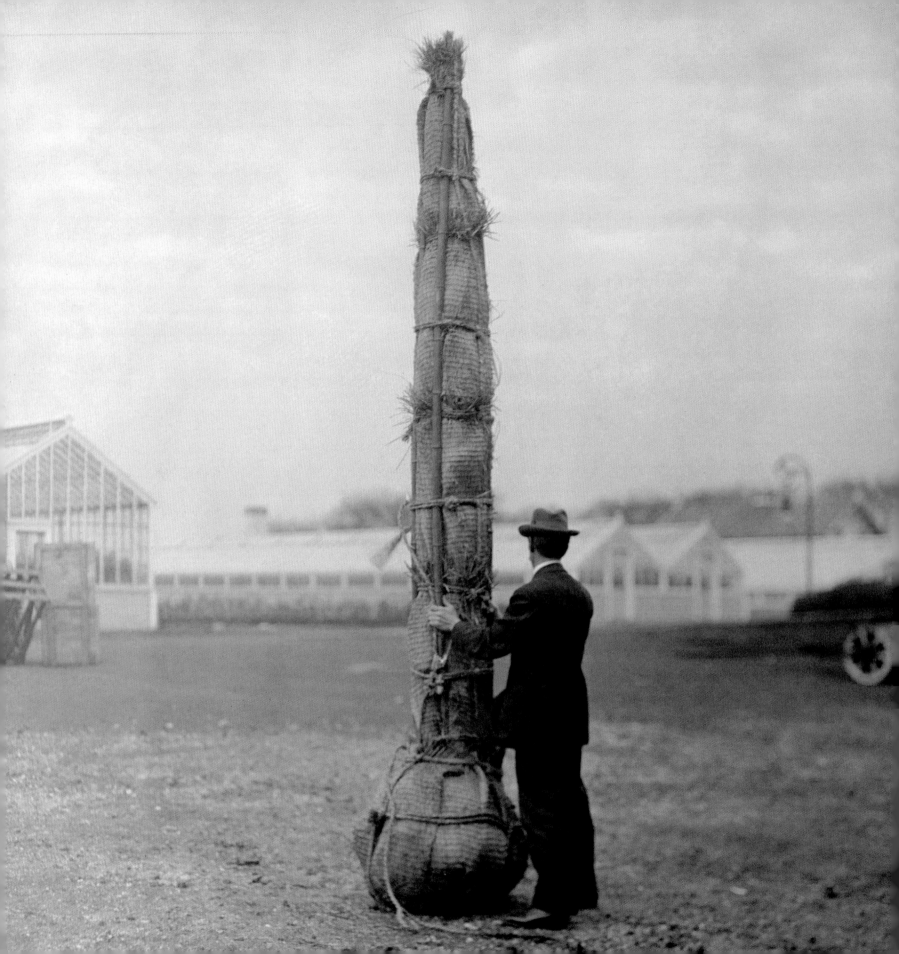

BLOSSOMS COME TO WASHINGTON

THE JAPANESE CHERRY BLOSSOM TREES CAME TO Washington, D.C., as a gift from the city of Tokyo through vision, perseverance, and the enduring power of international friendship. Eliza Scidmore, David Fairchild, and First Lady Helen Herron Taft all played important roles. Both Scidmore and Fairchild suggested that Mrs. Taft promote planting cherry blossom trees along the Speedway in Potomac Park on the city's newly reclaimed land. She agreed, and when the Japanese learned of her interest in cherry blossoms, they offered to make an official gift of the trees from the city of Tokyo to the city of Washington in her honor. The gift was accepted, and 2,000 trees arrived in 1910. Unfortunately, older trees were sent to ensure their blooming. These were found to be diseased and were ordered to be destroyed. ～ The Japanese were undeterred and resolved to carry on with the gift, growing new trees in pristine conditions. In 1912, 3,020 trees arrived in Washington, D.C., proudly sent by Tokyo's Mayor Yukio Ozaki. When these were inspected, they were found to be in excellent condition and were planted immediately. Of the 12 varieties sent, 1,800 were Yoshinos and 350 were Kwanzans. Both varieties flourish in Washington, D.C., today. ■

The older trees sent from Japan in 1910 were bound in bundles for shipment.

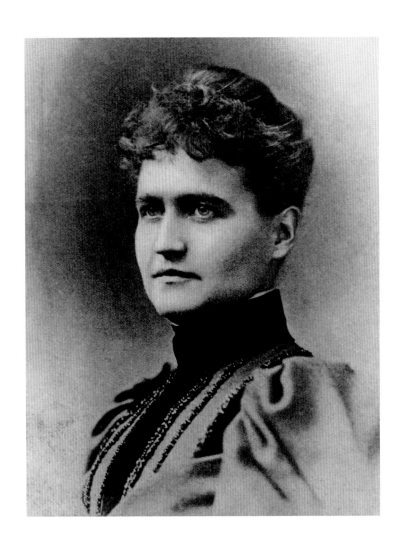

ABOVE: *Eliza Scidmore persevered for decades in her efforts to plant Japanese flowering cherry trees in Washington, D.C.*
OPPOSITE: *David and Marian Bell Fairchild planted Japanese cherry blossom trees successfully in Maryland.*
FOLLOWING PAGES: *One of four postcards from Japan shown to Helen Taft, depicting the trees overspreading a roadway*

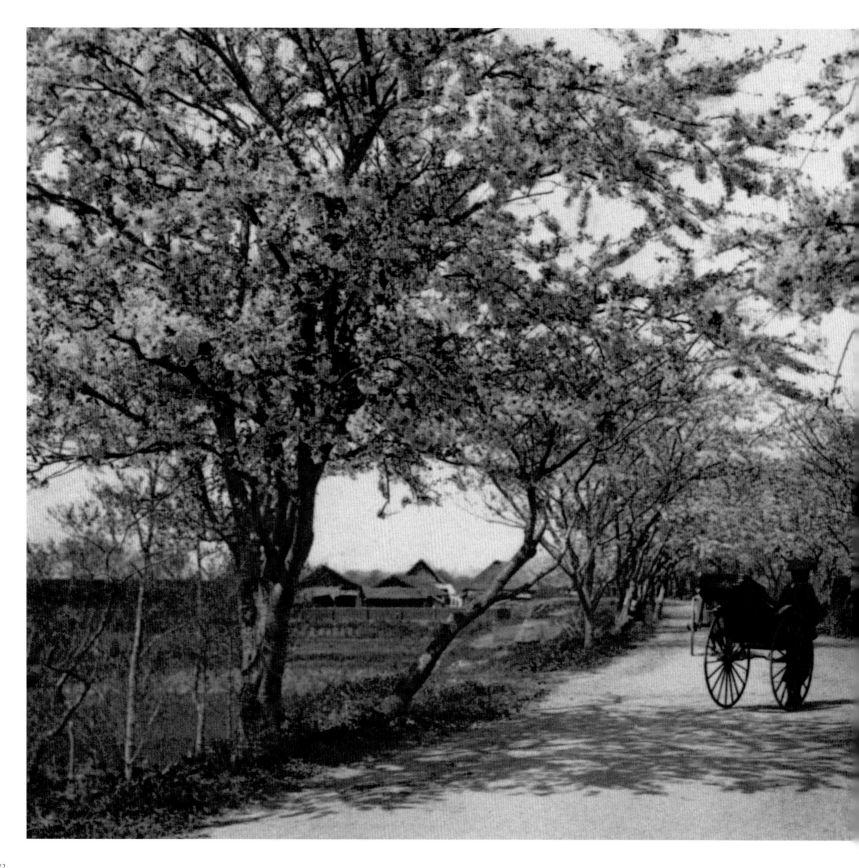

"No one . . .
in 1912
could have imagined
the exciting
celebration
the National
Cherry Blossom
Festival
has become . . ."

Tokyo's Mayor Yukio Ozaki, shown with his wife, displayed diplomacy and
determination about the gift of trees.

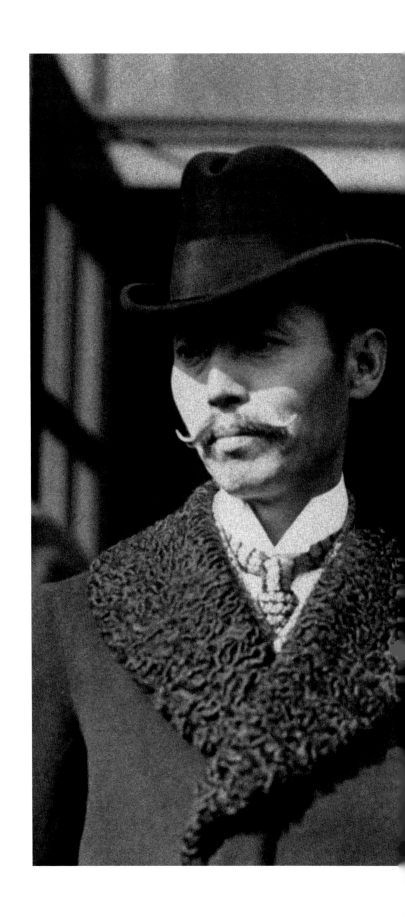

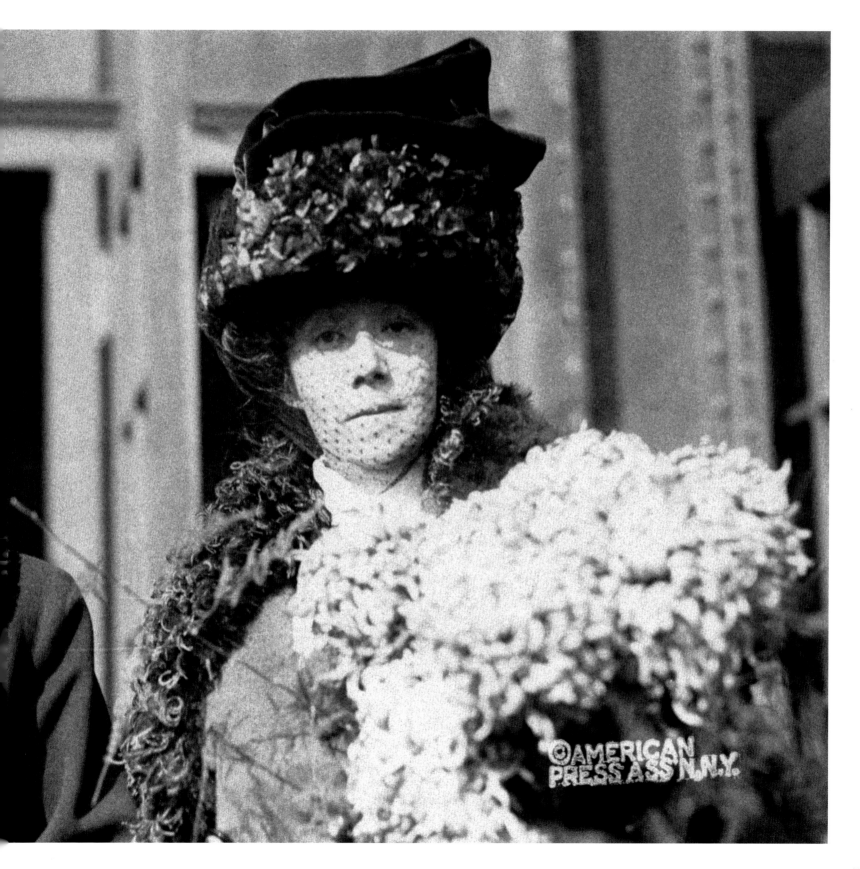

©AMERICAN
PRESS ASS N.N.Y.

CHERRY KOGANE

ABOVE: *Another of the Japanese postcards shown to Mrs. Taft, showing the cherry blossoms near water*
OPPOSITE: *First Lady Helen Herron Taft pressed to have cherry blossom trees planted in Potomac Park.*

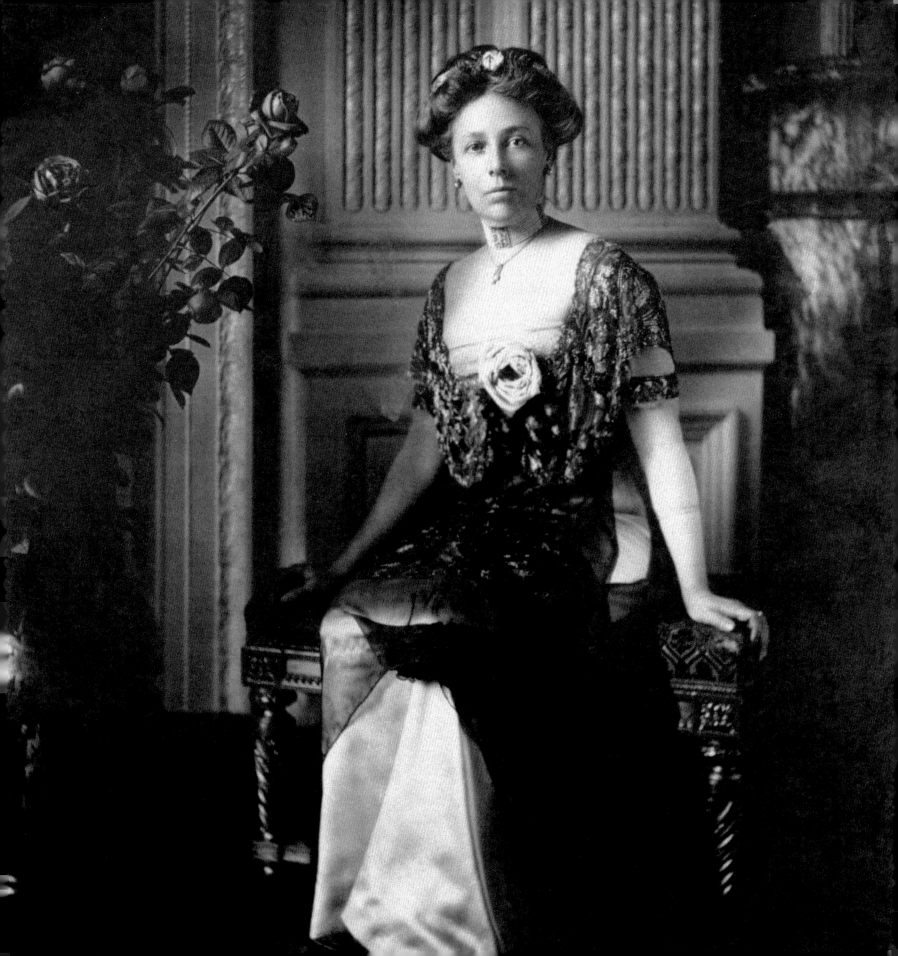

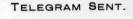

OPPOSITE: *Department of Agriculture inspectors examined the trees and found pests and diseases.*
ABOVE: *The decision to burn the infested trees was affirmed by President Taft.*

Dr. Jokichi Takamine is credited with playing a pivotal role in bringing the trees to Washington, D.C. The 1912 gift of trees was shipped with 3,000 trees he gave to New York City.

Yoshinos and Akebonos

MORE THAN 1,400 Yoshino and about 100 Akebono cherry blossom trees encircle the Tidal Basin. Yoshinos (*Prunus* x *yedoensis*) were first discovered in Tokyo in 1872. Their pale pink opening petals become almost white and then show traces of pink at their base before falling. Only about 100 Yoshino trees remain from Japan's original gift planted in 1912. The Akebono trees (*Prunus* x *yedoensis* 'Akebono') were introduced in California in 1920. Both are wide-spreading trees, meaning their branches reach side to side, growing to a height of 30 to 50 feet. Like other trees, they depend on their roots for uptake of water and nutrients. For this reason, the soil compacted by the thousands of footsteps of their adoring visitors at the Tidal Basin is their greatest challenge, reducing their normal life span of about 100 years by half.

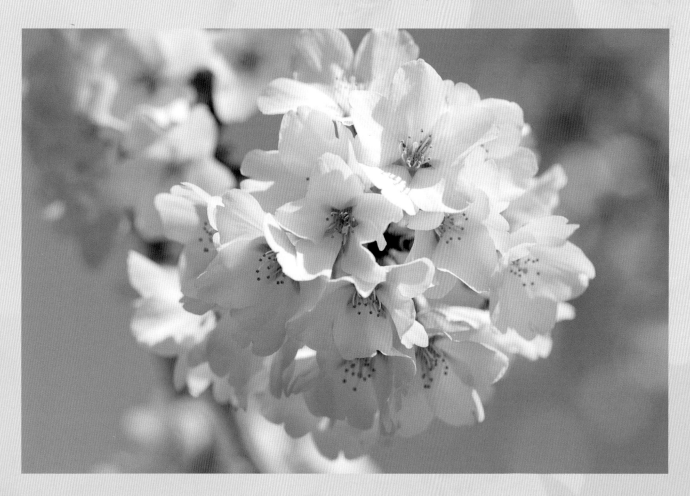

Yoshino and Akebono blossoms have five petals, each with a notched edge.

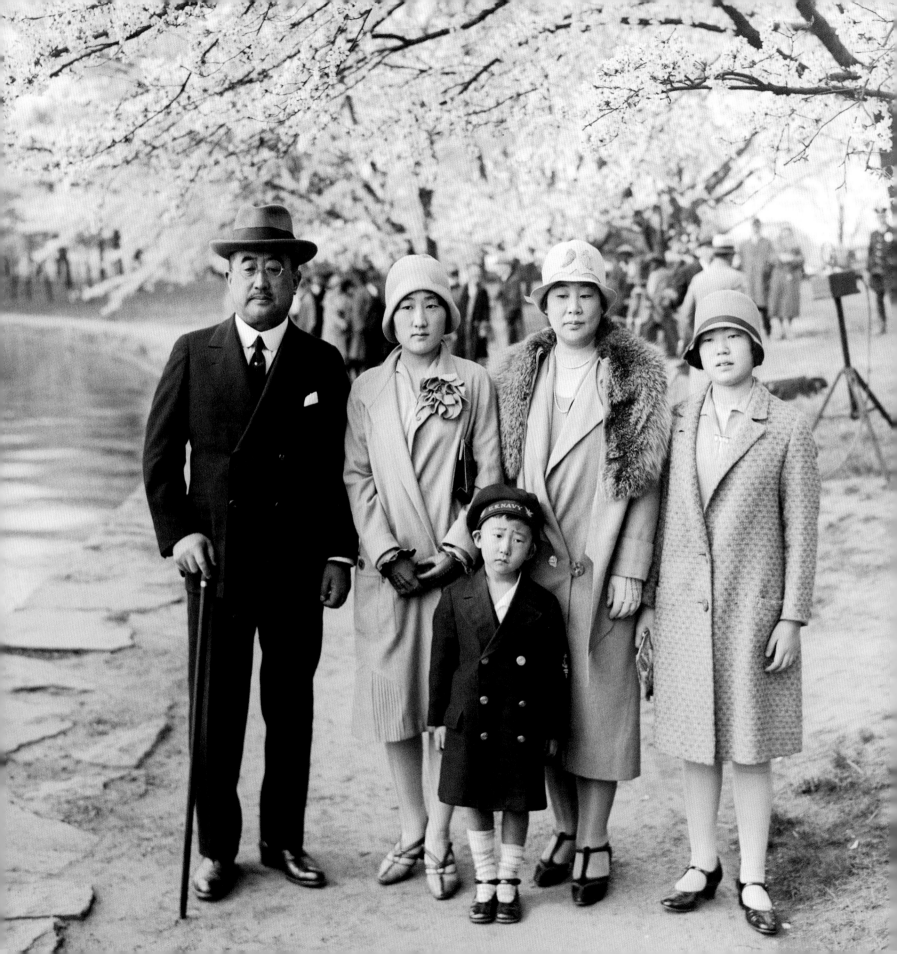

CELEBRATING THE TREES

A T FIRST, CHERRY BLOSSOM VIEWING IN WASHINGTON, D.C., was mostly independent and personal. People strolled under the blooming trees, undeterred by spring's uncertain weather, inspired by the blossoms to make the most of each day. Groups gathered, of course, and milestones were celebrated, as they are today, but there were no "official" celebrations. The trees' blooming also attracted myriad artists, writers, photographers, musicians, and other performers. Their work now fills many family and institutional archives and can also be seen on gallery walls. ≈ In 1927, the first event was held to commemorate the trees' arrival and to honor the friendship between Japan and the United States. Helen Taft was in the audience to view a reenactment of the first planting, a pageant presenting Japanese myths, and children dancing a "Cherry Petal Ballet." In 1934, the District of Columbia commissioners sponsored a three-day celebration, which later evolved into an annual "Cherry Blossom Festival" observance. The early festivals varied in duration, though they typically included a parade, a ball, musical entertainment, and other springtime revels. High-ranking government officials and popular socialites participated, lending prestige to the events. ▪

The ambassador from Japan and his family pose with the blooming trees in 1928.

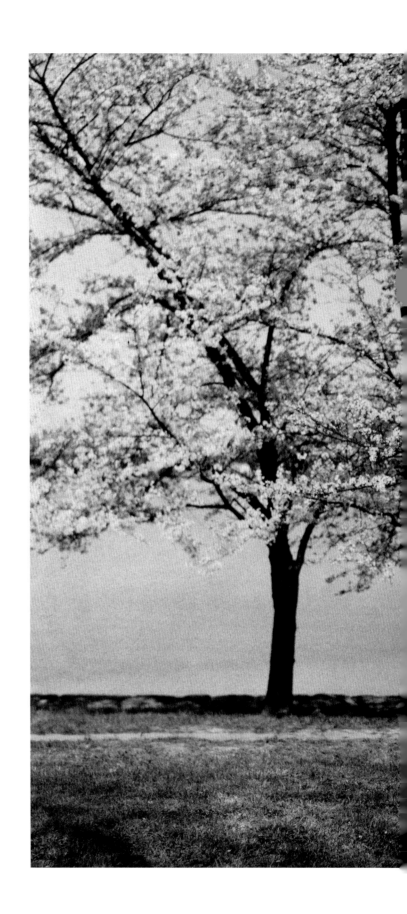

"*Many people . . .
indulge
in their own
inner artist,
inspired
by the sight
of the
breathtaking
blossoms.*"

OPPOSITE: *A man painting the blossoms in 1935 captured
their fleeting beauty on canvas.*
FOLLOWING PAGES: *The Lincoln Memorial overlooks the Tidal Basin
and flowering cherry trees in 1922.*

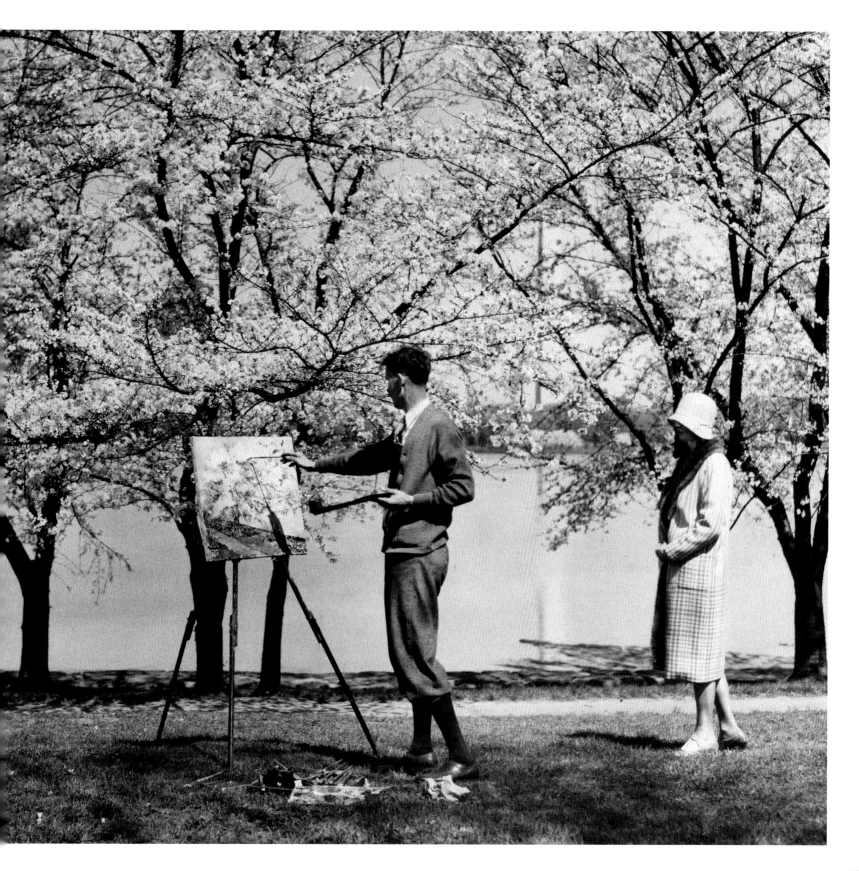

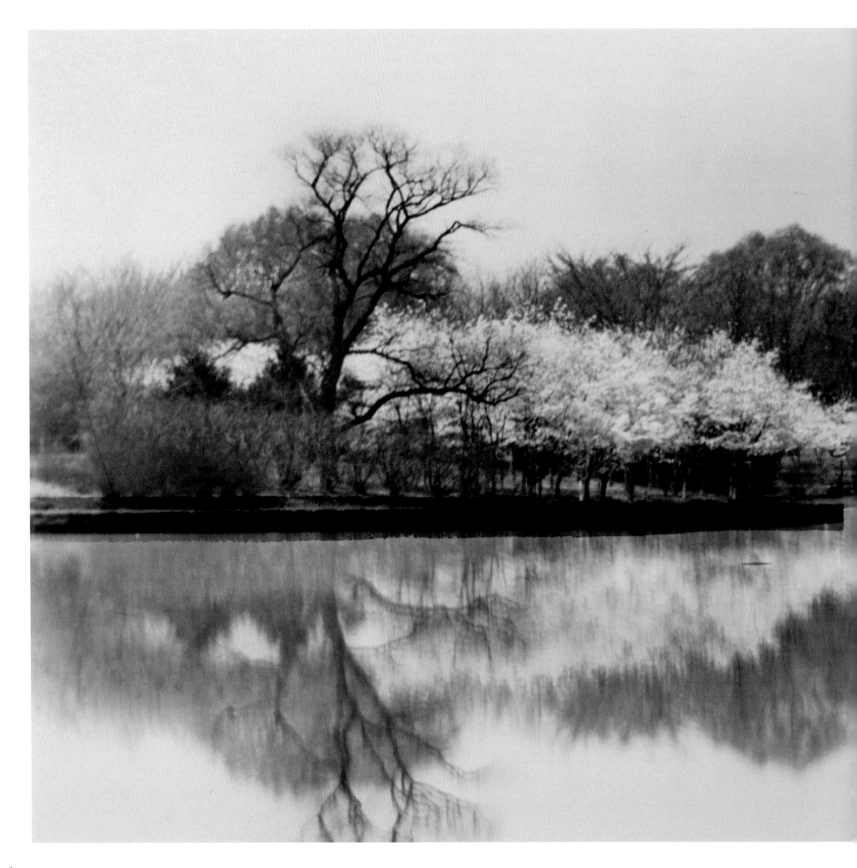

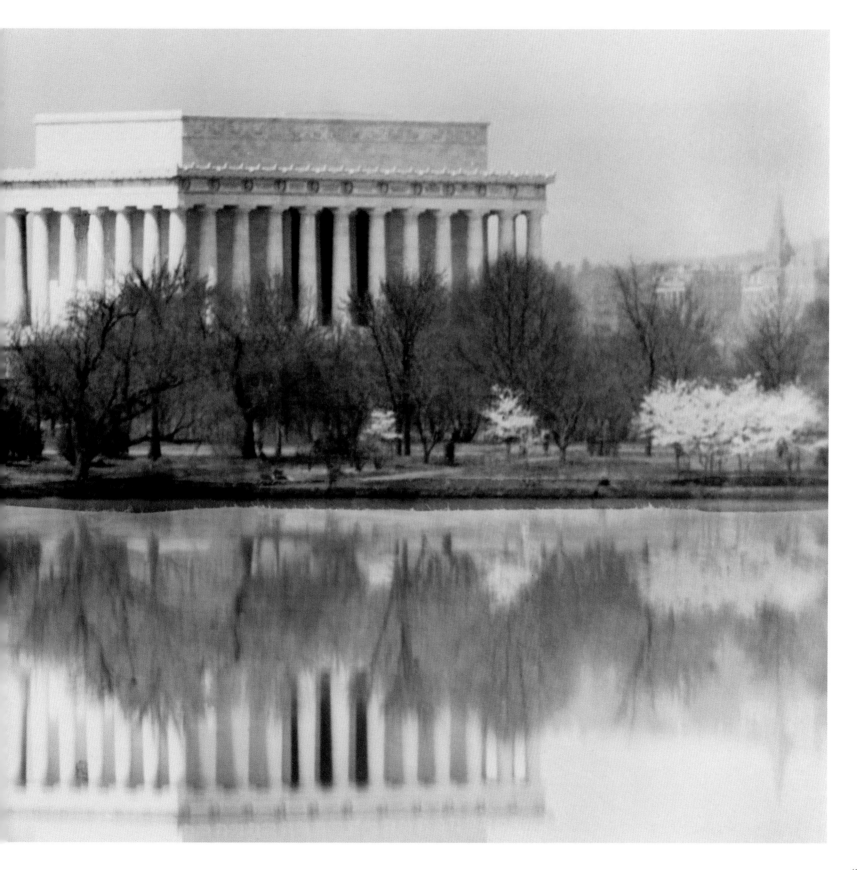

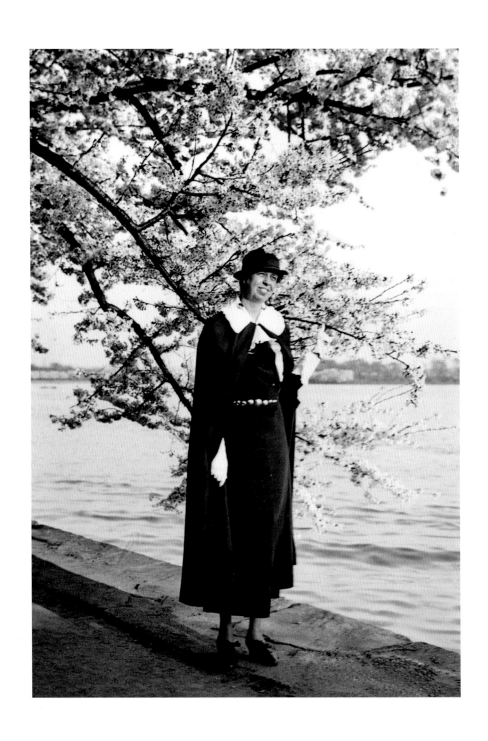

ABOVE: *Eleanor Roosevelt enjoyed the blossoms at their peak when visiting the Tidal Basin in April 1933.*
OPPOSITE: *A daughter of the Japanese ambassador is crowned Queen of Cherry Blossoms in 1937 by a D.C. commissioner.*

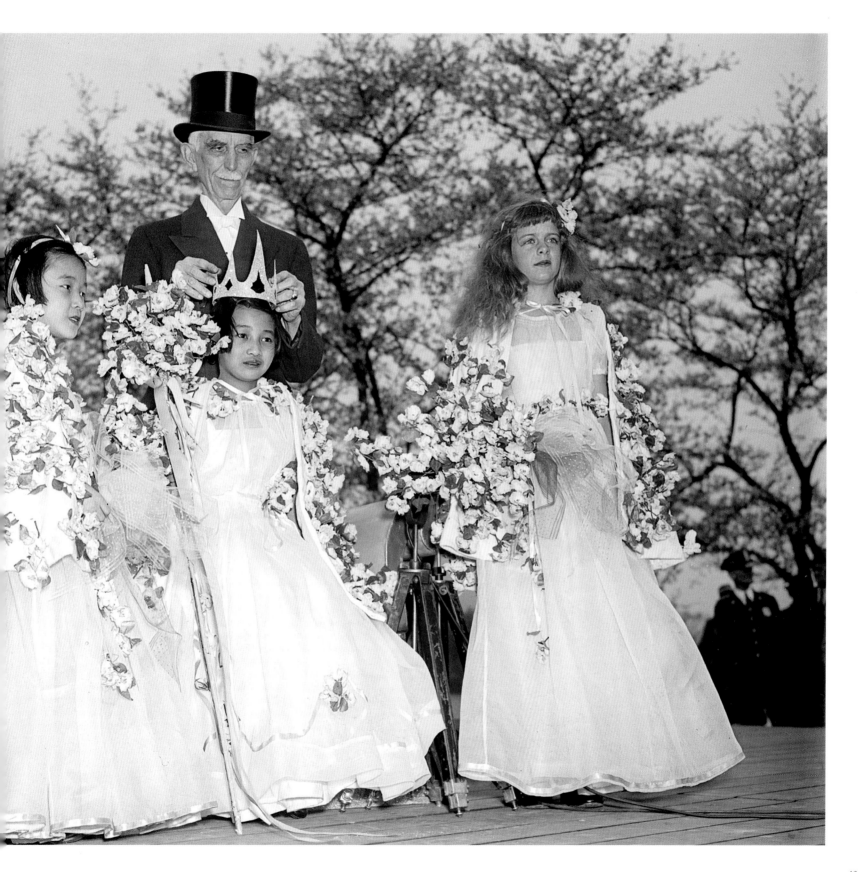

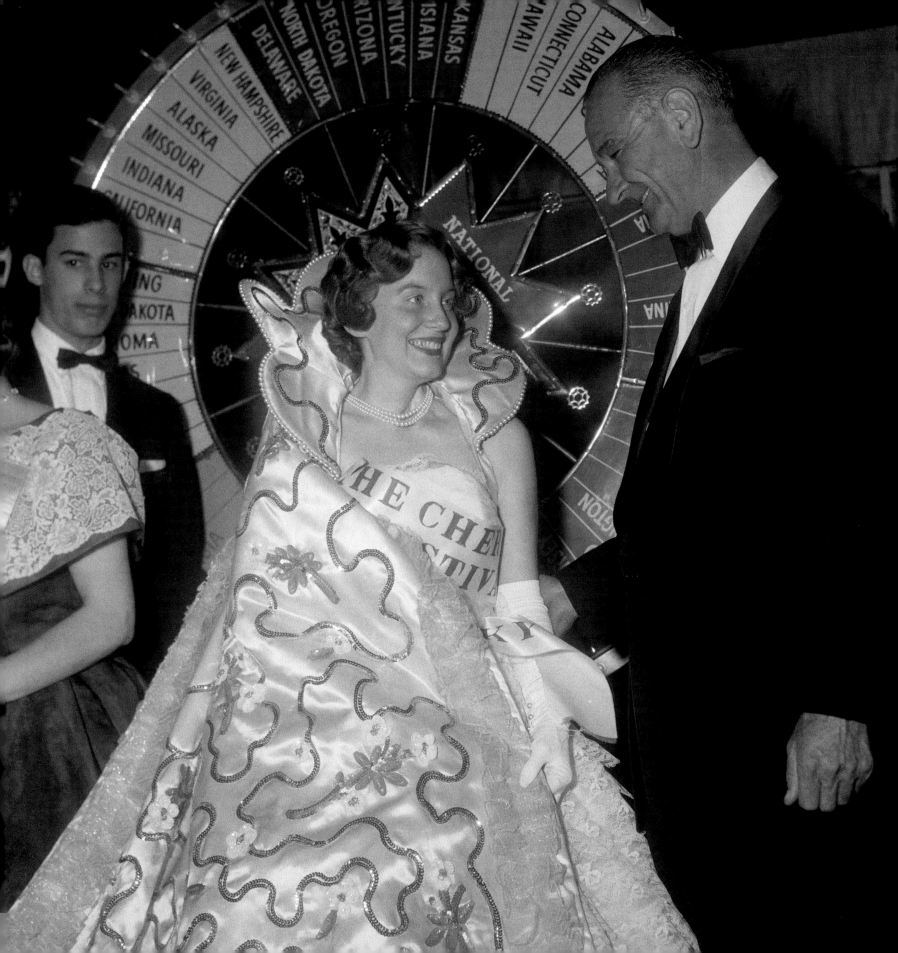

THE FESTIVAL GROWS

THE FESTIVAL THAT WE KNOW TODAY BEGAN to take shape in 1947, when it was revived following World War II. By 1949, it was a three-day affair, highlighted by a U.S. Navy Band radio broadcast, other song and dance performances, and the crowning of the National Conference of State Societies' Cherry Blossom Queen. By 1953, the Festival was five days long, encompassing a fashion show and luncheon, a nighttime "Illuminated Float Parade," a water show in the Tidal Basin, and a pageant where First Lady Mamie Eisenhower crowned the queen. ∞ The lighting of the Japanese lantern became a Festival tradition beginning with the lantern's arrival in Washington in 1954. Given to commemorate the 100th anniversary of the signing of the Treaty of Kanagawa in 1854, the two-ton, eight-foot-tall granite lantern from Tokyo dates from 1651. ∞ Later, the Festival expanded to two weeks, with events hosted by the area's most renowned cultural organizations. First Ladies have continued to be involved in the Festival, promoting beauty and international friendship, often serving as honorary chairs. In addition, Lady Bird Johnson and Hillary Clinton participated in tree plantings, and Laura Bush helped open the Festival at the Kennedy Center in 2001. ∎

Vice President Lyndon B. Johnson congratulates Elizabeth Howard, Cherry Blossom Queen of 1961.

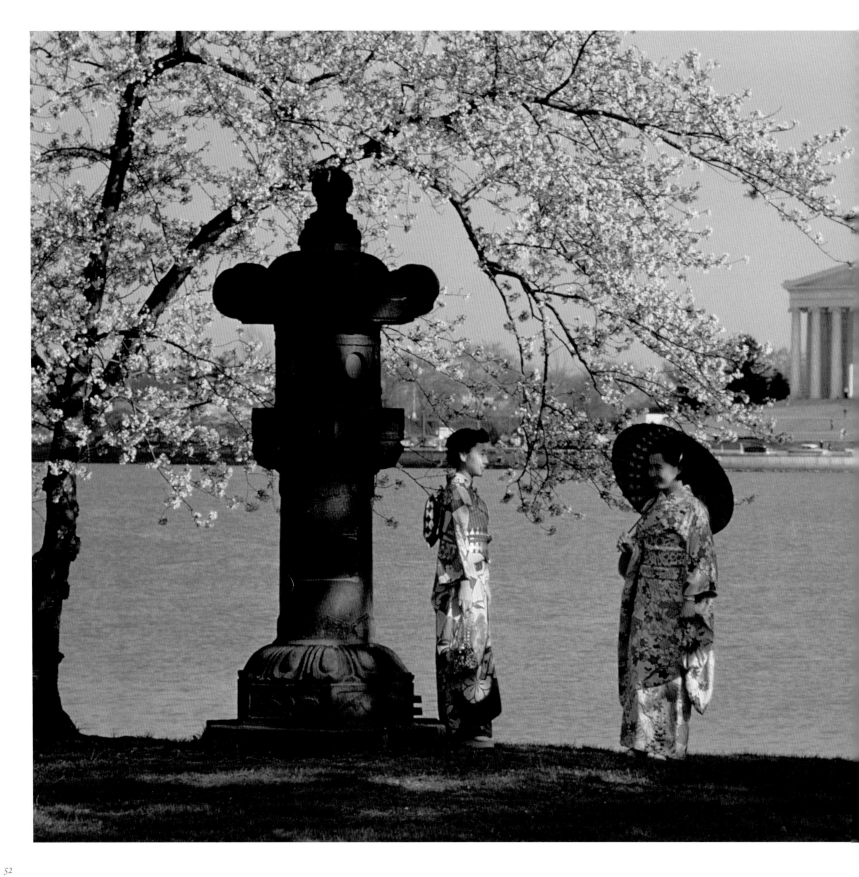

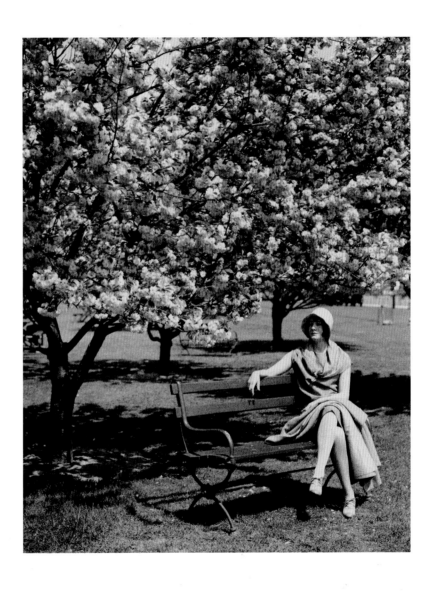

ABOVE: *A woman sits under cherry blossoms in East Potomac Park in the 1930s.*
OPPOSITE: *Kimono-clad employees of the Japanese Embassy enjoy the blossoms in 1954.*

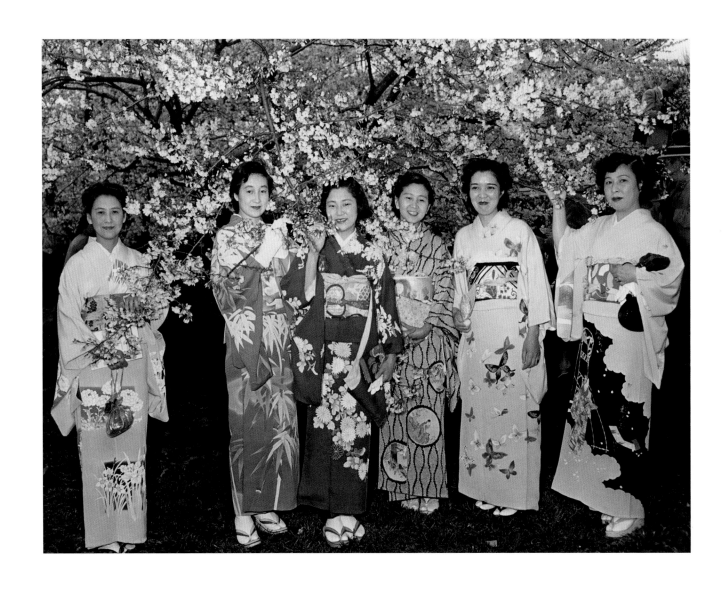

ABOVE: *Wearing kimonos as beautiful as the cherry blossoms, visitors in 1954 pose in a group.*
OPPOSITE: *A "peace pigeon" flies high during the Lantern Lighting Ceremony in 1956.*

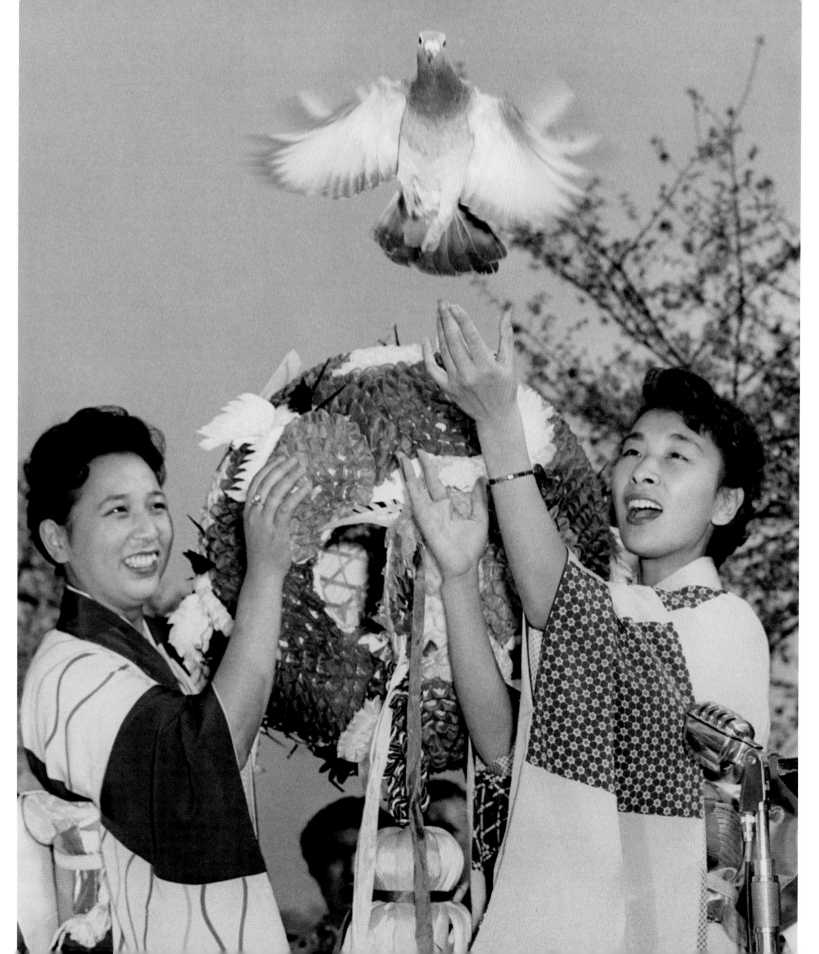

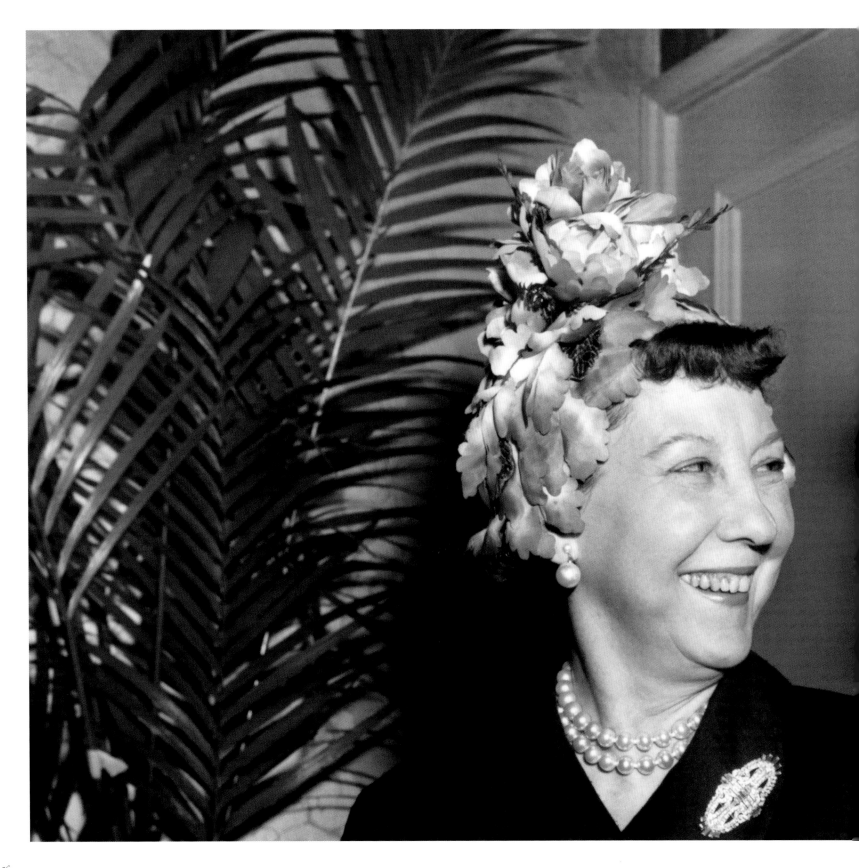

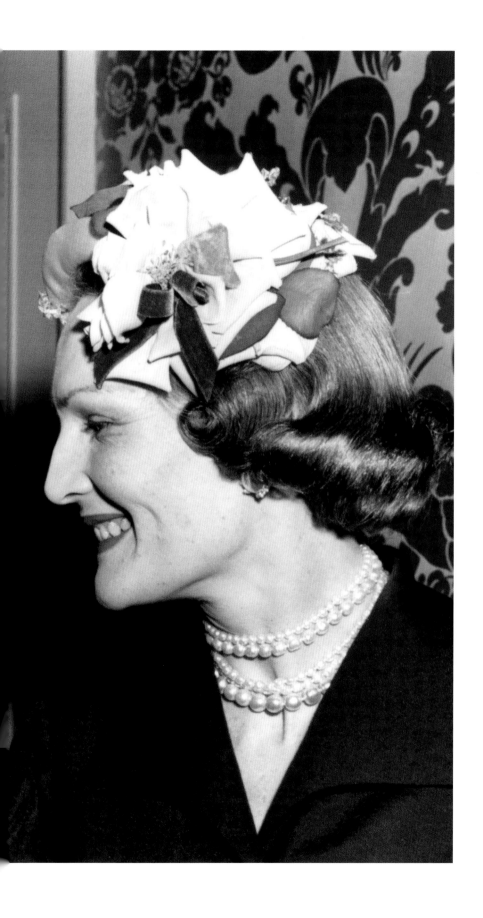

"*First Ladies have continued to be involved in the Festival, promoting beauty and international friendship . . .*"

Mamie Eisenhower and Pat Nixon show off their flower-themed hats at a cherry blossom luncheon and fashion show in 1958.

When Will They Bloom?

EACH YEAR, everyone wants to know when the flowering cherry trees around the Tidal Basin will blossom. The "peak bloom date" is the day on which 70 percent of the cherry blossoms are open, usually around April 4, but as early as March 15 in 1990 to as late as April 18 in 1958. Although "peak bloom" may last only a few days, the blooming period can last as long as two weeks because the blossoms on each tree unfurl at different times.

National Park Service horticulturists attempt to predict the peak bloom date each spring. They study the trees, looking for the following five stages of bud development: Green Color in Buds, Florets Visible, Extension of Florets, Peduncle Elongation, and Puffy White. They also watch the "indicator tree," a cherry tree of unknown origin located near the Outlet Bridge. When it blooms, it blooms alone, and the Tidal Basin's cherry blossom trees will bloom seven to ten days later.

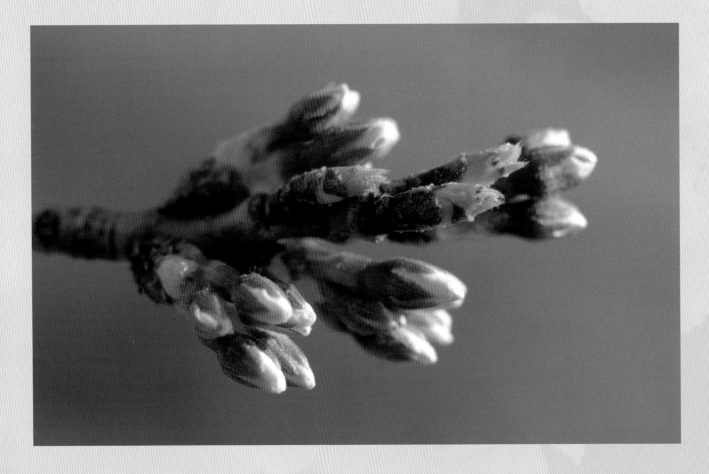

Park Service horticulturists measure the buds' growth to determine peak bloom dates each year.

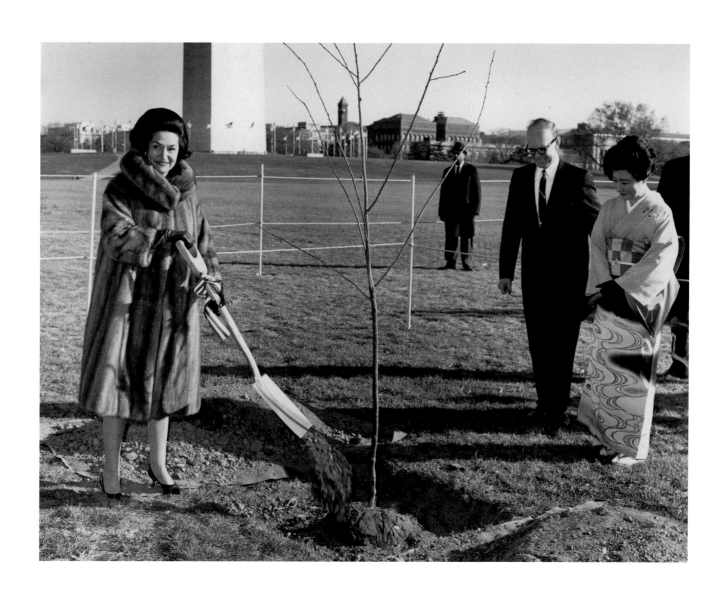

Lady Bird Johnson planted one of 3,800 cherry blossom trees given by Japan on the Washington Monument grounds in 1966.

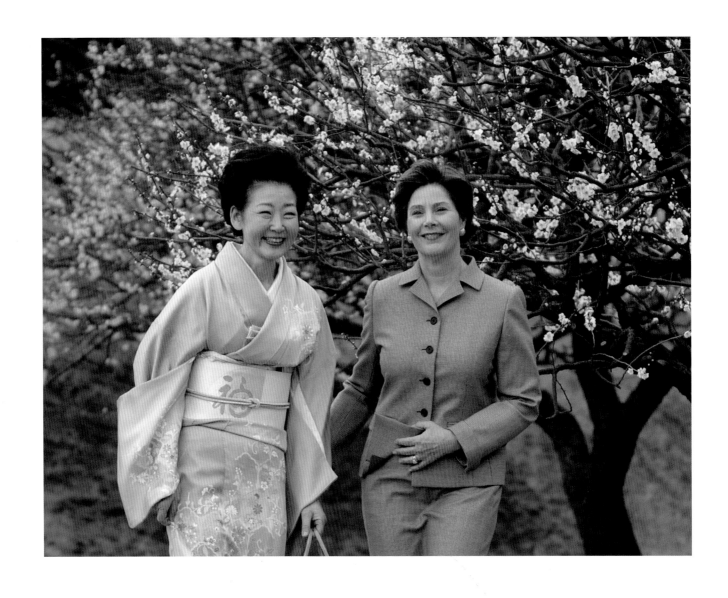

ABOVE: *Laura Bush participated in many National Cherry Blossom Festival events.*
OPPOSITE: *Tricia Nixon welcomed the Cherry Blossom Princesses to the White House in 1970.*
FOLLOWING PAGES: *Early morning visitors to the Tidal Basin find tranquillity.*

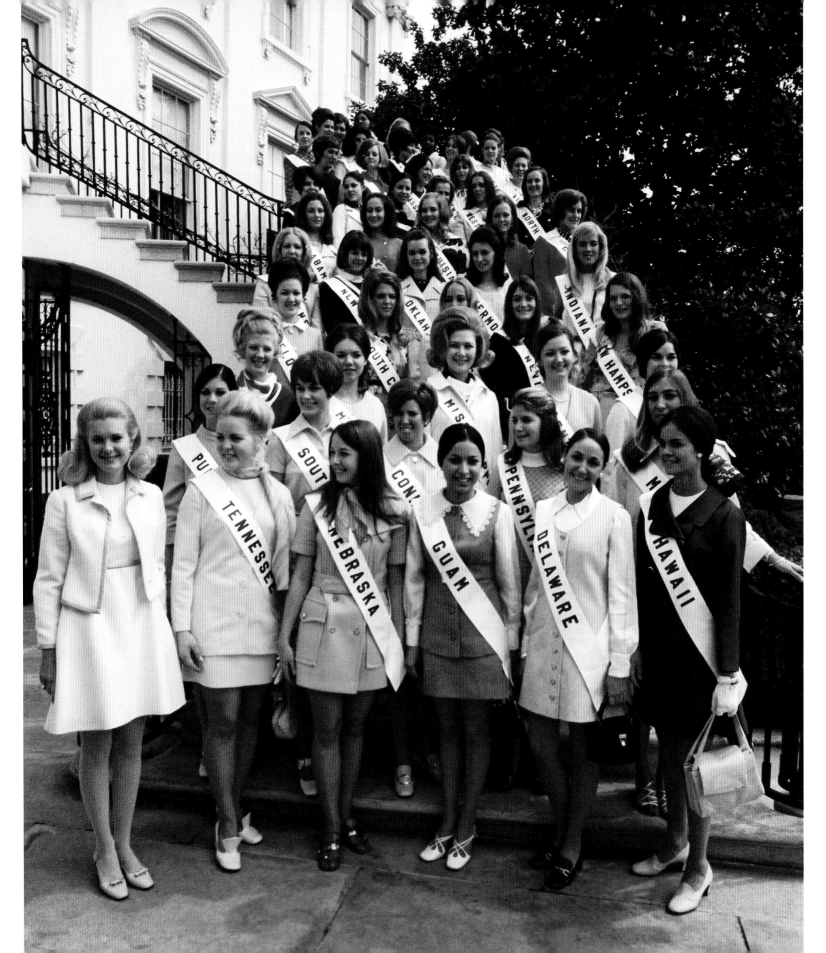

61

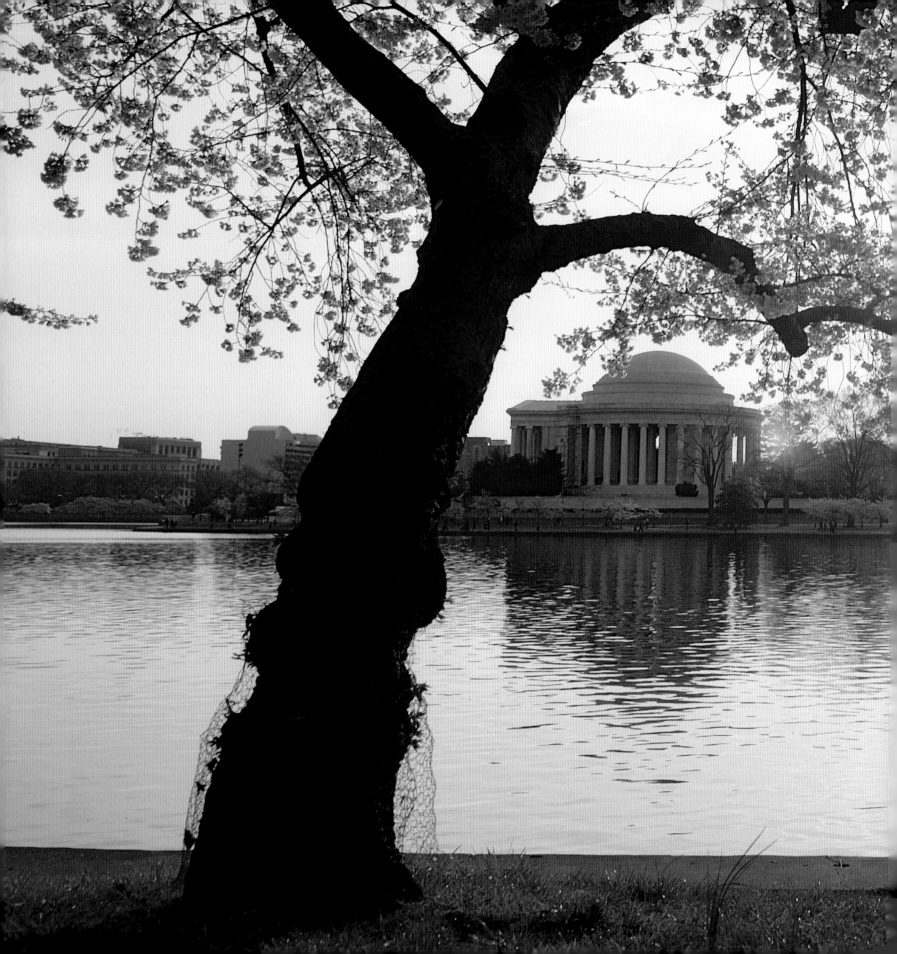

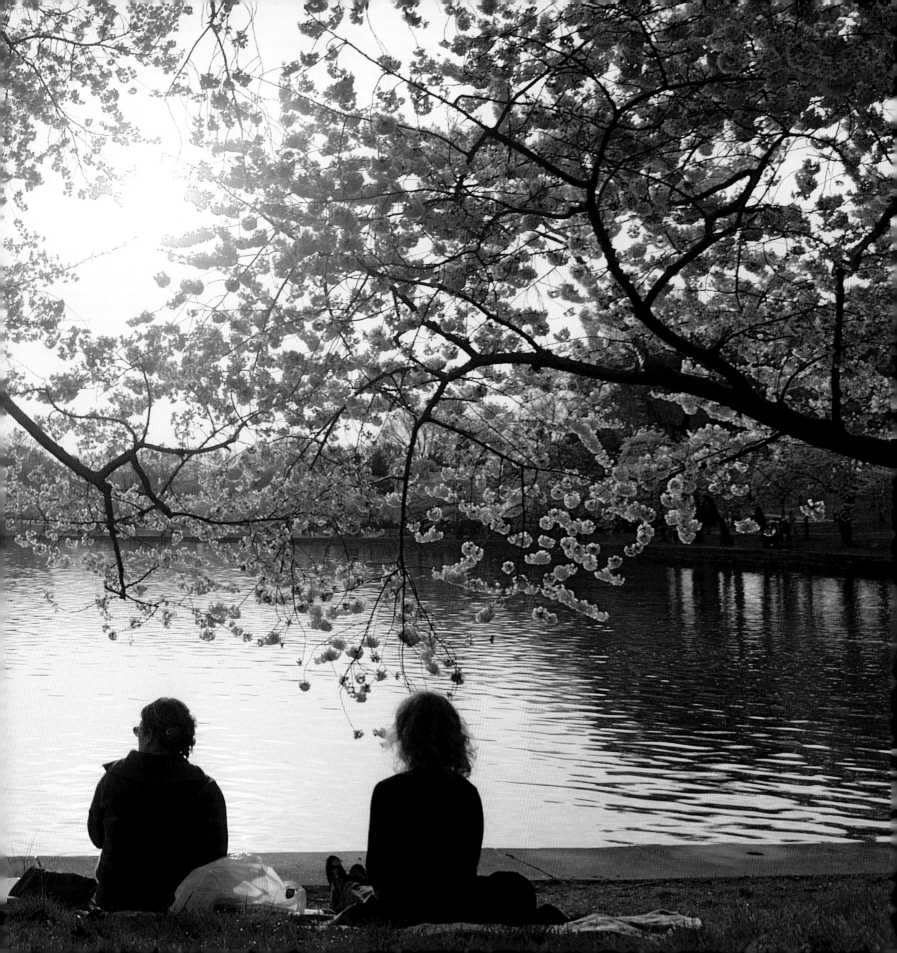

SPRINGTIME CELEBRATION

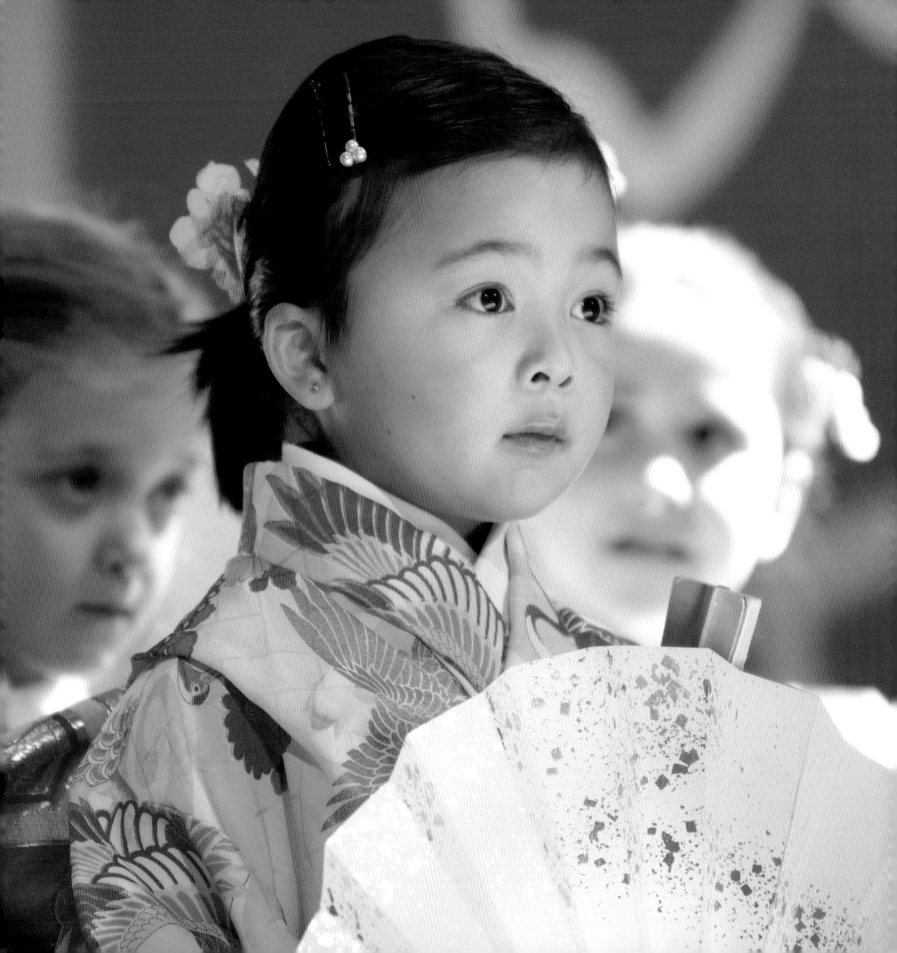

The Nation's Greatest Springtime Celebration

UST LIKE THE BLOSSOMS THEMSELVES, the National Cherry Blossom Festival bursts onto the scene each spring, dispelling the cold and dark of winter with vibrant ceremonies and captivating events. Washingtonians and visitors alike feel the excitement in the air. Some visit the blossoms year after year, returning to the spot where they became engaged or enjoyed their baby's first family picnic. New visitors, not sure what to expect, are truly awed by the breathtaking beauty of the flowering cherry trees in bloom. Whatever visitors are looking for, the National Cherry Blossom Festival offers something for everyone: hands-on Family Day activities, an inspiring Opening Ceremony, the Pink Tie Party fund-raiser, the Blossom Kite Festival, the Sakura Matsuri–Japanese Street Festival, and a panoply of dining and entertainment events ranging from classic to cutting edge.

The many different events of the National Cherry Blossom Festival are described throughout three chapters in this book. In this chapter, you'll find signature events and programs produced by the Festival: opening events, Japanese-inspired activities, parties, and community involvement. Chapter Three contains the National Cherry Blossom Festival Parade and the vocal, dance, and instrumental performances seen on stages around town. In Chapter Four, you'll find cherry blossom tours, as well as water, sports, and art events, all made possible by the Festival's partner organizations.

The Pink Tie Party kicks off the city's spring social season. Partygoers flaunt festive pink garb as they enjoy entertainment by sensational performers and consume cherry-inspired food and cocktails prepared by area chefs known for their gastronomic creativity. The Pink Tie Party's silent auction offers a vast array of choices, such as one-of-a-kind artwork and trips to exotic locations.

The Shizumi Kodomo Dance Troupe, composed of kids ages 4 to 17, performs at Family Days.

From internationally renowned performers to up-and-coming talent, the Festival's Opening Ceremony offers a glimpse of global stars. In between performances, welcome remarks are given by dignitaries, including the ambassador from Japan, the mayor of Washington, D.C., and Festival officials.

In recent years, Opening Ceremony performers have included a collaborative performance between the all-female Tateshina High School Jazz Club (the inspiration for the Japanese film *Swing Girls*) and the Howard University Jazz Ensemble; *taiko* (Japanese drumming) artist Kenny Endo; the Washington Ballet; comedy by the Shigeyama family of *kyogen* actors; guitar music by Kevin Eubanks, formerly of the *Tonight Show* Band; TAKE Dance Company; *enka* (traditional Japanese folk music) sung by Pennsylvania-born Jero; and the jazz fusion of composer and keyboardist Keiko Matsui.

The Opening Ceremony also introduces the National Cherry Blossom Festival's annually selected Goodwill Ambassadors. These young men and women, between the ages of 18 and 24, have diverse backgrounds, attend school in the Washington, D.C., area, and share an enthusiasm for Japanese language and culture. They participate in many Festival events, assisting with community outreach

and youth education programs. They serve as Festival spokespeople and focus attention on enhancing Americans' understanding of Japan.

Family Days at the National Building Museum offers an array of activities and entertainment open to all ages, especially younger children and their guardians. Hands-on activities often include *origami* (Japanese paper folding), cutting crafts, decorative kite making, and face painting, among many others. Complementing the hands-on activities are performances featuring Washington, D.C.-area troupes like the Boys and Girls Clubs of Greater Washington dance performers, Washington Toho Koto Society, Taratibu Drill Team, Shizumi Kodomo Dance Troupe, and Levine School of Music Suzuki Strings, among others.

The Lantern Lighting Ceremony, presented by the National Park Service and National Conference of State Societies, is a long-standing tradition of the Festival. It recognizes the Societies' Cherry Blossom Princesses and the Embassy of Japan's princess, who lights the massive stone lantern.

The exciting Sakura Matsuri–Japanese Street Festival, produced by the Japan-America Society of Washington, D.C., is the largest daylong Japanese street

Phyllis Saroff's art was featured on 2007 merchandise, including shirts and bags.

festival in the United States. It offers entertainment, shopping, food, and activities over several blocks of Pennsylvania Avenue. Evoking the energy and buzz of downtown Tokyo, it has a mini-Ginza area, multiple performance stages featuring traditional and "J-pop" contemporary music, and an abundance of Japanese food, beer, and sake. A variety of Japanese wares, clothing, and accessories are sold, and crafts booths offer demonstrations and hands-on experiences of Japanese arts. Special activities attract admirers of wildly popular *anime* (cartoon movies) and *manga* (cartoon books). Japanese drummers, dancers, musicians, and performers of every ilk, from traditional to trendy, entertain the crowds throughout the day. Some years, the Sakura Matsuri–Japanese Street Festival offers sumo wrestling demonstrations, Kabuki, or other Japanese theatrical performances.

The Blossom Kite Festival, held on the Washington Monument grounds on the National Mall, attracts international master kite makers and kite flying clubs, and allows both professional and amateur kite flyers to demonstrate and perfect their high-flying skills. Kite makers compete for prizes as do contestants in the Hot Tricks Showdown and traditional Rokkaku kite

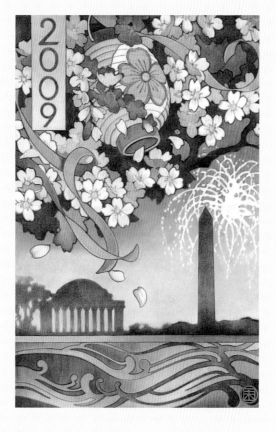

battle. Kids can fly kites they have made too, providing uplifting enjoyment for everyone.

The Southwest Waterfront Fireworks Festival is produced by the Washington Waterfront Association and Hoffman-Madison Waterfront. Entertainment at three stages with a lively lineup of eclectic performances, ranging from military bands to jazz and blues musicians, along with arts and crafts activities, amuses the crowds under the blossoms. Nightfall brings a brilliant and booming fireworks display.

The Festival encourages citywide involvement. Schoolchildren participate in a poster contest and in the Youth Ambassadors program. Youth Ambassadors learn about the trees and the Festival and, like the Goodwill Ambassadors, share their knowledge with others. Residents throughout the city participate in cherry blossom tree plantings: In the last decade, the Festival has planted more than 900 trees throughout the city.

No one involved in the original gift of the cherry blossom trees from the city of Tokyo to the city of Washington, D.C., in 1912 could have imagined the exciting celebration the National Cherry Blossom Festival has become a century later. ◼

Carol Tomasik's colored-pencil drawing was selected as the official art in 2009.
FOLLOWING PAGES: *After tightly curled buds bloom, some will change in color before they fall.*

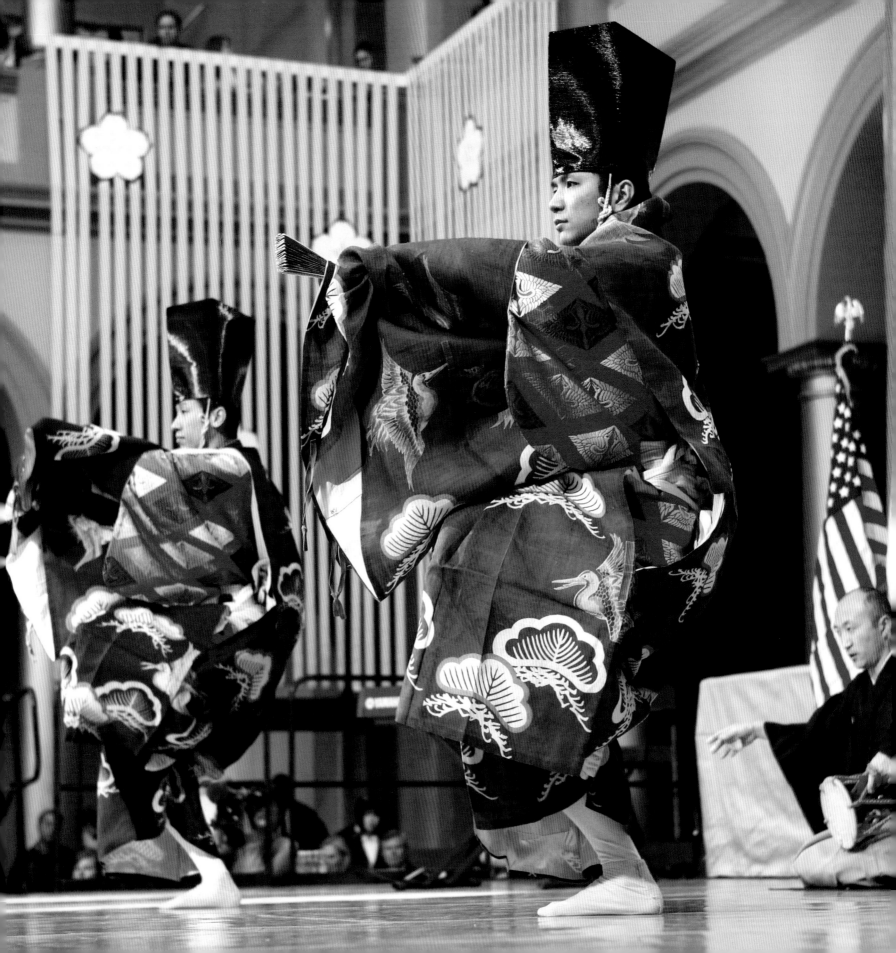

OPENING EVENTS

THOUSANDS ATTEND THE NATIONAL CHERRY BLOSSOM FESTIVAL'S opening events: the Opening Ceremony, Family Days, and the Blossom Kite Festival. ∞ Local, national, and international dignitaries lend gravitas to the Opening Ceremony's exuberant performances by world-renowned musicians, dancers, and singers. From electrifying taiko drummers to thrilling ballet, the performances showcase the best of East and West. With a mix of traditional and innovative, the Opening Ceremony inspires the crowd, setting an exciting tone for the Festival. Family Days at the National Building Museum is a weekend play space that parents love because their kids leave exhausted. Families find energetic performances inside and out, with hands-on activities, such as making *kirigami* flowers out of cut and folded paper or making cherry blossoms out of pipe cleaners and pink tissue paper. ∞ The Blossom Kite Festival, one of the largest, free kite competitions in the United States, draws master kite makers and kite flying clubs from around the world. People enjoy flying or watching the kites in the shadow of the Washington Monument. Family fun is highlighted in handmade kite contests with categories such as "most patriotic," "most beautiful in the sky," and "the people's choice." ∎

The Shigeyama family, famous kyogen players with a 400-year history, perform.

"*Just like the blossoms themselves, the National Cherry Blossom Festival bursts onto the scene each spring . . .*"

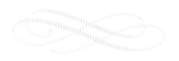

The Washington Ballet's graceful ballerinas captivate crowds at
Opening Ceremony and Family Days events.

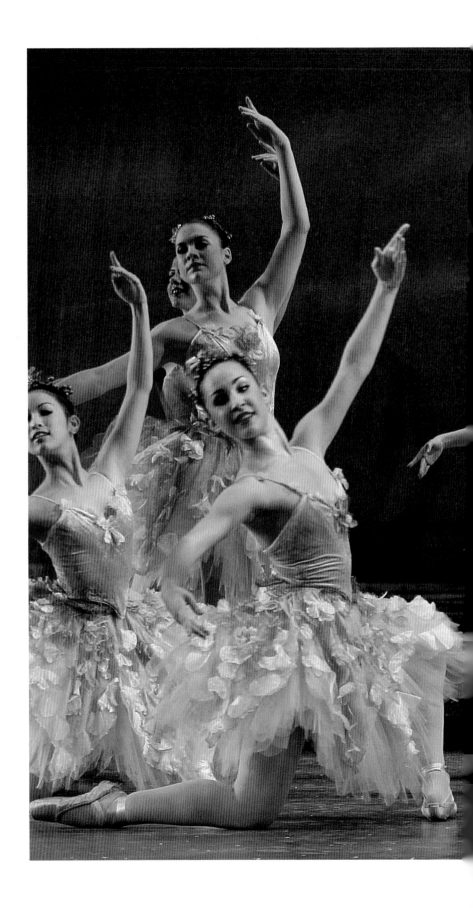

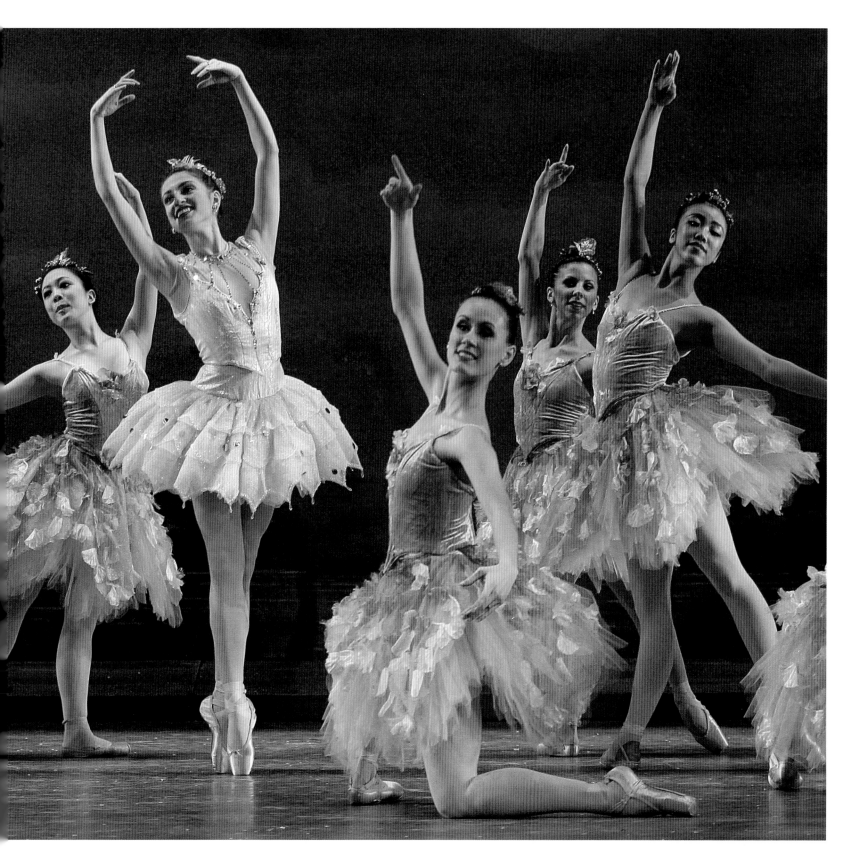

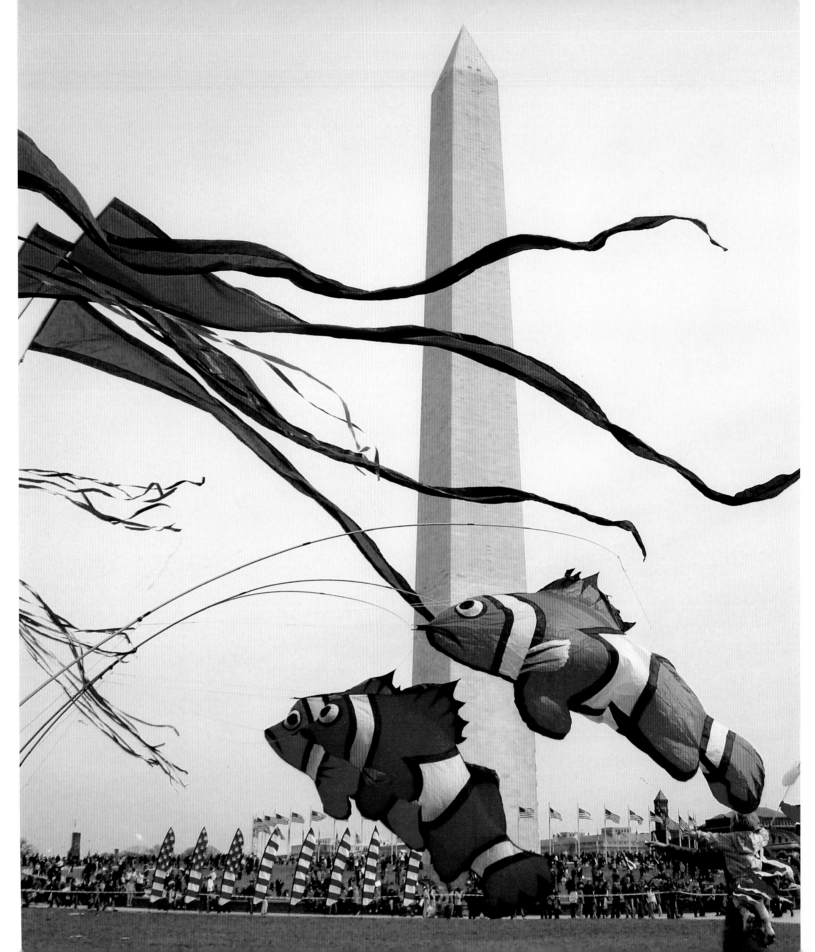

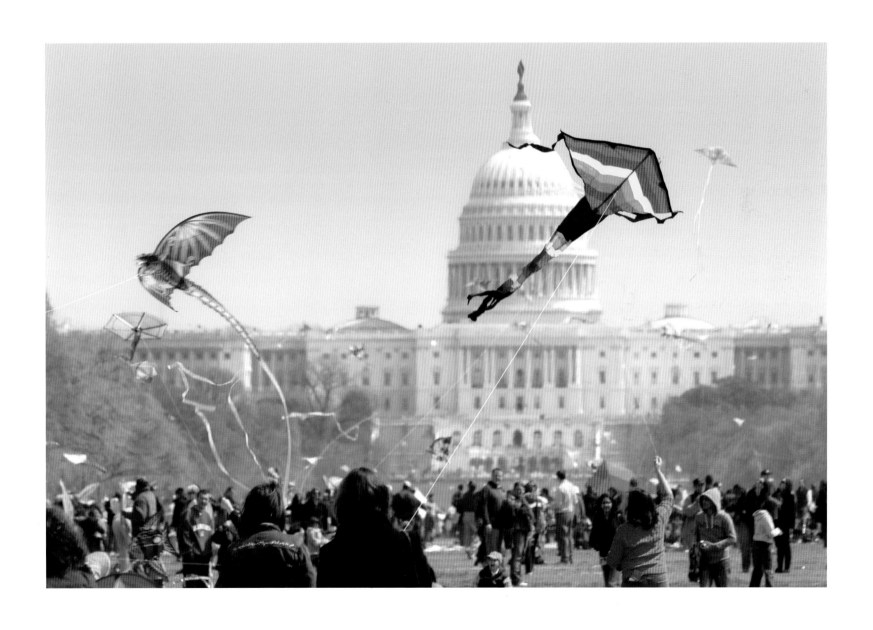

ABOVE: *The Blossom Kite Festival brings excitement to the National Mall.*
OPPOSITE: *Brightly colored kites soar near the Washington Monument.*

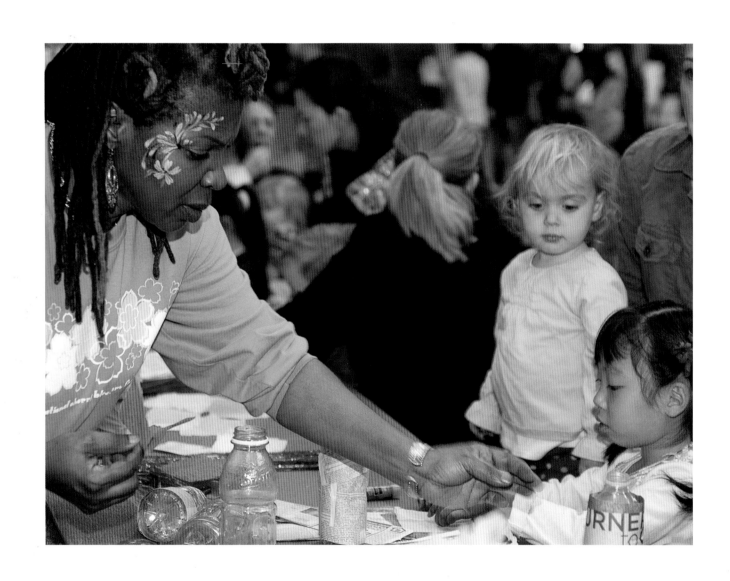

ABOVE: *A friendly volunteer assists kids with arts and crafts at Family Days.*
OPPOSITE: *Talented Goodwill Ambassadors act as cultural liaisons at Festival events.*
FOLLOWING PAGES: *The National Building Museum is filled to the rafters for an Opening Ceremony.*

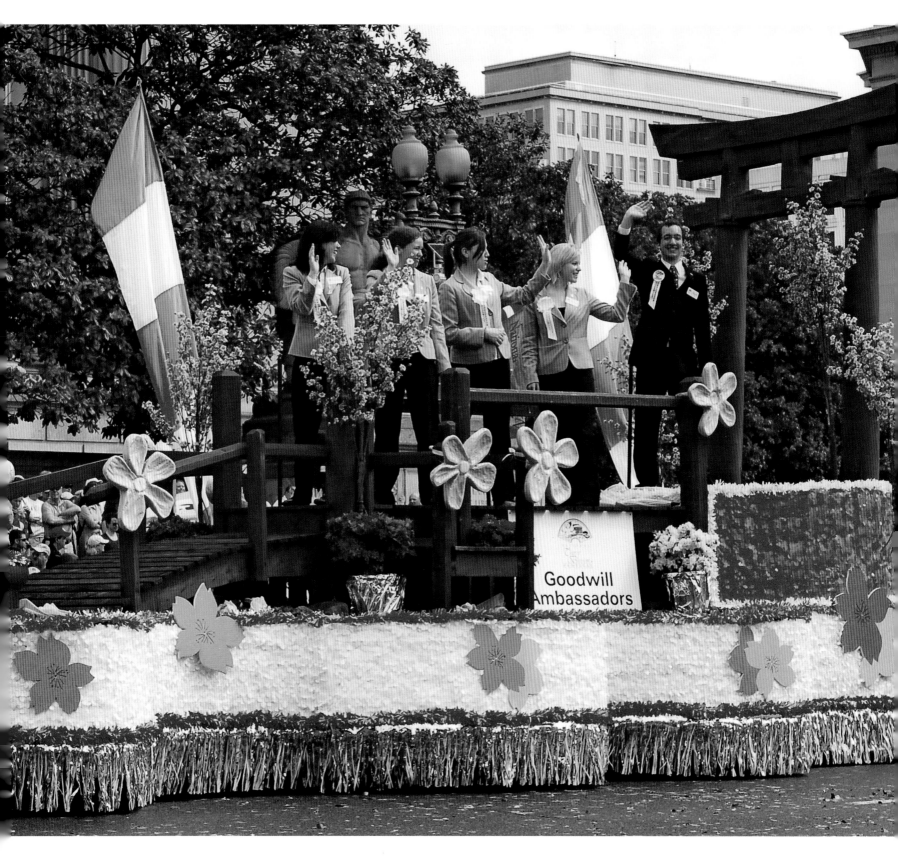

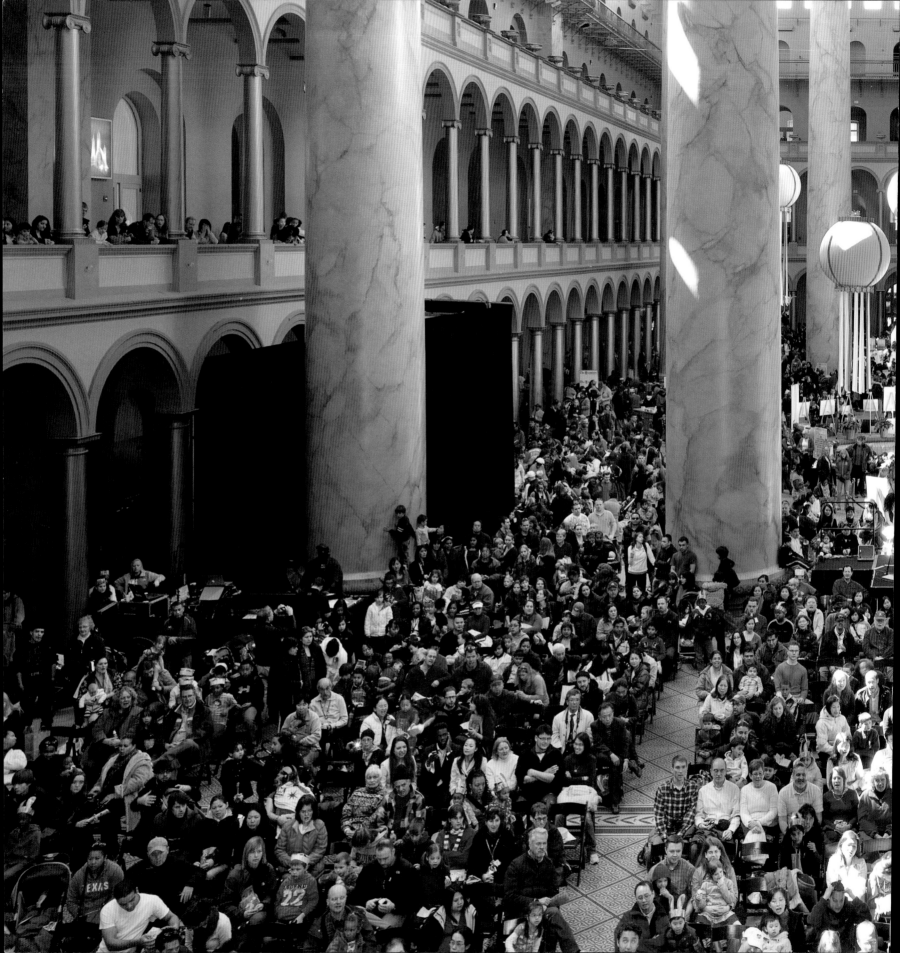

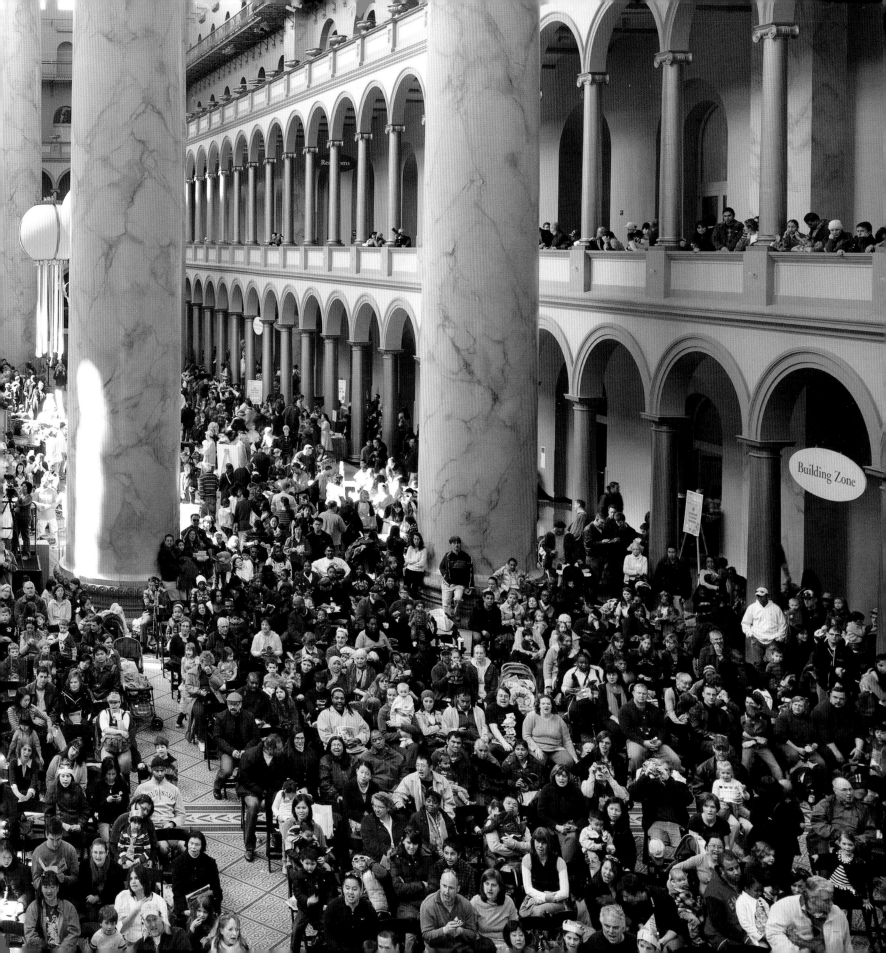

"Visitors . . .
are truly awed
by the
breathtaking
beauty of the
flowering
cherry trees
in bloom."

Cherry blossoms bloom on an older tree, reaching out over the Tidal Basin.

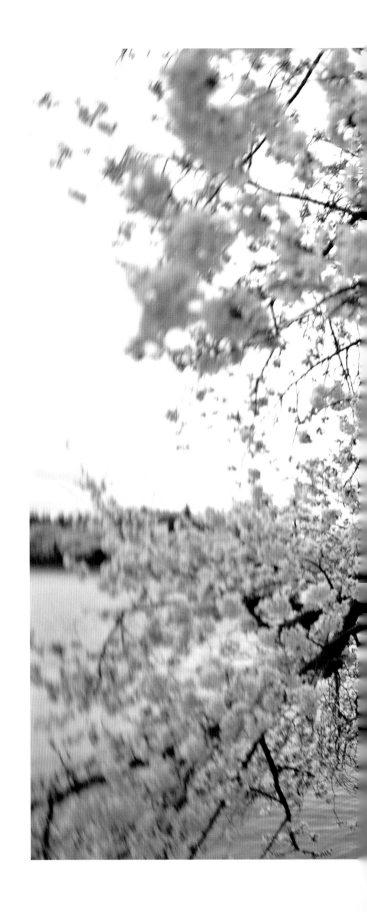

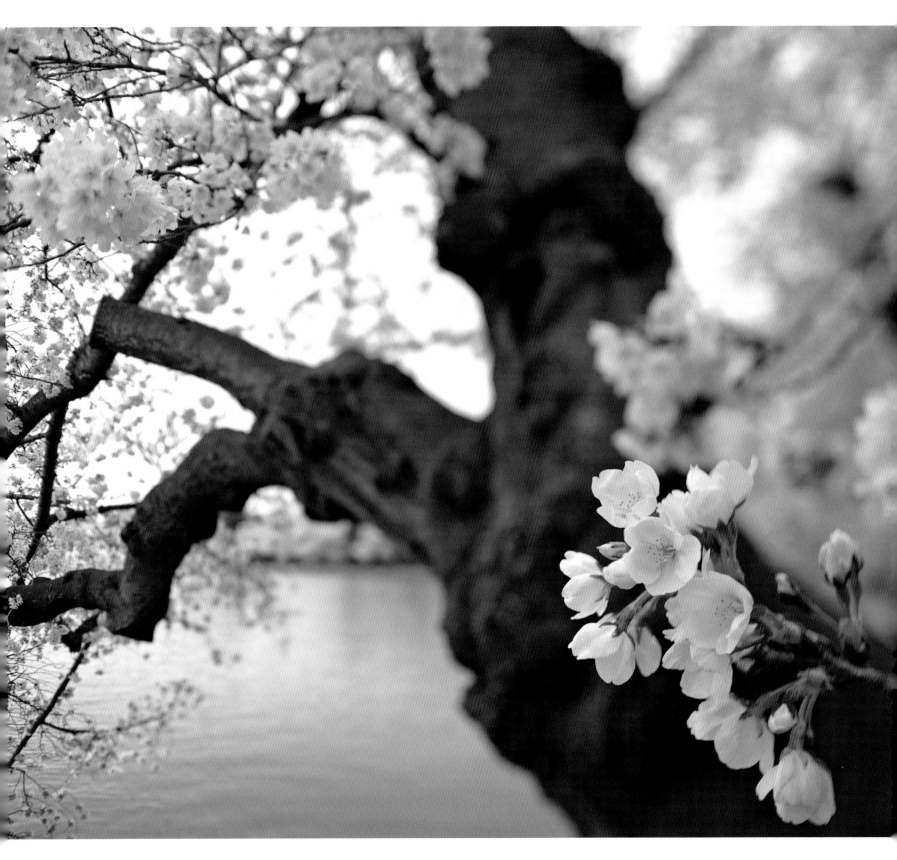

JAPANESE INSPIRATIONS

THE NATIONAL CHERRY BLOSSOM FESTIVAL CELEBRATES Japanese-style traditions and culture with the exuberant Sakura Matsuri–Japanese Street Festival, a daylong celebration of Japanese culture, as well as the Lantern Lighting Ceremony. ❧ The much-anticipated, annual Sakura Matsuri takes over several downtown blocks of Pennsylvania Avenue near Federal Triangle. It features Japanese entertainment on multiple stages, including martial arts displays and anime events, and arts and crafts for all ages. Hands-on activities range from origami and ikebana (flower arranging) to calligraphy and dollmaking workshops and demonstrations. Japanese and Asian food as well as Japanese beer and sake are available, and merchants offer modern and traditional Japanese wares. ❧ A peak moment of each Festival is the Lantern Lighting Ceremony—the lighting of the Japanese stone lantern beside the Tidal Basin. The lantern, lit only once each year by the reigning Japanese Embassy Cherry Blossom Princess and the daughter of a Japanese diplomat, celebrates international friendship. The ceremony is attended by international dignitaries, and the program begins with a presentation of the colors by United States Color Guards complemented by a *koto* (Japanese harp) performance. ■

Japanese-crafted gifts are sold at the Sakura Matsuri–Japanese Street Festival.

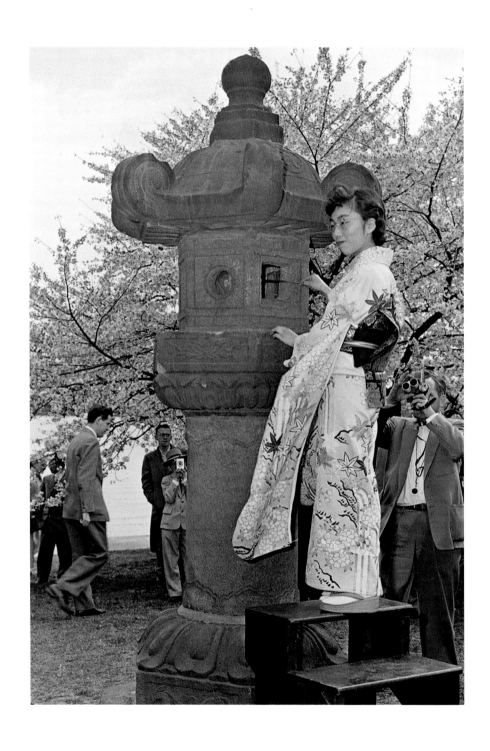

ABOVE: *The Japanese ambassador's daughter lit the stone lantern at its dedication in March 1954.*

OPPOSITE: *A daughter of a Japanese diplomat now lights the lantern during annual Festivals.*

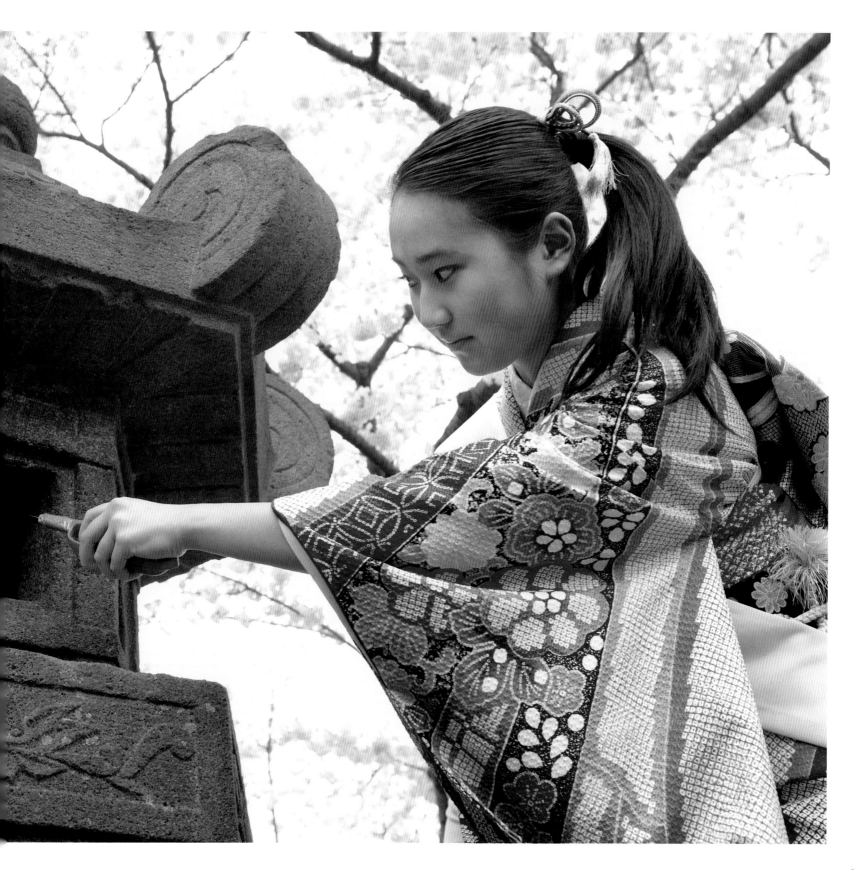

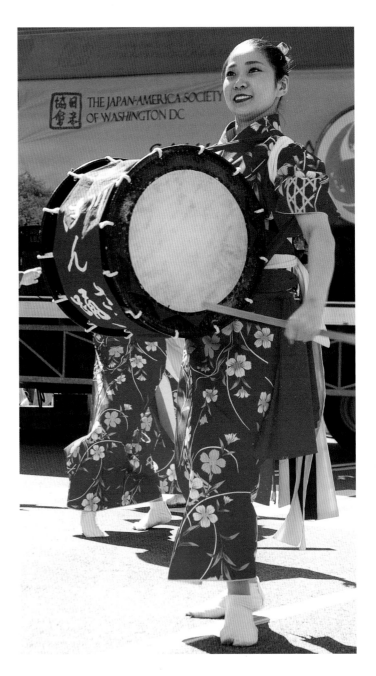

ABOVE: *Traditional and pop cultures from Japan are highlighted at the street fest.*
OPPOSITE: *Two cherry blossom fans carry a petal-covered parasol and wear blossom decor.*

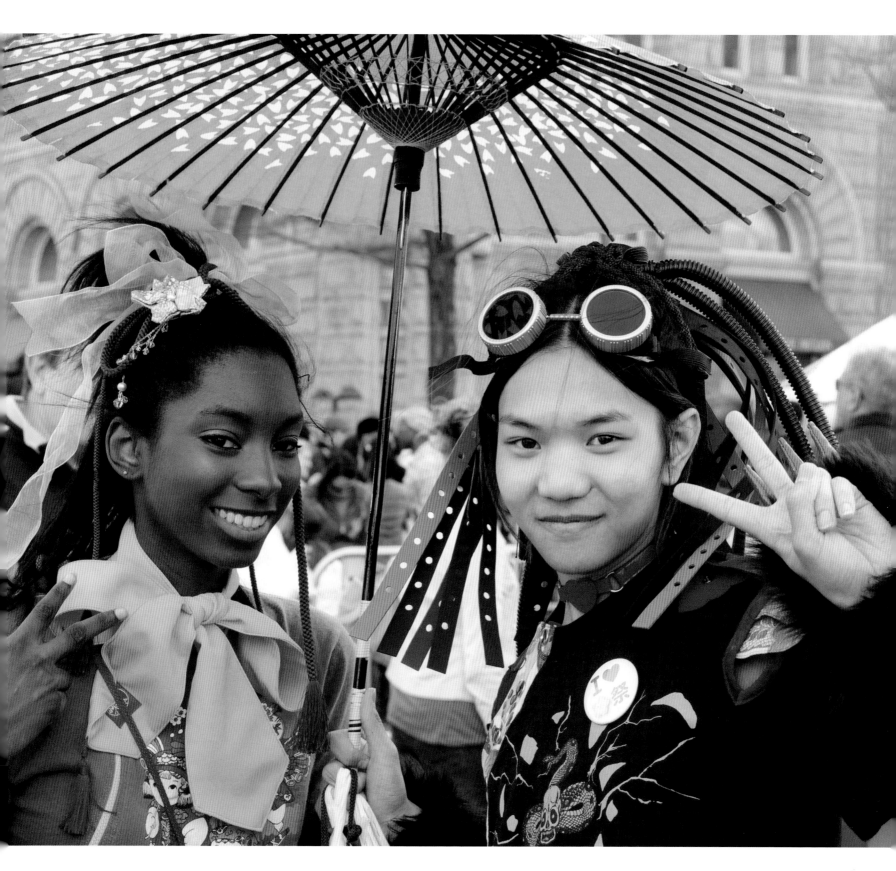

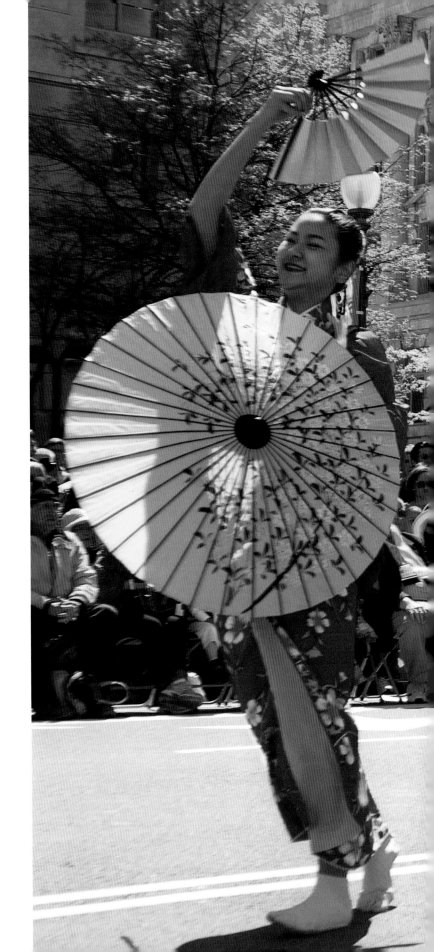

"Excitement
about the
cherry blossoms'
blooming
pervades the entire
capital region . . ."

The 40-member taiko dance group from Tokyo's Tamagawa University performs.

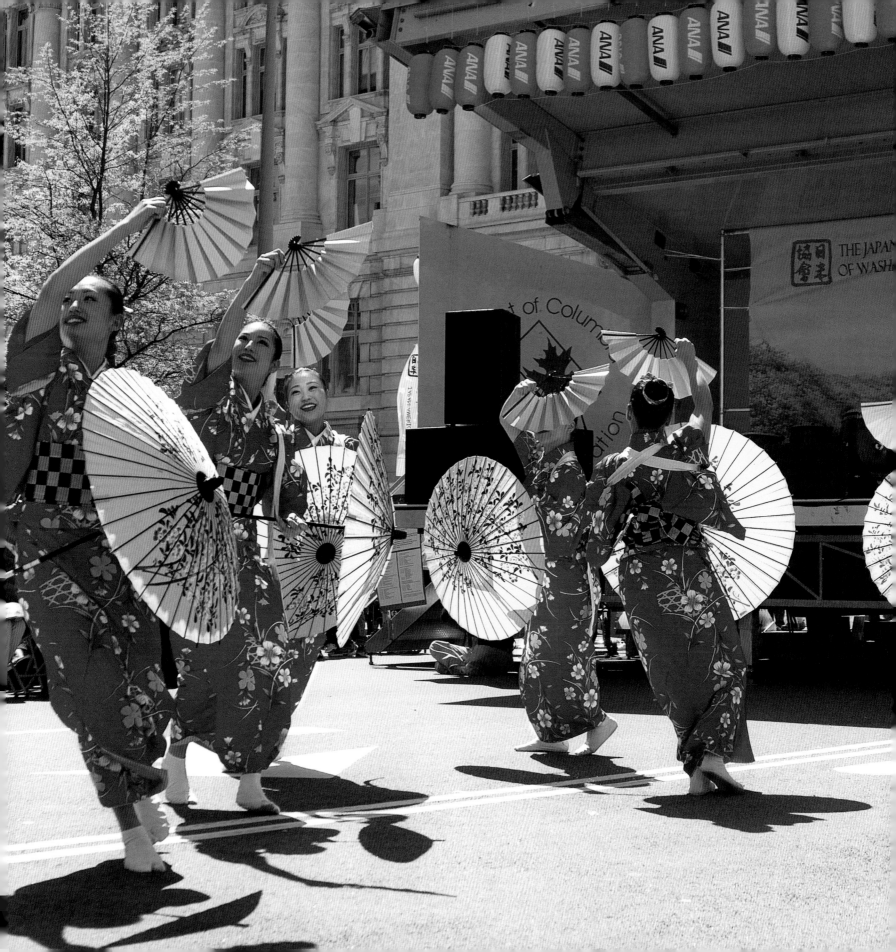

Okame

OKAMES ARE NAMED for the Japanese goddess of mirth. According to legend, when the sun goddess Amaterasu hid in a cave, the world suffered without her light. No one could entice her to come out until Okame's joyful dancing with the other gods at the cave's entrance created a commotion. When Amaterasu's curiosity compelled her to investigate the noise, she was blinded by her own reflection in a mirror, permitting the gods to capture her. Okame's mirth and happiness were contagious, and Amaterasu recovered her courage and returned her light to the world.

There is only one Okame tree (*Prunus* x 'Okame') on Hains Point by the Washington Channel near the Tidal Basin. Early to flower each spring, Okames have vivid pink blossoms, and reach 25 feet in a spreading, oval silhouette. They are a hybrid between the delicate *Prunus incisa* and the early flowering *Prunus campanulata*, with deep red blossoms.

The Okame tree, a hybrid, takes its name from the Japanese goddess of mirth.

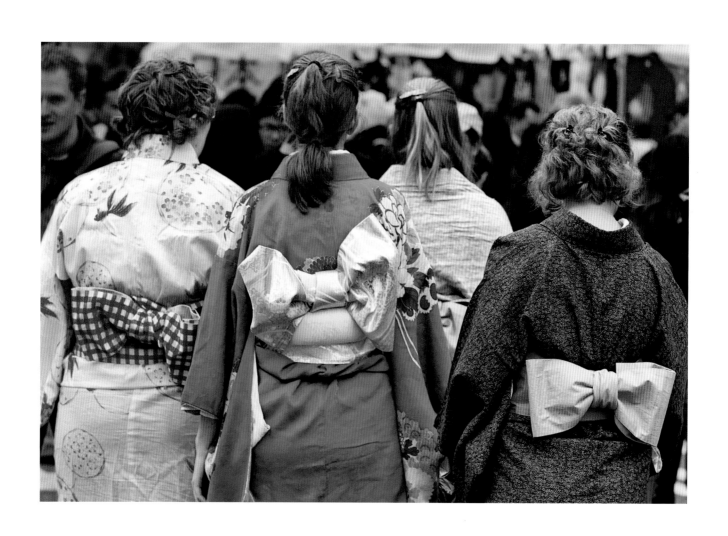

A group of girls wear traditional Japanese garb at the street festival.

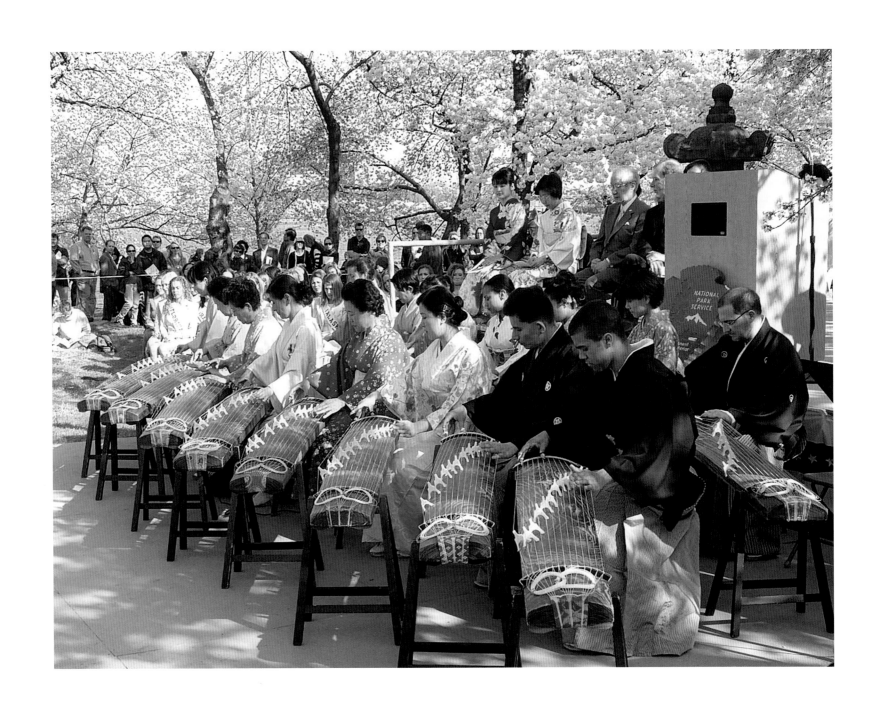

ABOVE: *The Toho Koto Society of Washington, D.C., performs at a Lantern Lighting Ceremony.*
OPPOSITE: *Walkers seek out views of the blossoms in out-of-the-way corners near the Tidal Basin.*

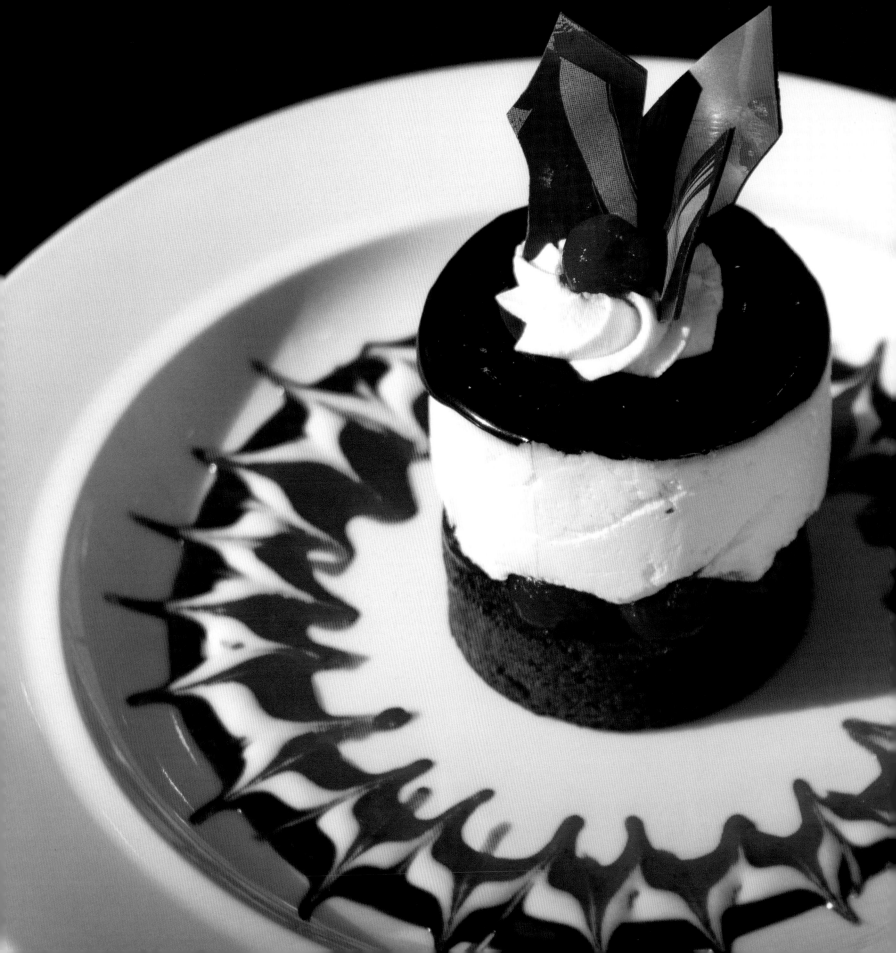

CHERRY BLOSSOM GLAMOUR

FESTIVAL EVENTS HELD AFTER THE SUN GOES DOWN light up the dark. The Pink Tie Party fund-raiser is an exciting affair where festive pink garb is de rigueur. A celebrity chef such as Robert Irvine or Charlie Palmer hosts the party. Proceeds from its silent auction help keep the vast majority of the Festival's events free. Another way to sample top chefs' cherry-inspired offerings is through Cherry Picks. Over 100 participating restaurants add cherry- and blossom-inspired dishes to their menus throughout the Festival. Japanese cuisine is highlighted with a sushi event each year. To address the growing scarcity of some fish used in making sushi and add an educational aspect to sushi events, guests might learn the "Four S" rule to help make the best choice: Select small, silver, seasonal, and shellfish. Guests also can learn about wine and sake food pairings. Cherry Blast is nighttime fun for adults. Highlighting multimedia and art in every form, there's something different to discover in each corner, from spoken-word performances, expressionistic dances, and photo booths to artists incorporating live subjects into their work. Pop-up bars are set up in the unfinished space, and music pumps from DJs and live bands all night. ■

Black Forest cake with chocolate cherry sauce was a cherry-inspired Festival special at the restaurant RIS.

ABOVE: *Blossom-inspired cuisine in many forms tempts diners at the Festival.*
OPPOSITE: *Revelers don festive cocktail attire at the Pink Tie Party fund-raiser.*

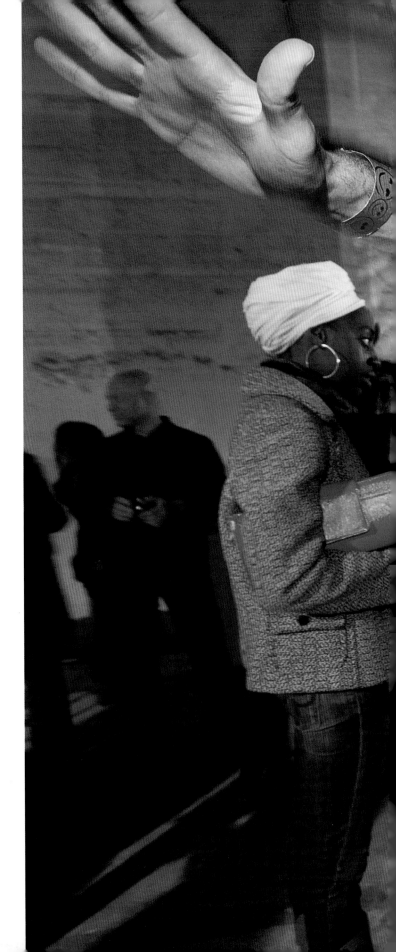

"*The National Cherry Blossom Festival offers something for everyone . . . from classic to cutting edge.*"

A Hula-Hoop dancer grabs the spotlight on the Cherry Blast dance floor.

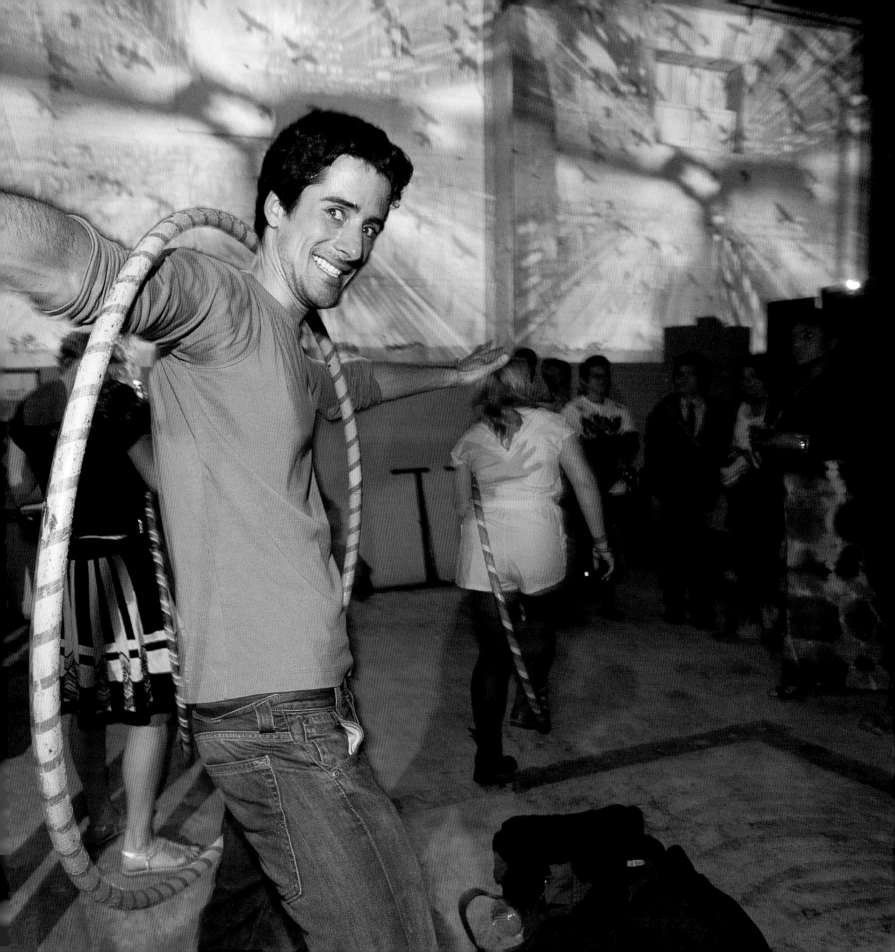

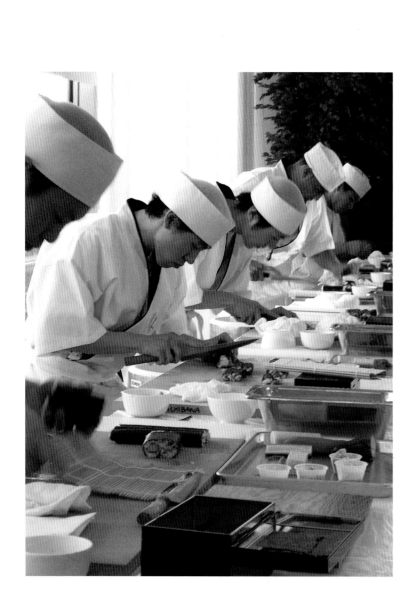

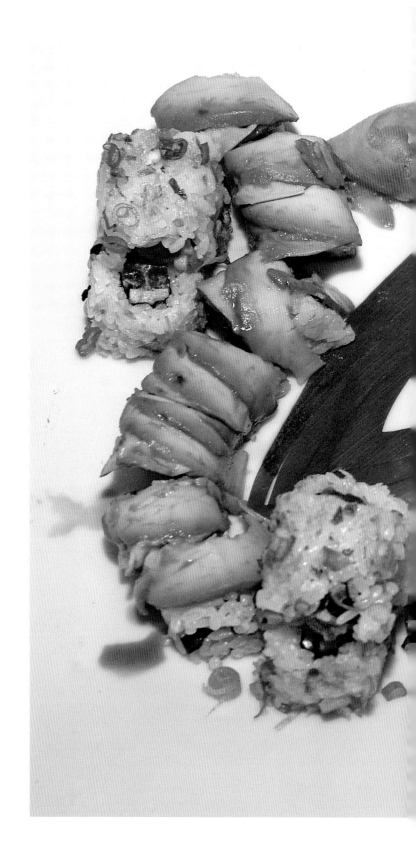

ABOVE: *Sushi masters demonstrate their craft at sushi and sake tastings.*
OPPOSITE: *A dragon and blossom are created entirely out of edible sushi.*

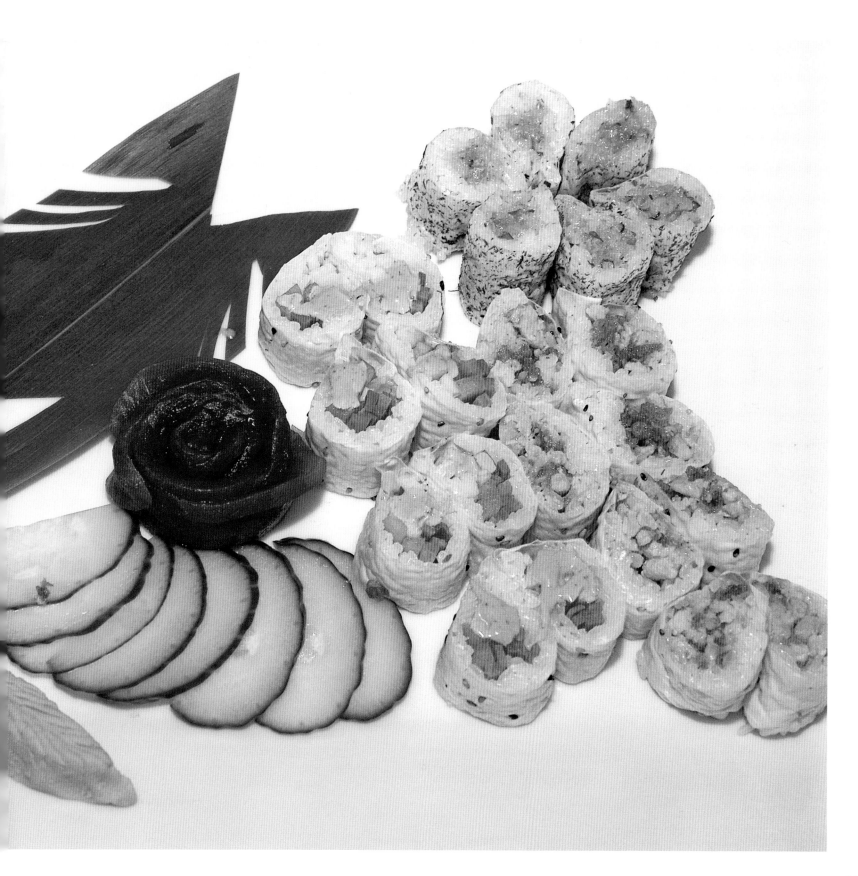

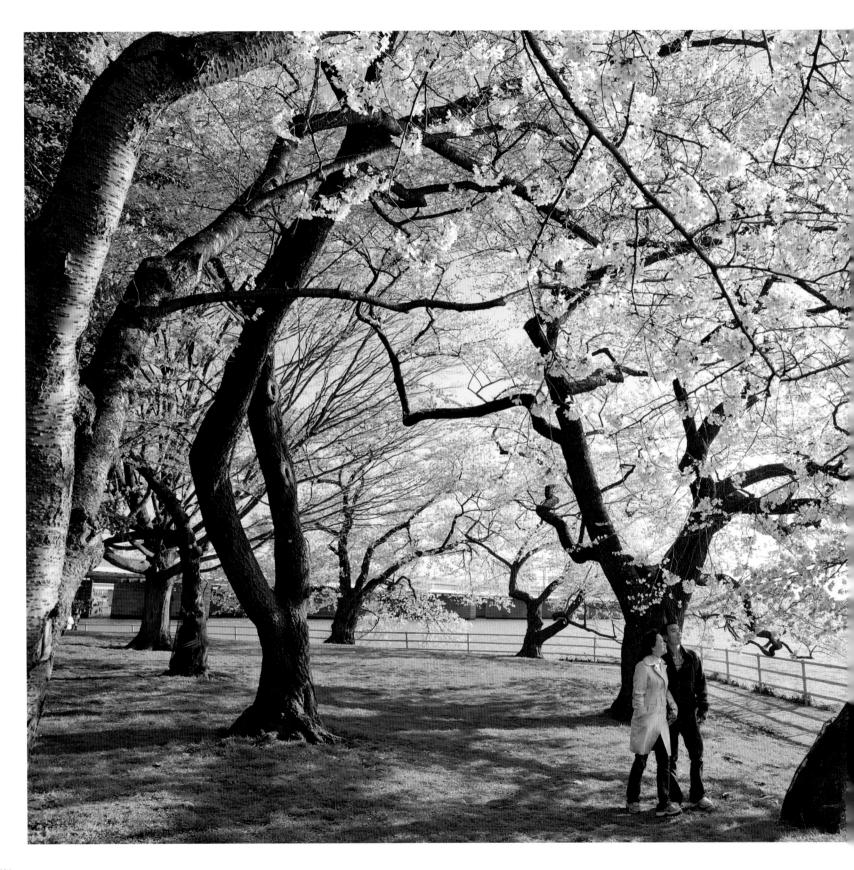

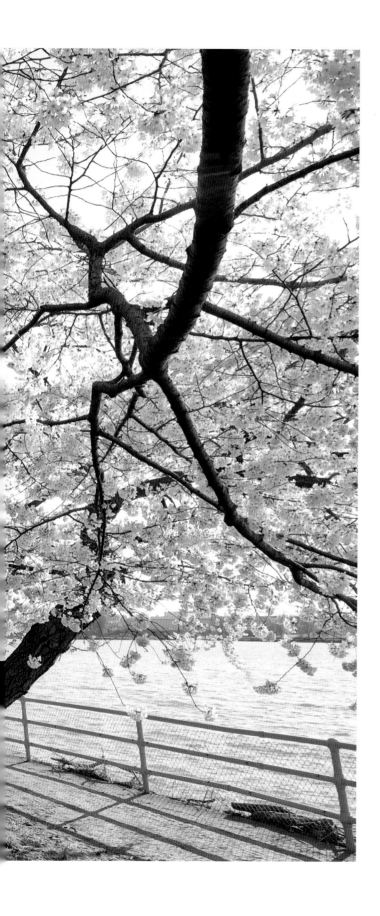

"*Poems were written,
music was played,
dances were danced,
and picnics
were eaten
as everyone marked
the arrival
of spring.*"

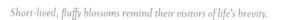

Short-lived, fluffy blossoms remind their visitors of life's brevity.

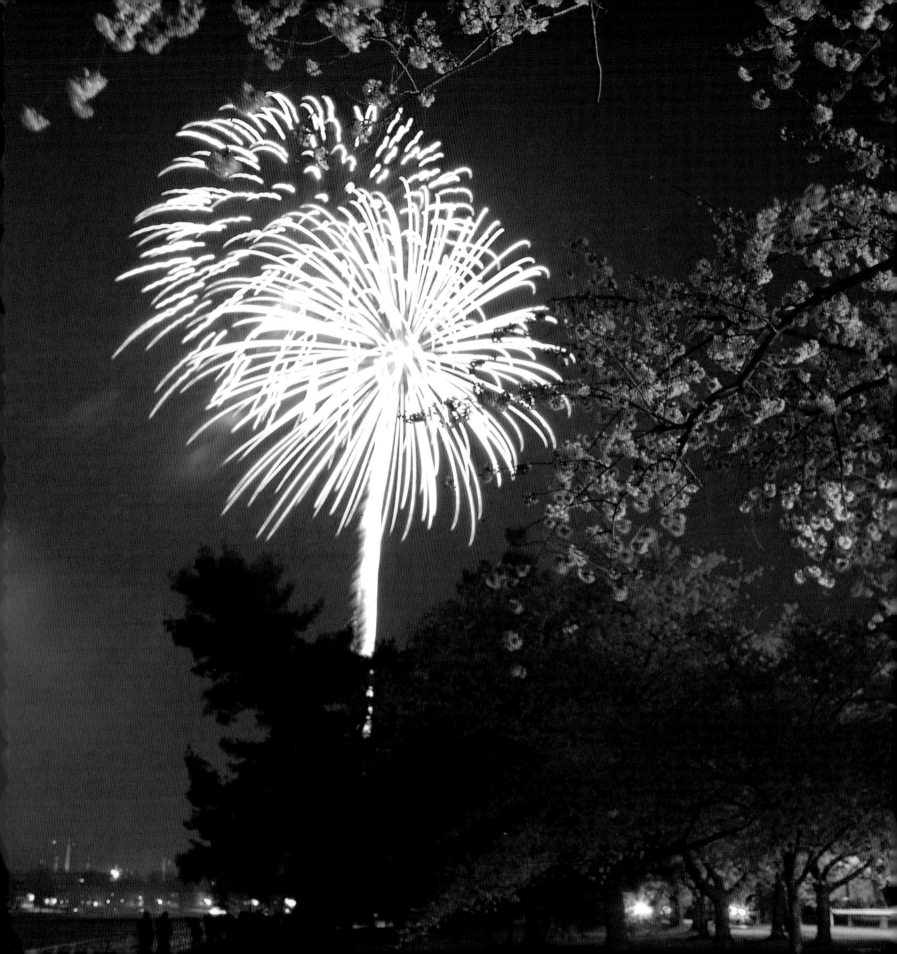

COMMUNITY CELEBRATIONS

NTIMATE FESTIVAL CELEBRATIONS UNIFY COMMUNITIES. Block parties, garden tours, and cherry blossom tree plantings are just some of the ways the Festival brings its spirit into neighborhoods. Other community connections are made through the Southwest Waterfront Fireworks Festival, Youth Ambassador Program, and Youth Poster Art Contest. ◈ Filled with music and activities under the blossoms, the Southwest Waterfront Fireworks Festival is a daylong event leading up to the Festival's evening fireworks display. All ages enjoy the dynamic entertainment and exuberant activities at the Fireworks Festival's waterfront location. ◈ The Youth Ambassador Program and the Youth Poster Art Contest involve kids from all over town in the Festival. Youth Ambassadors share what they learn about the trees and the Festival with city visitors. Budding poster artists are proud when their prize-winning artwork is displayed at Union Station throughout the entire Festival for all to see. ◈ Each year, Festival representatives and residents plant cherry trees in all eight wards of Washington, D.C. After the trees begin to bloom, annual celebrations continue, creating mini-fests with community picnics and neighborhood gatherings. ■

Stunning fireworks at the Southwest Waterfront light up the evening sky.

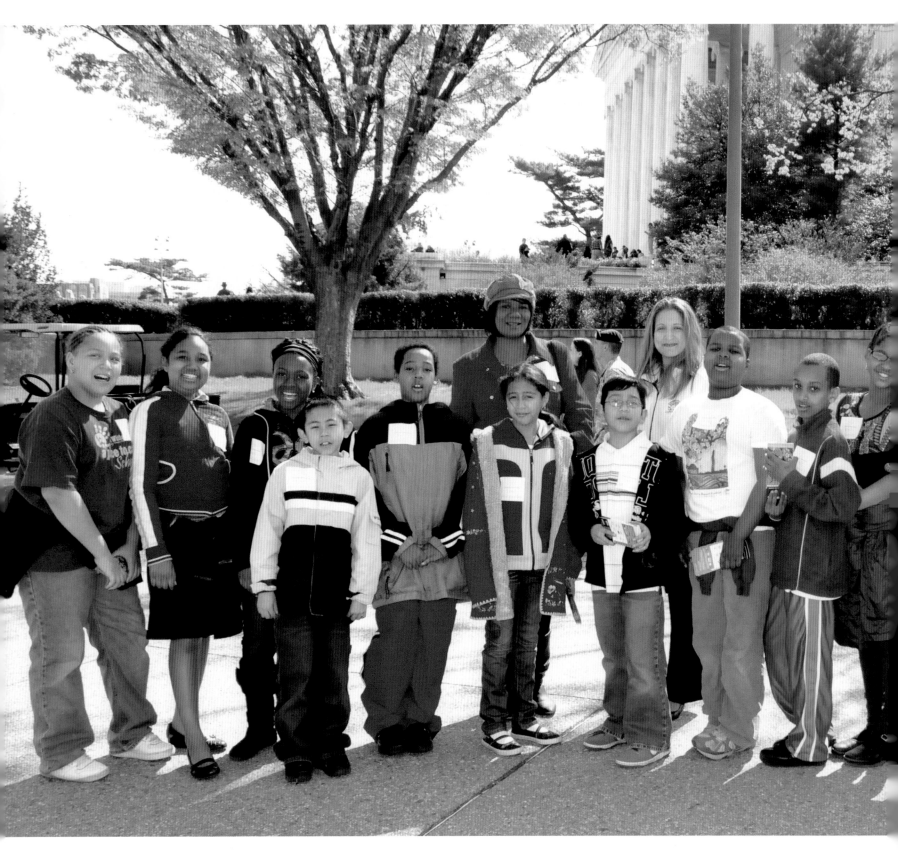

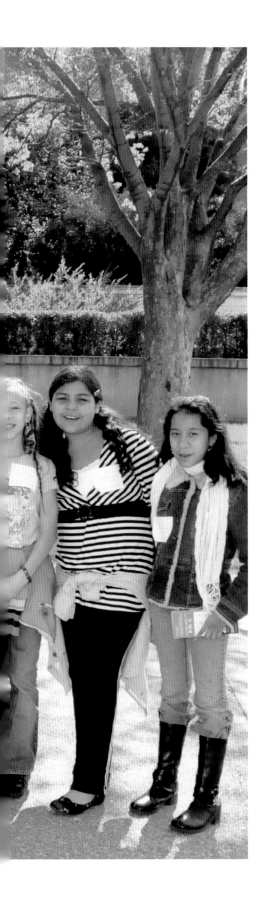

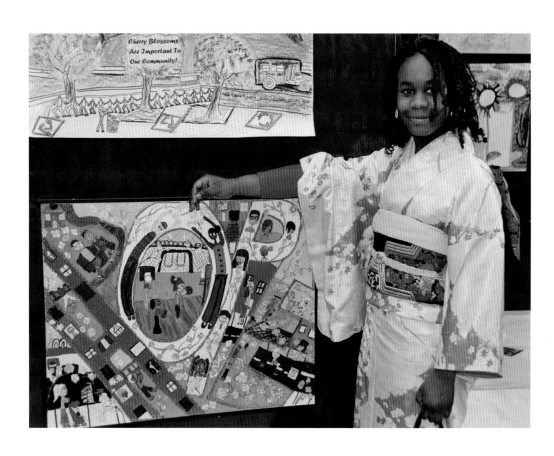

ABOVE: *The winner of 2009's Youth Poster Art Contest shows off her colorful masterpiece.*
OPPOSITE: *A gaggle of Youth Ambassadors pose at the Tidal Basin before greeting visitors.*

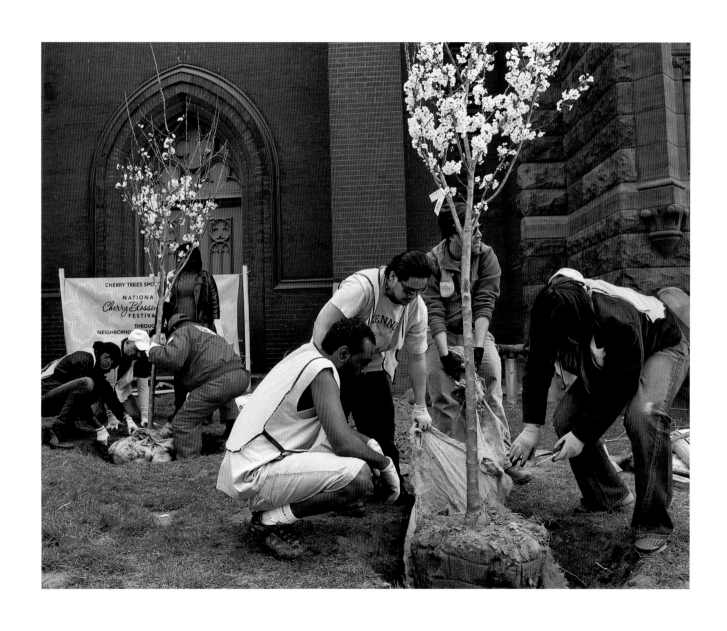

ABOVE: *Community members plant cherry blossom trees at Calvary Baptist Church.*
PAGES 112-113: *This contest-winning photo of leaping girls was featured in a Festival calendar.*

Who Takes Care of the Cherry Blossom Trees?

CHERRY BLOSSOM TREES, like other trees, require pruning, fertilizing, and regular health inspections. National Park Service arborists care for the Tidal Basin's trees. Known as the "Tree Crew" of the National Mall and Memorial Parks, they tend the trees full time. Certified by the International Society of Arboriculture, they can identify the different varieties of trees, their pests and diseases, and provide day-to-day care to maintain the trees' optimum health. Their most important task is pruning the trees, most of which is done from January into early March.

The Tree Crew's biggest challenge is to counter the impact of many people visiting the cherry blossom trees in a short amount of time, especially easing soil compaction. Their mascot, a beaver named Paddles, tours the Tidal Basin during the blooming period, reminding visitors not to pick the blossoms or climb the trees.

Some cherry blossoms have pinkish buds that then turn pure white in bloom.

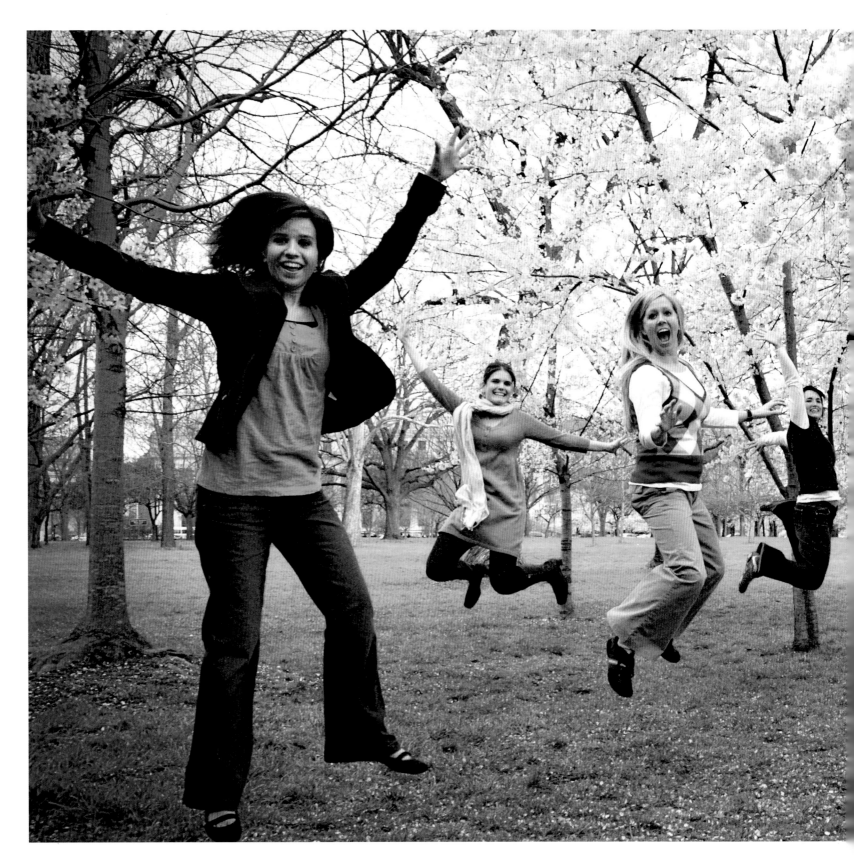

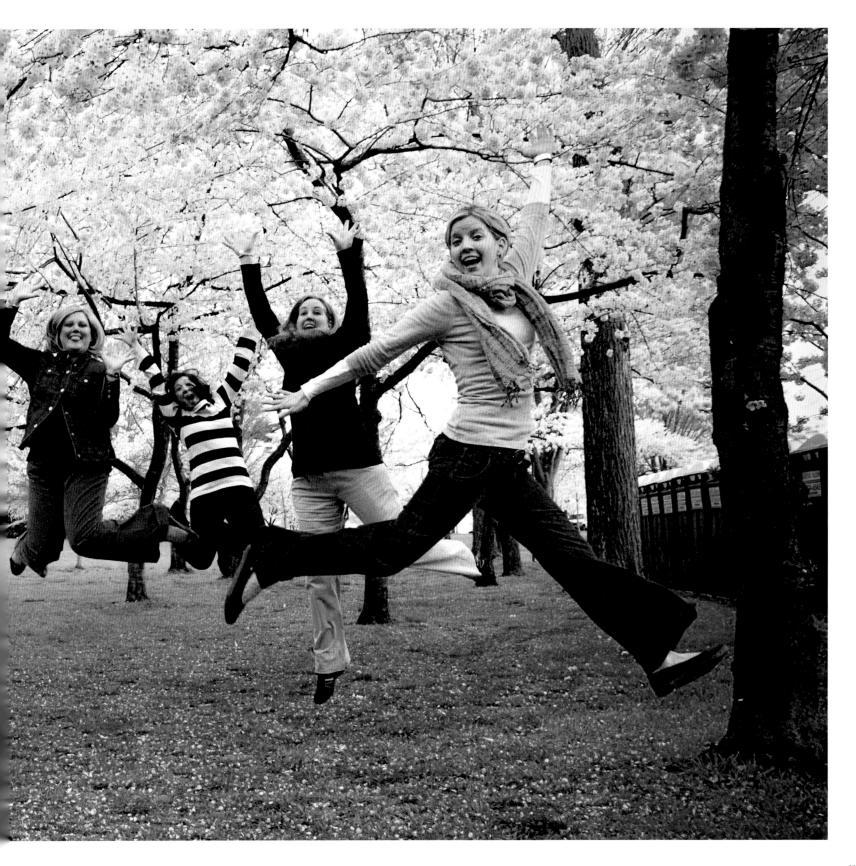

PARADE AND PERFORMANCES

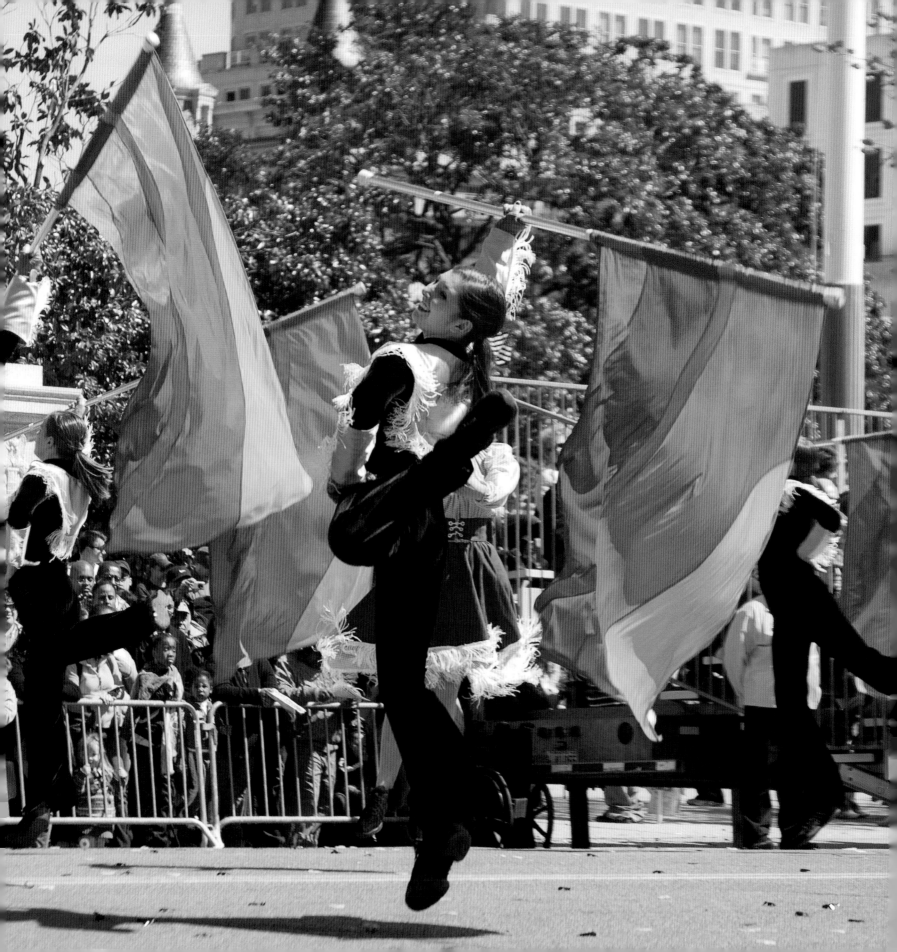

Springtime Spectaculars

THE NATIONAL CHERRY BLOSSOM FESTIVAL'S SIGNATURE PARADE and panoply of performances draw spectators and participants from across the country and around the world. Their high quality and variety attest to the Festival's status as the nation's premier welcome to spring. ❧ The ever popular National Cherry Blossom Festival Parade brings riotous color, electrifying performances, giant balloons, and sensational music to Constitution Avenue between 7th and 17th Streets in northwest Washington, D.C., each spring. More than 120,000 spectators attend, knowing they will be thrilled by the celebrities, marching bands, awe-inspiring balloons, costumed characters, gorgeous floats, and lively entertainers who make up

the parade every year. Whether they are seated in the ticketed grandstands, are standing along the free route, or are watching the live telecast, no one wants to miss a minute of the legendary parade

At dawn on the day of the parade, participants have already begun preparations while most people are still asleep. As helium fills the gigantic balloons, they take shape and begin to rise. Finishing touches are applied to the floats. Throngs of talented youth from all parts of the country—marching bands, dance ensembles, and acrobatic teams, to name a few—

convene in their brightly colored costumes, giddy with excitement, eager for their turn to shine in the televised foremost springtime parade. Boisterous fans wielding poster board signs gather early too, hoping to catch a glimpse of their favorite famous entertainer or *American Idol* competitor.

Before long, the sky is filled with oversized cartoon characters, giant cherry blossoms, and huge Japanese-style lanterns. Hundreds of volunteers learn and practice techniques for managing the massive balloons by tugging on their ropes, essential for keeping Elmo,

High school girls leap in the air with an energizing flag performance.

Curious George, Hello Kitty, Bugs Bunny, Yogi Bear, and others from flying away when they sail above the parade route.

As the parade's start nears, the grand marshal takes his or her place of honor in the lead vehicle. Over the years, celebrity grand marshals have included actress and singer Pearl Bailey; television host Larry King; actress Cheryl Ladd; Olympian Jesse Owens; *Tonight Show* announcer Ed McMahon; singers Roy Rogers and Dale Evans; actor Atticus Shaffer of *The Middle*; host Alex Trebek of *Jeopardy!*; and universally renowned Mickey Mouse. The bands, floats, and performing groups then take their places in the lineup, along with banner carriers, balloon handlers, and other entertainers. At the stroke of 10 a.m., they're off.

What would a parade be without the sound of heart-pounding drums? The beat is set by top high school and college marching bands, all featuring high-stepping, well-synchronized marching patterns and stirring music. Adult amateur and professional bands play as well, like Batala Washington, an all-female Brazilian percussion band known for energetic performances. The award-winning Tamagawa University Taiko Drumming and Dance Troupe often

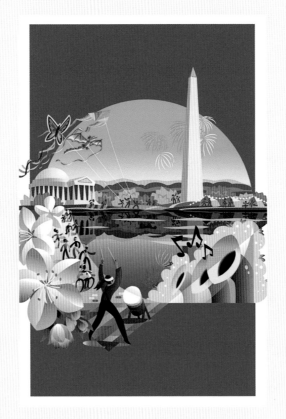

comes to Washington from its home campus near Tokyo to perform astonishing high-powered taiko drumming and Japanese folkloric dances. Some years, the Ryukyukoku Matsuri Daiko group from Okinawa adds to the uplifting performances from Japan.

Elaborate floats convey celebrities—from near and far—along the parade route. Among recent featured stars are the reigning Miss America; *American Idol* contestants Anthony Fedorov, Justin Guarini, Kimberley Locke, and Ace Young; rhythm and blues vocalist Deborah Cox; Broadway legend Maurice Hines; singer Thelma Houston; singer Wintley Phipps; *America's Got Talent* winner Bianca Ryan; a cappella group Sweet Honey in the Rock; Martha Wash of "It's Raining Men" fame; and gospel great Vickie Winans. Some floats even have acts from Broadway shows such as *Chicago, Duke Ellington's Sophisticated Ladies,* and *Mamma Mia!* Festival luminaries, such as the Goodwill Ambassadors, the Festival's board chair, and the Japanese and U.S. Cherry Blossom Queens ride on floats distinguished by their intricate and predominantly pink decorations.

Dancers, singers, clowns, and other performers put on a two-hour display of talent and energy

Jim Starr created a montage of Festival activities for his 2008 winning artwork.

as they gambol and romp down the parade route. A combined 1,000-member Youth Choir and All-Star Tap Dance Team delights and amazes the audience with their jubilant singing and fancy footwork. Mascots and dancers representing local sports teams sashay along the avenue, interacting with the crowd.

The parade is only one way to see top performers during the Festival. Musicians, dancers, singers, and entertainers perform on stages all over the city every day throughout the Festival. The temporary stage at the Tidal Basin provides an unforgettable setting. The audience sits on the steps of the Jefferson Memorial, viewing the acts with a backdrop vista of water and cherry blossoms. At the Sylvan Theater, a permanent installation on the grounds of the Washington Monument, viewers seated on the Monument lawn can see the cherry blossoms just beyond the stage. Both stages capture the spirit of the Festival with their free multicultural performances and views of cherry blossoms among Washington's iconic monuments. Other performances can be found at the Kennedy Center's Millennium Stage, Woodrow Wilson Plaza at the Ronald Reagan Building and International Trade Center, the Southwest Waterfront Fireworks Festival, and Union Station.

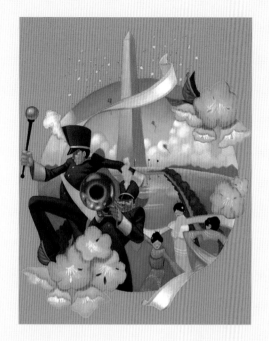

In recent years, Festival musical performers have ranged from *America's Got Talent* singers to the Washington area taiko drumming ensemble Nen Daiko. They included the a cappella singing group Harmonization without Representation; La Única, an Irish/Latin/rock/jazz fusion group; American University's Pep Band; and Levine School of Music students.

Festival dance highlights encompass the Washington, D.C., Alumnae Chapter of Delta Sigma Theta Sorority, Inc.'s step performance; Ballet Petite; the Davis Dance Center performing ballet and modern dance; the Dhoonya Dance and Nrityaki from India; Furia Flamenca; the Metropolitan Youth Tap Ensemble; the O'Neill-James Irish School of Dance; Step Afrika!; the Blue Ridge Thunder Cloggers; and the X-Faction hip-hop ensemble.

Cross-cultural offerings are the cornerstone of the Festival's programming. Some years, the performances include an "Embassy Day," when various embassies in Washington showcase cultural performers from their home countries. These multicultural performances celebrate the power of international friendship and understanding, recalling the original gift of trees.

The Festival's stunning parade and array of performances are sure to intrigue, entertain, or uplift anyone of any age from anywhere in the world. ■

Steven S. Walker's art was featured on Festival marketing materials in 2007.
FOLLOWING PAGES: *Some cherry blossoms feature subtle shades of pink to white when open.*

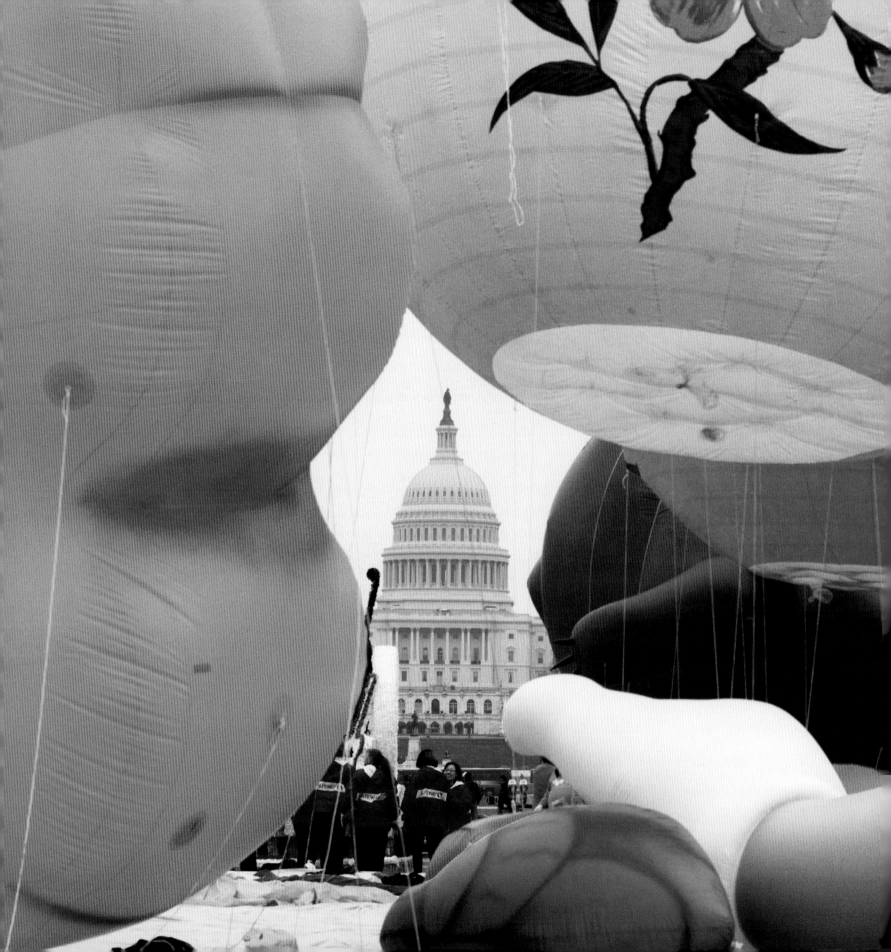

PARADE HIGHLIGHTS

THE NATIONAL CHERRY BLOSSOM FESTIVAL PARADE thrills spectators and television viewers with its celebrities, high-energy performers, marching bands, beautiful floats, and gigantic balloons. The two-hour parade starts with a bang. Its spectacular opening act explodes with singing, dancing, acrobatic displays, and showers of colorful confetti. A grand marshal leads over 100 parade elements, including more than ten marching bands from across the country, down Constitution Avenue. Enormous balloons, many of familiar cartoon characters, fill the sky. World-renowned entertainers sing and dance for the audience, as do the Youth Choir and All-Star Tap Dance Team, assembled just for the parade. Elaborate floats glide by bearing high-profile stars, as well as local and Festival dignitaries. Taiko drummers, often from Japan, create thundering sound with their skillful beats. Stars sing their pop hits, while others, outfitted in brilliant colors and resplendent costumes, perform spellbinding numbers unique to the parade. ✳ At noon, after an exuberant, confetti-splashed finale, the crowds disperse and many head to the Sakura Matsuri–Japanese Street Festival on nearby Pennsylvania Avenue, where they can revel in all things Japanese. ▪

Giant balloons take shape in front of the Capitol Building on parade day.

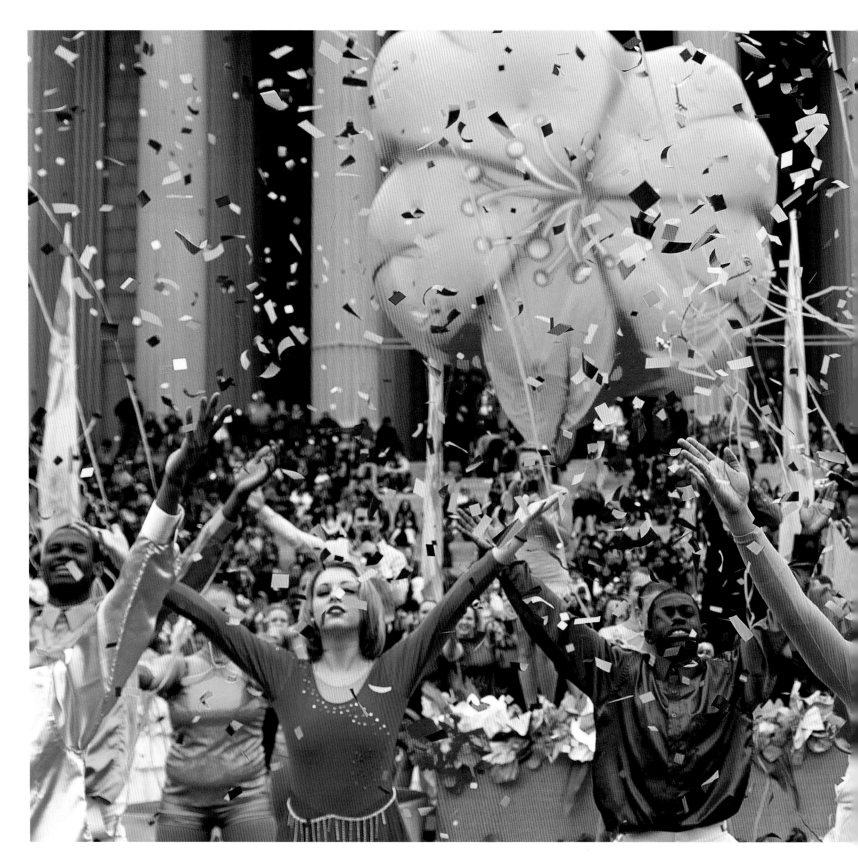

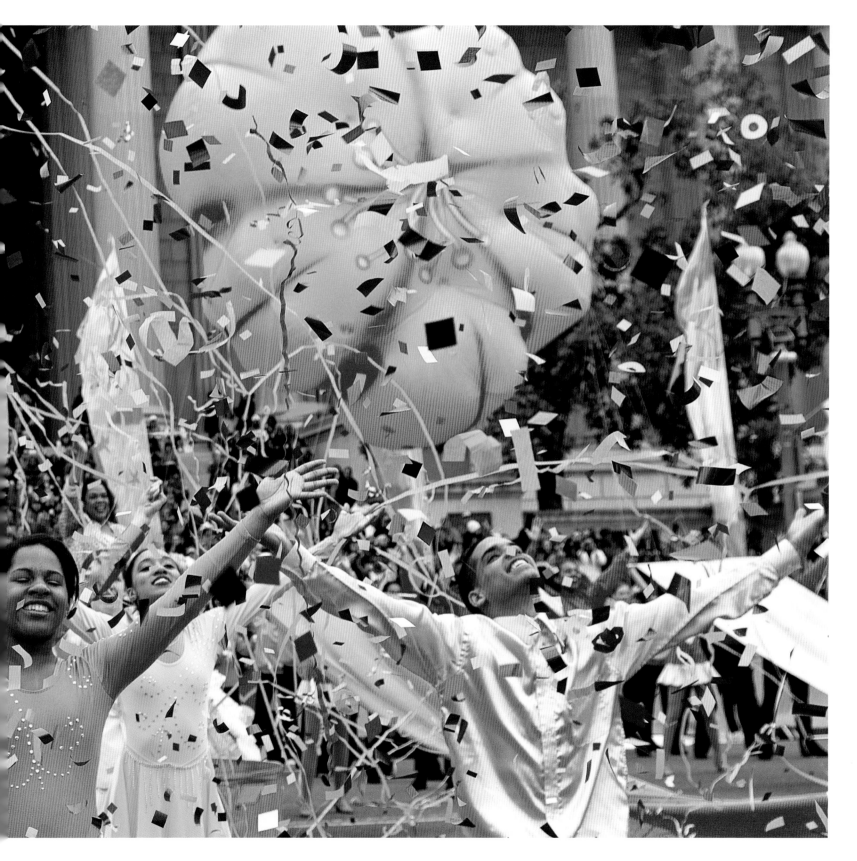

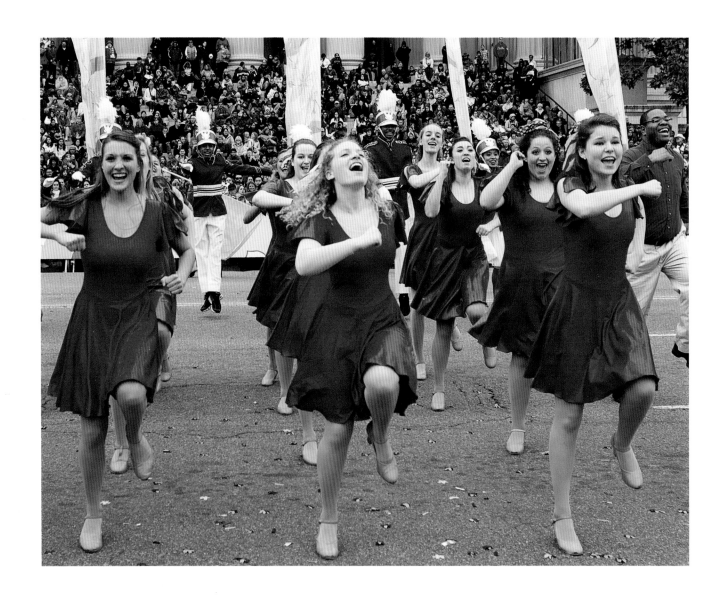

PREVIOUS PAGES: *A parade performance closes with a colorful confetti-filled burst.*
ABOVE: *All-Star Tap Dance Team members perform a high-stepping number during the parade.*
OPPOSITE: *The Ballou Senior High School Marching Band of Washington, D.C., struts and shines.*

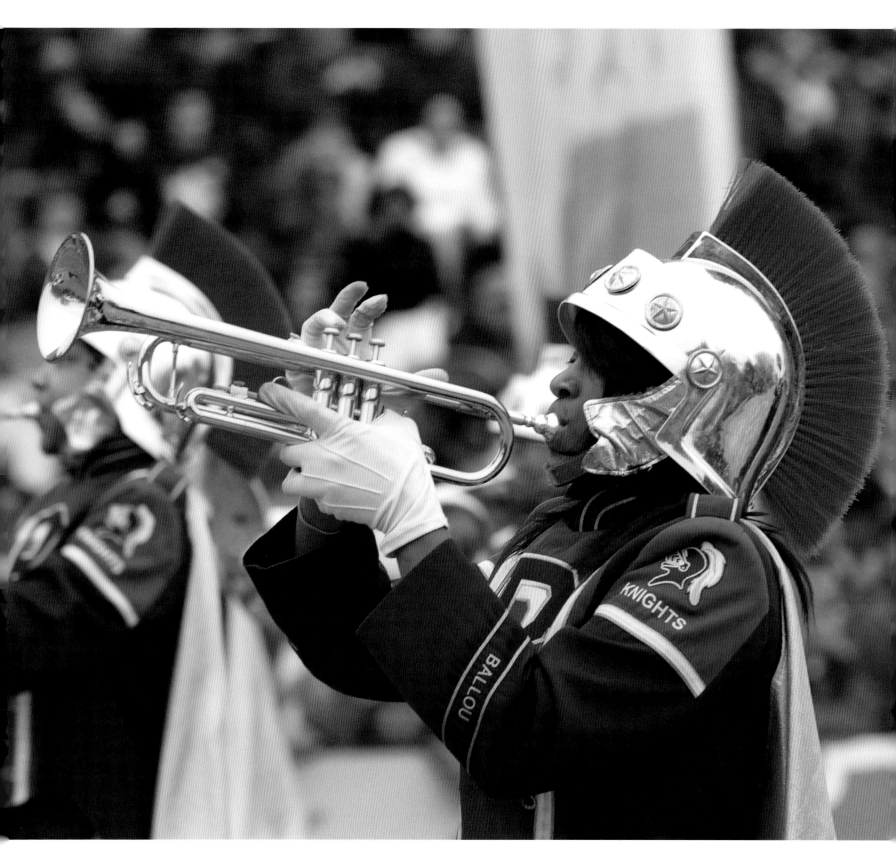

"...no one wants to miss a minute of the legendary parade."

A convertible carries Miss America and Miss D.C.'s Outstanding Teen
in the parade.

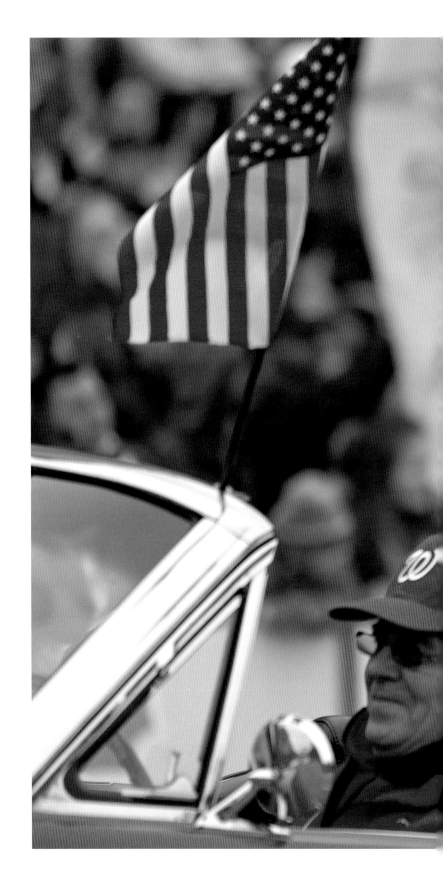

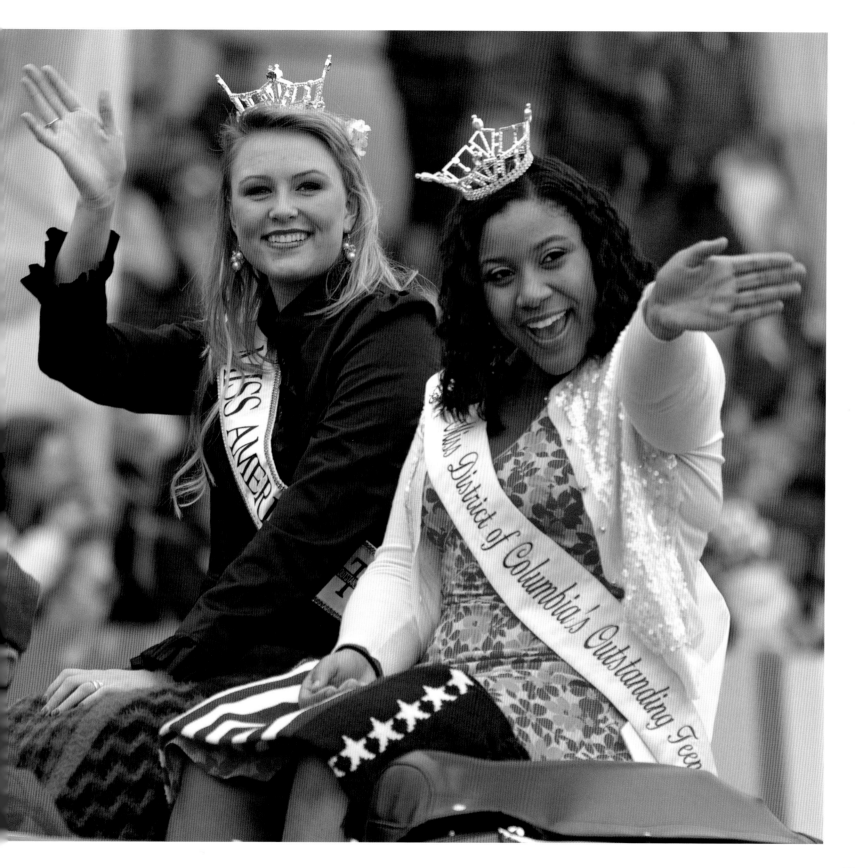

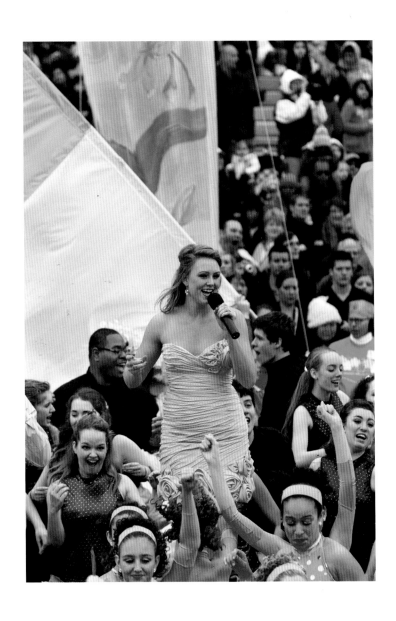

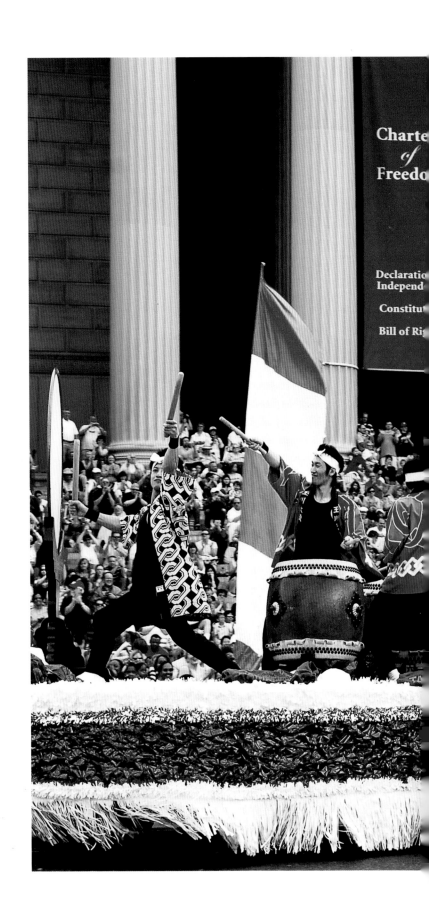

ABOVE: *Lacey Russ, Miss America's Outstanding Teen 2011, performs in the parade.*
OPPOSITE: *Tamagawa University taiko drummers come from Japan to perform.*

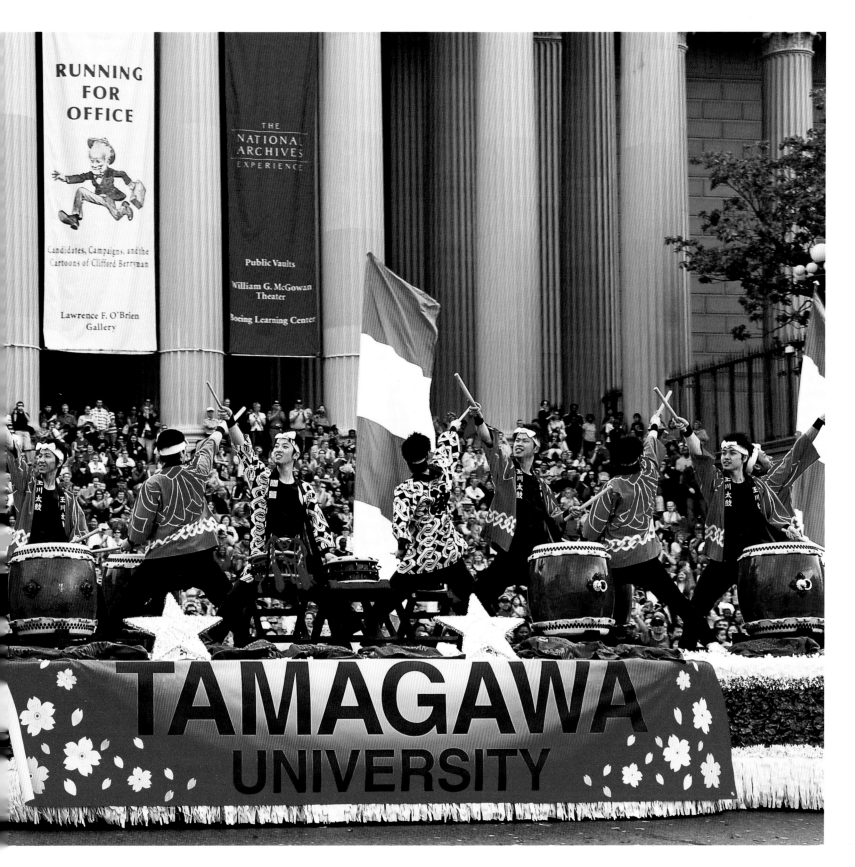

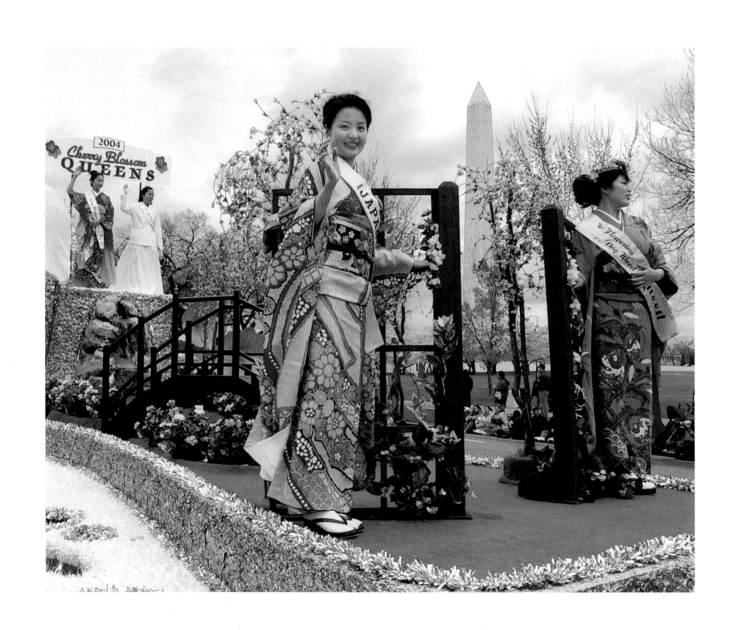

Cherry Blossom Queens are joined on a float by a Dogwood Queen from Japan.

Usuzumi

USUZUMIS ARE NAMED "pale sumi blossoms" for their unusual blooming hues. Their single blossoms are pink in bud and during early blooming, and then become white when in full bloom, turning pale gray, the color of faded sumi calligraphic ink, just before they fall.

Planted in 1999 as a gift to Washington, D.C., from the people of the Neo village in Gifu Prefecture in central Japan, most of the 50 Usuzumi trees (*Prunus spachiana* f. *ascendens*) in West Potomac Park can be found between the Potomac River and Ohio Drive. They were propagated from the oldest living cherry blossom tree in the world, the original "Usuzumi-no-sakura." They say that Japan's 26th emperor, Keitai, planted the tree in the sixth century at the village to commemorate the 18 contented years he spent there. Designated a national treasure by Japan in 1922, the 1,500-year-old tree survives, tenderly cared for, flowering each spring.

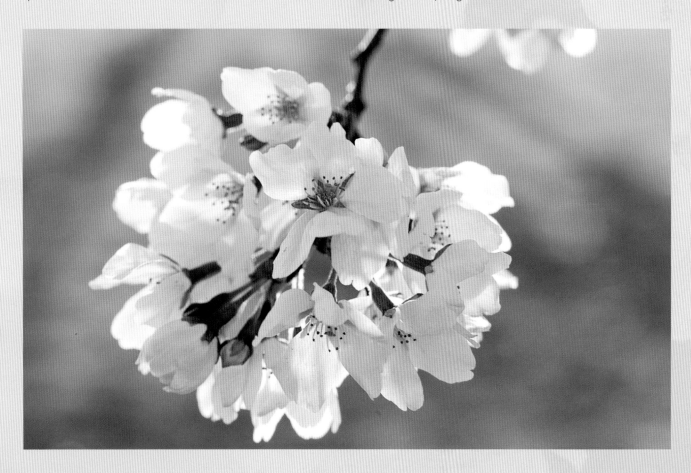

Soft blossoms create a fluttering effect when blown in a breeze.

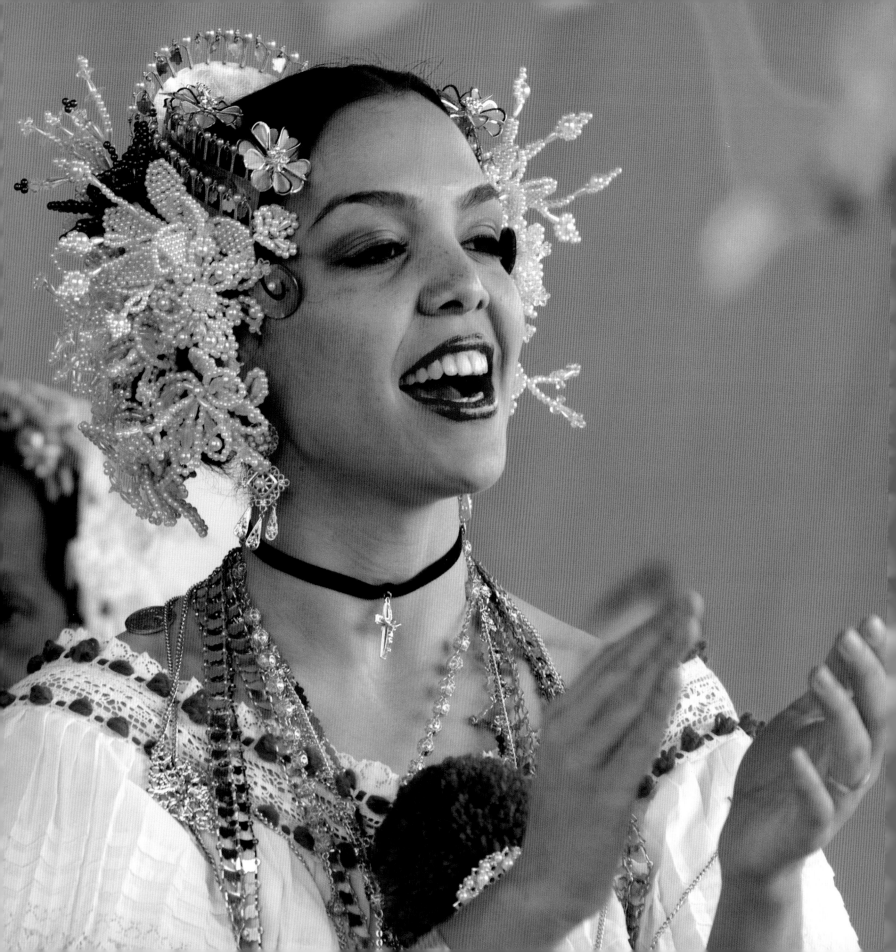

SINGING

SINGING UNDER THE CHERRY BLOSSOMS is a long-standing tradition in Japan. Even a well-known Japanese folk song touts this: "Sakura, Sakura" or "Cherry blossom, Cherry blossom" in Japanese. During the Festival in Washington, D.C., too, many lift their voices to sing as soloists or in groups, some singing a cappella while others have musical accompaniments. Classical performers, contemporary musicians, rock bands, singing storytellers, and gospel choirs all perform. Some years there are operettas, such as the Washington Savoyards presenting "The Condensed Mikado." ∞ The Festival has presented notable vocal acts, including Washington's own "Godfather of Go-Go" Chuck Brown; acoustic artist Deb Felz; Christylez Bacon, a Grammy-nominated progressive hip-hop artist; and Maryland-based Lloyd Dobler Effect. Traditional choral music from the Japanese Choral Society of Washington along with contemporary "J-pop" music from Morning Musuko and operas from the Harmonia Opera Company have showcased Japanese singing traditions. Whoever is performing and wherever they are found, there is sure to be an audience, often singing along, lending their voices to the Festival's celebration of spring, new life, and international friendship. ■

Sounds of the Festival echo throughout the Tidal Basin during the Festival.

ABOVE: *The band Diafanes plays rock mixed with traditional Japanese music.*
OPPOSITE: *Crowds fill the Jefferson Memorial steps to watch free shows.*
FOLLOWING PAGES: *Spring's warmth inspires loving embraces under the cherry blossoms.*

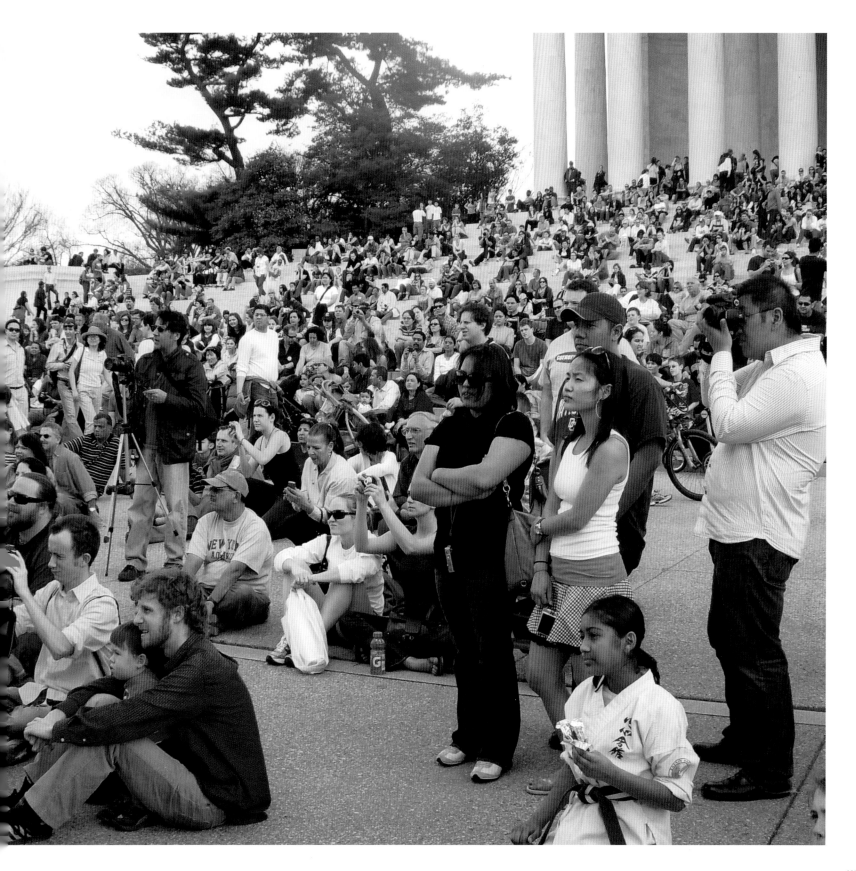

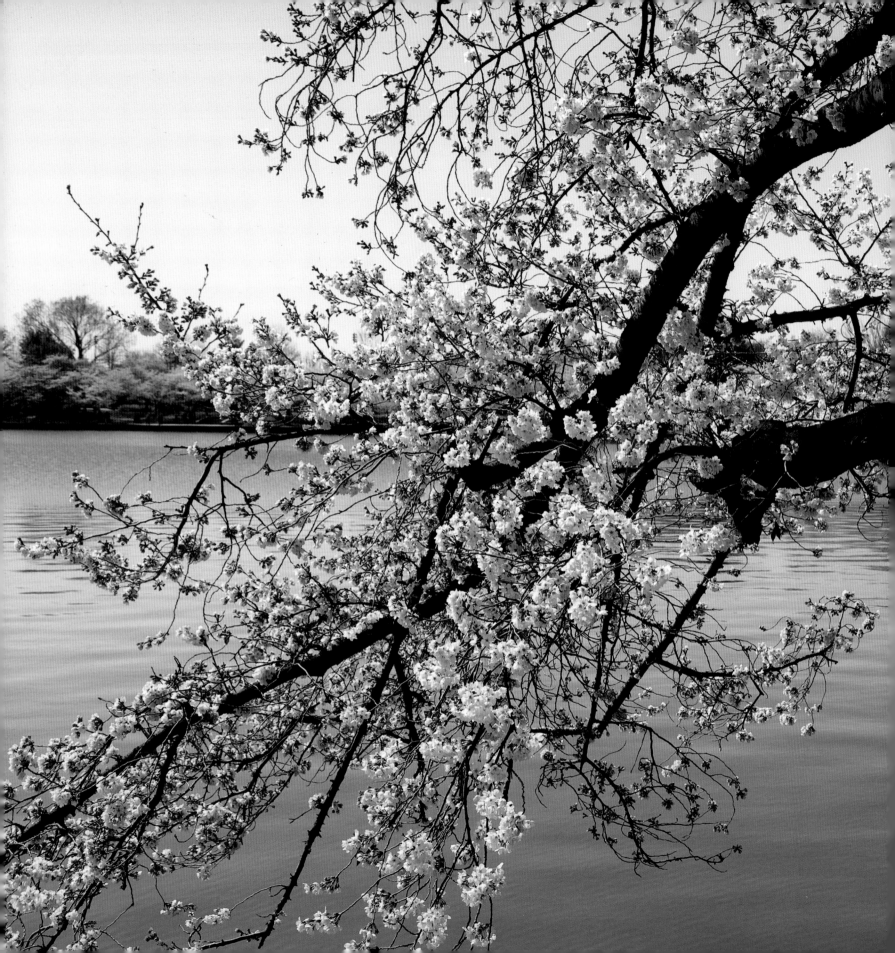

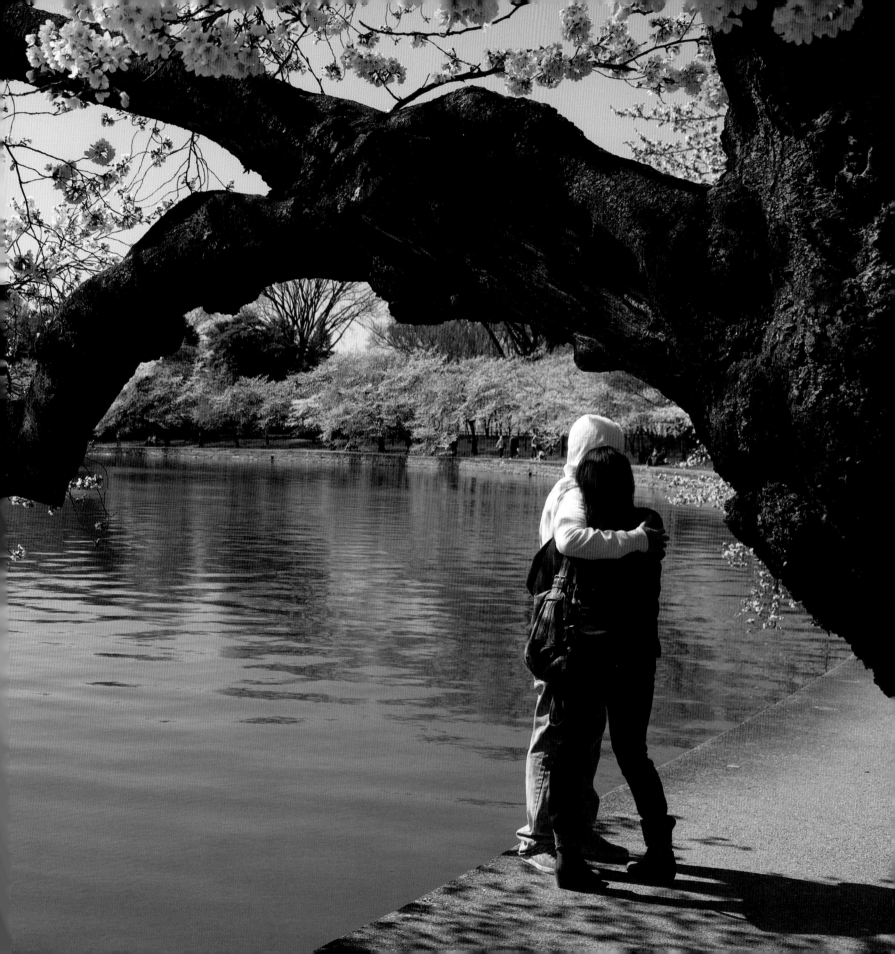

"*Musicians,
dancers, singers,
and entertainers
perform
on stages
all over
the city . . .*"

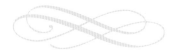

*The Japanese Choral Society of Washington has performed
at the Festival since 2002.*

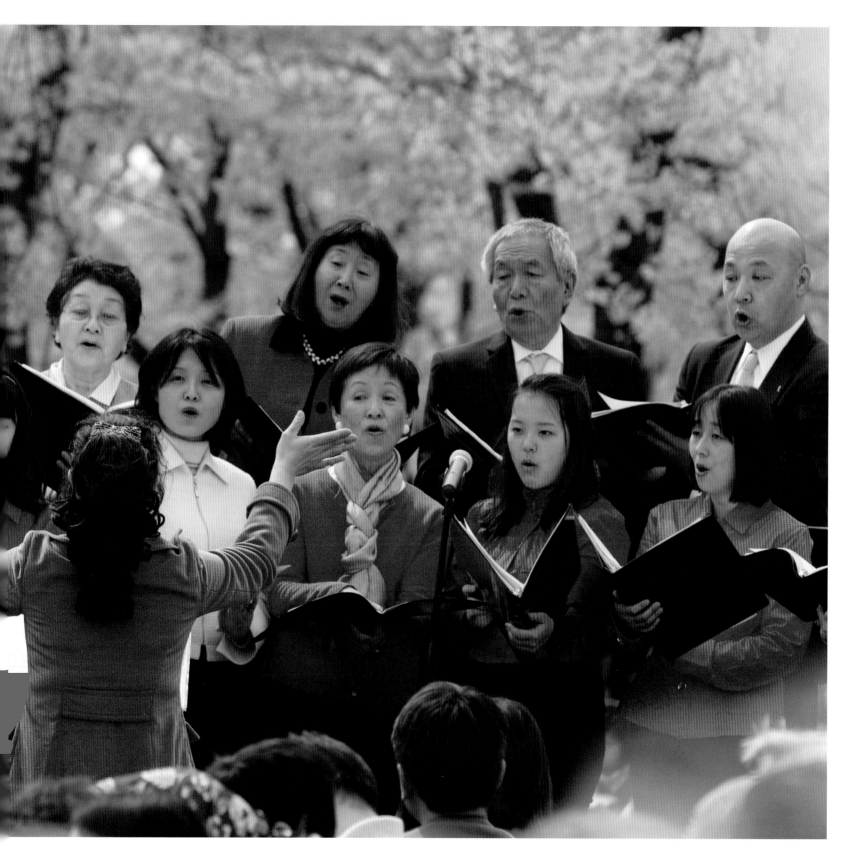

ABOVE: *Every family member enjoys the view from the Tidal Basin's edge.*
OPPOSITE: *Family outings when the blossoms are in bloom create lasting memories.*

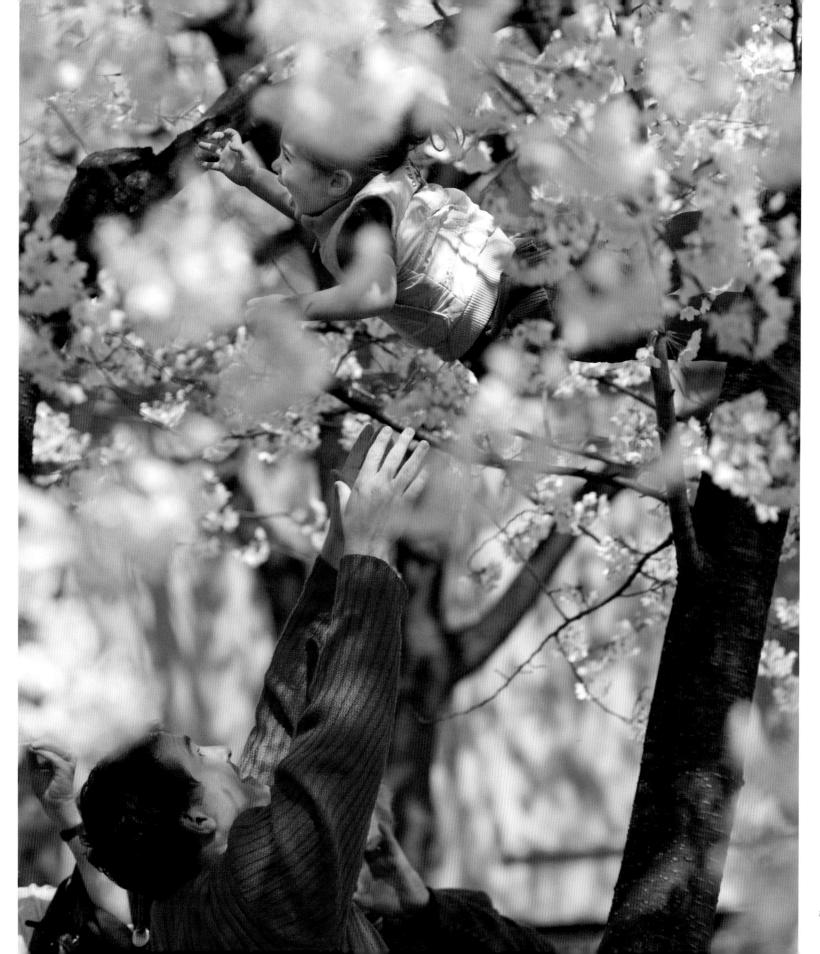

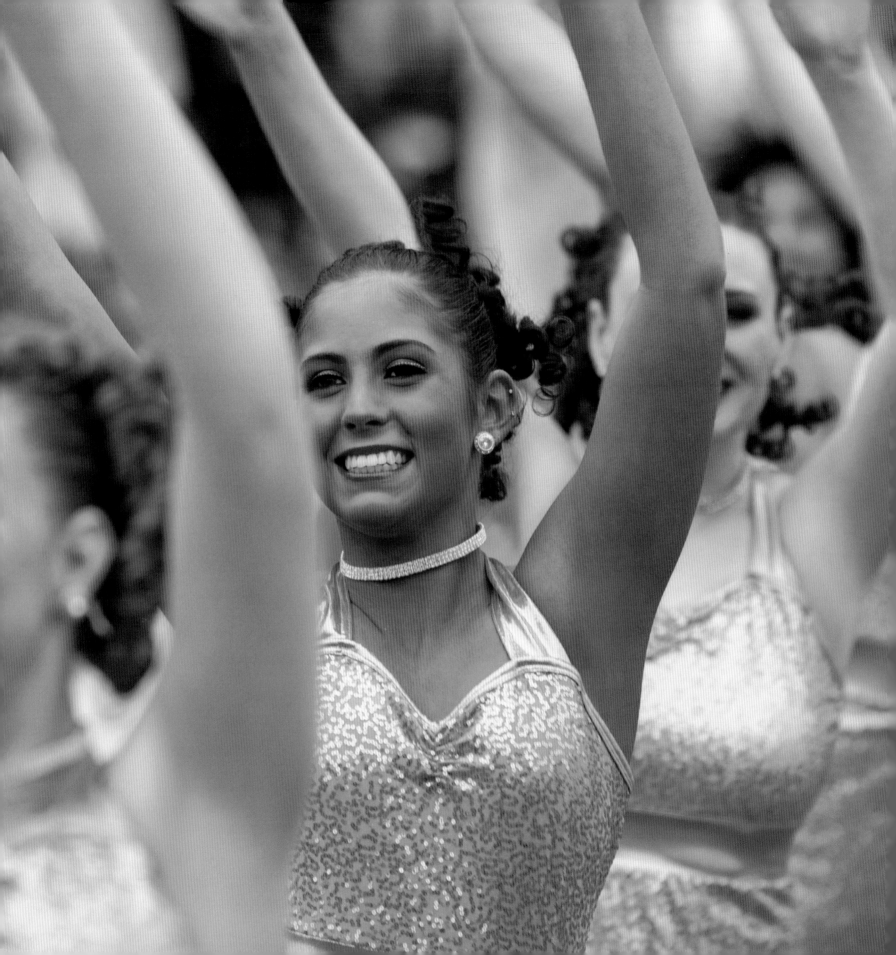

DANCING
AND MAKING MUSIC

D ANCERS AND MUSICIANS FROM AROUND THE WORLD show off their skills and talents on the National Cherry Blossom Festival's performance stages. From graceful ballet to raucous step acts and hip-hop artists, tap or Irish dancing, the dance performances all share one thing—they make you want to move! Impassioned flamenco performers rivet viewers with their rhythmic steps and poses, while Asian storytelling dancers enthrall audiences with their stylized, swirling movements. ∽ From modern jazz, rhythm and blues, and hip-hop to big band and international instrumentalists, the Festival features a multitude of musical performances to delight listeners' ears. The dynamic beats of different cultures keep toes tapping and hearts pounding as the crowd enjoys percussionists ranging from the Afro-Brazilian and samba-reggae rhythms of Brazil to taiko drumming, often performed by ensembles from Japan as well as by local groups. Kids perform too, like the District Strings, a Levine School Suzuki Strings performing group. Whether showcasing local talent or highlighting international performers, the Festival's stages are the go-to places for dancers and musicians to join in the Festival's exhilarating celebration of spring. ■

Dancers in shimmery gold costumes add to the parade's splendor.

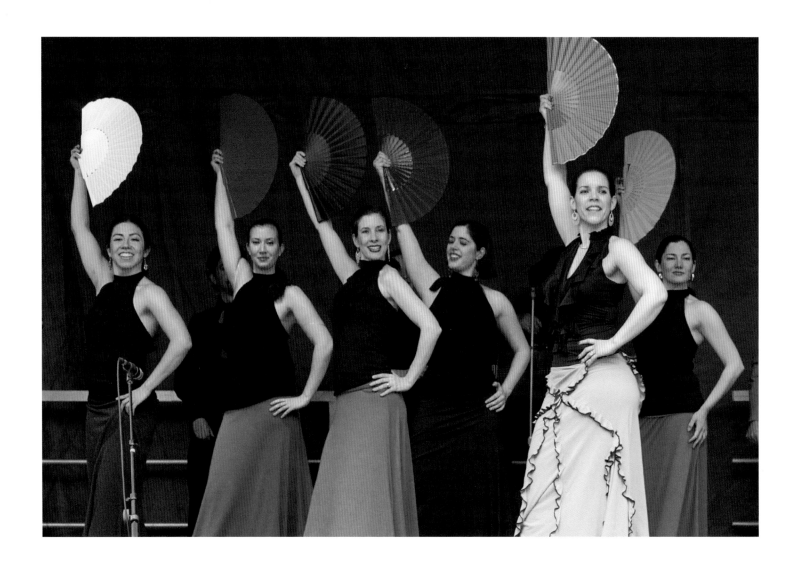

ABOVE: *Furia Flamenca brings the passion and ferocity of flamenco dancing to the stage.*
OPPOSITE: *Grufolpawa presents stylized, colorful folkloric dances from Panama.*

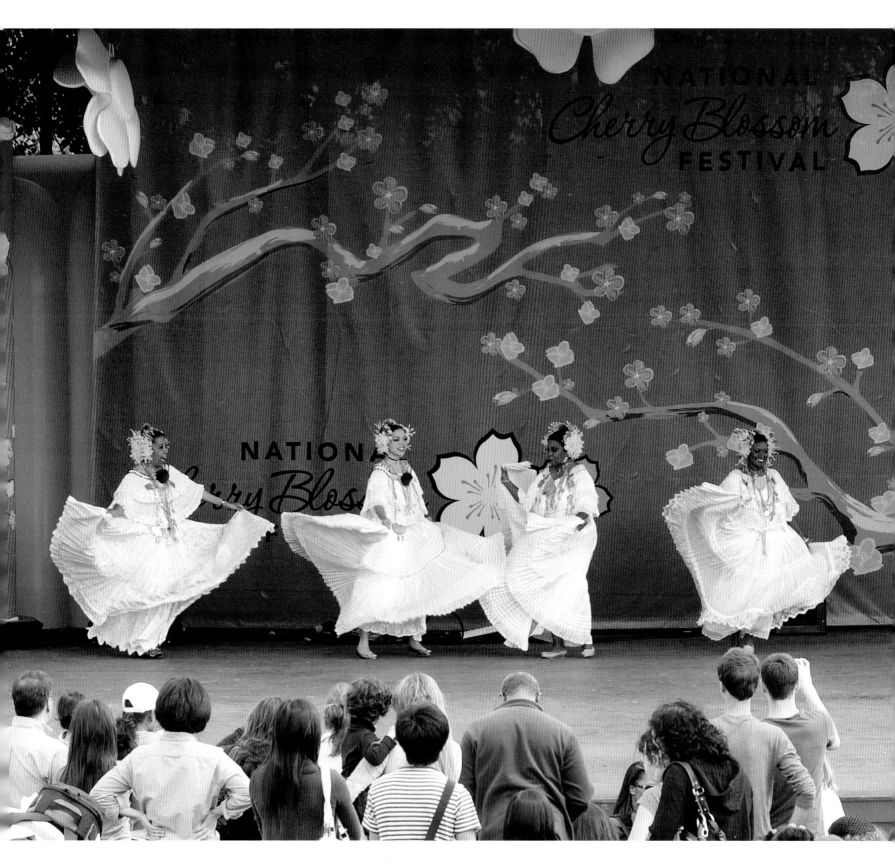

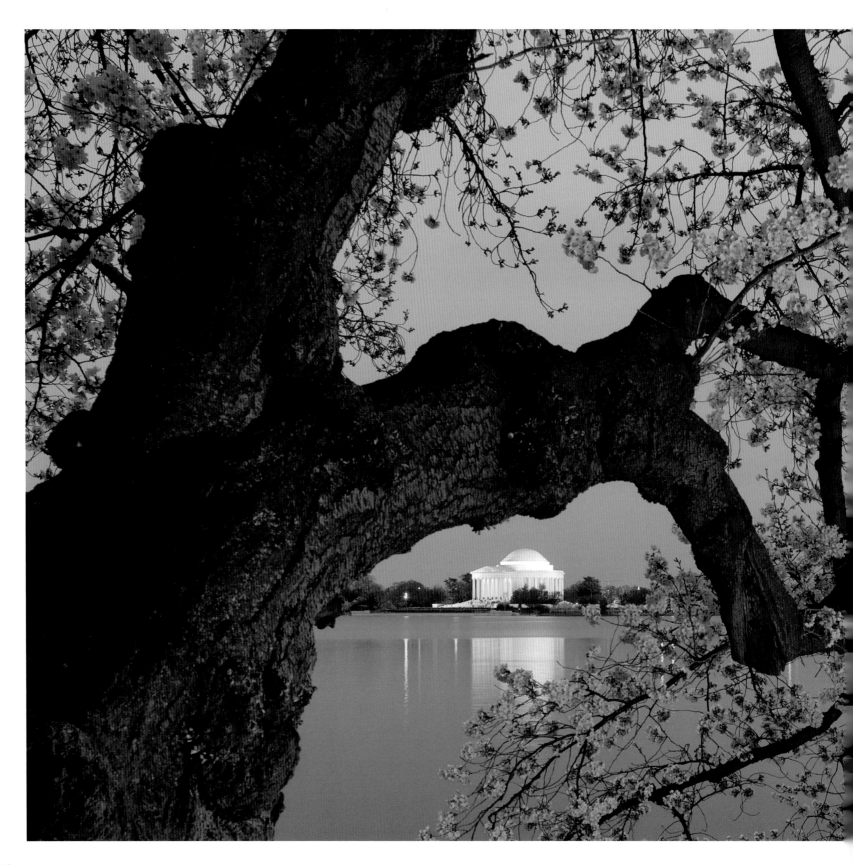

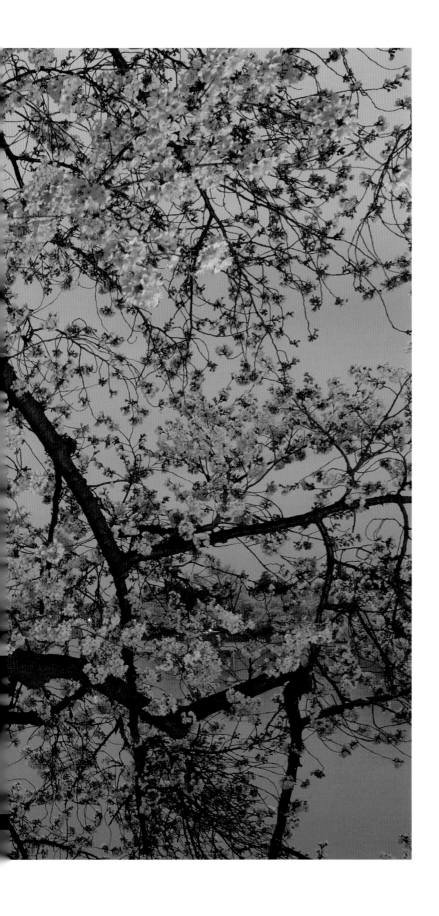

" . . . performances celebrate the power of international friendship and understanding, recalling the original gift of trees."

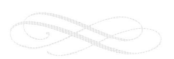

The Jefferson Memorial glows at dusk, framed by an aged cherry blossom tree.

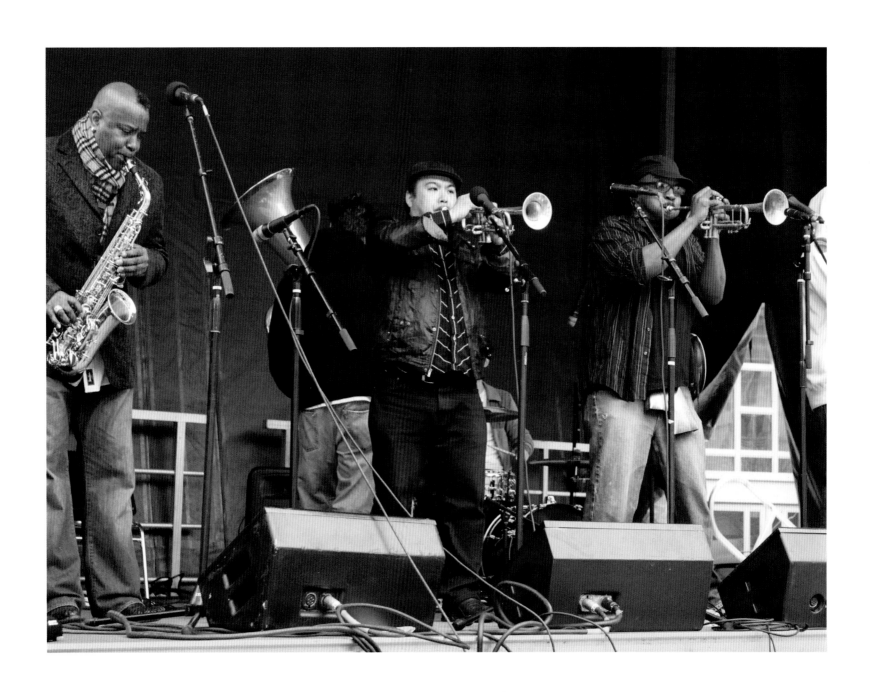

The High and Mighty Brass Band's percussion and tribal groove keep the crowd abuzz with energy.

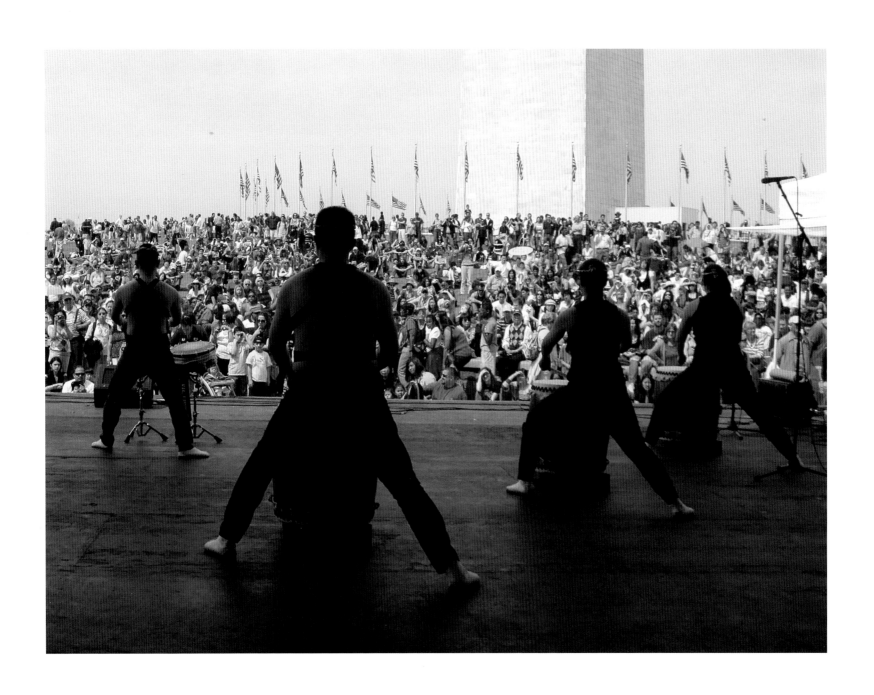

Nen Daiko, a taiko drumming group, performs for throngs of people at the Washington Monument.

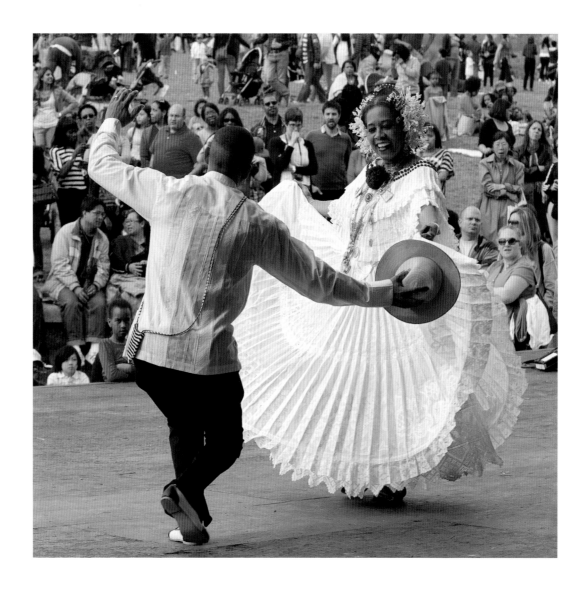

ABOVE: *Rollicking dancers entertain all ages, enhancing cross-cultural understanding.*
PAGES 154-155: *A bird's-eye view shows the Tidal Basin before the rush of visitors.*

Picnics Under the Blossoms

CHERRY BLOSSOM TREES in bloom have inspired revelers in Japan for more than a thousand years. Winter-weary people gathered under the trees, basking in the warmth of spring and losing themselves in the beauty of the flowers, an experience known as *hanami* in Japanese. Formalized cherry blossom viewing rituals were established at Japan's Imperial Court by the ninth century. These ceremonies live on in modern Japan, where groups of families and friends eat special foods, drink sake, and sing karaoke under the blooming trees.

Like those in Japan, the cherry blossom trees around the Tidal Basin also attract families and friends to celebrate the arrival of spring. Although there are no specific American cultural traditions to uphold, the trees' blossoming provides an ethereal environment for sharing food brought from home or purchased from Tidal Basin food vendors, creating treasured memories.

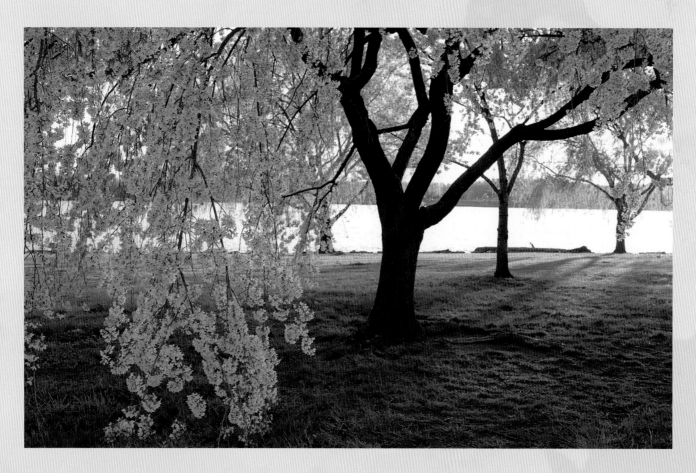

Underneath a cherry tree is the ideal spot for a leisurely spring picnic.

CHAPTER FOUR

TIDAL BASIN AND BEYOND

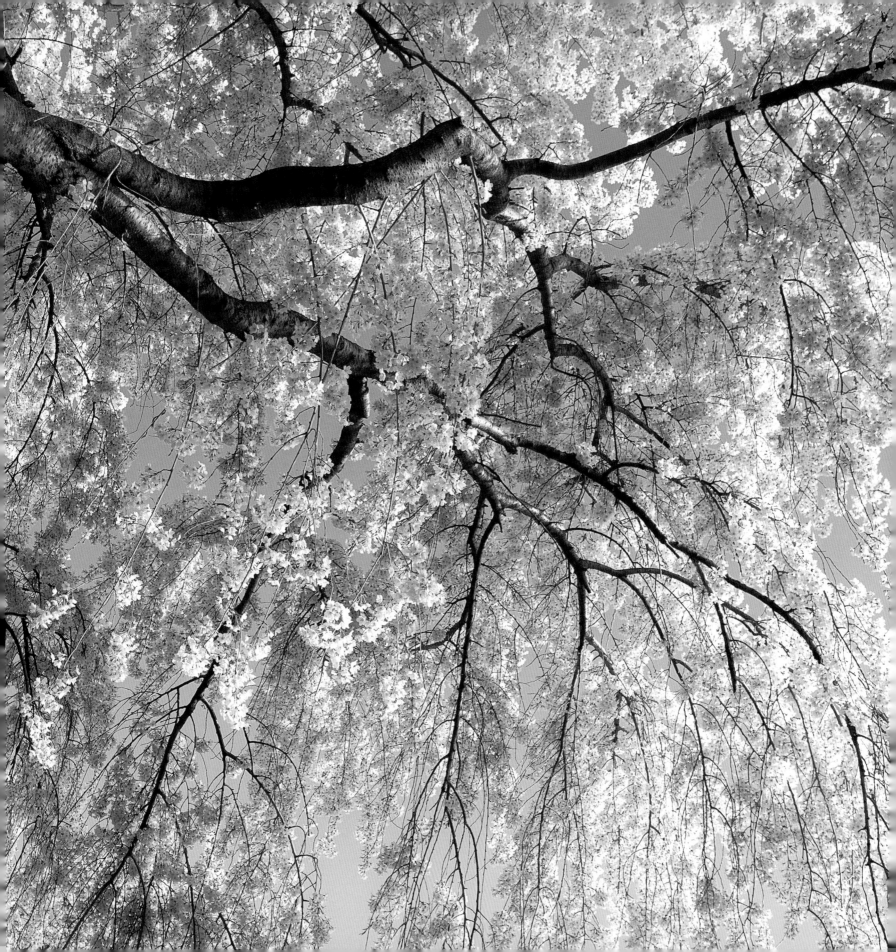

The Festival All Around Town

THE AREA'S GREATEST CULTURAL INSTITUTIONS, ORGANIZATIONS, AND businesses join together during the National Cherry Blossom Festival to showcase Washington, D.C., as a city "in concert," all playing in harmony to create a joyful tune, celebrating the return of spring. These official partner organizations make possible the panorama of activities that complement the Festival's signature events and programs that were highlighted in Chapters Two and Three. ∼ Excitement about the cherry blossoms' blooming pervades the entire capital region, far beyond the Tidal Basin and Hains Point, and the arrival of spring brings on the urge for activity. Nearly anywhere you go—on land, on water, or even indoors—there is another Festival activity

to participate in or a new way to enjoy the blossoms. The athletically minded can watch or compete in several events, and the culturally inclined can visit special exhibits at the region's museums. Many people prefer to indulge their own inner artist, inspired by the sight of the breathtaking blossoms.

Walking is one of the most common ways to enjoy the blossom-laden trees. For those interested in learning more about the trees and how they came to Washington, D.C., the National Park Service and other groups offer an array of tours and activities. The

Bloomin' Junior Ranger Activity Tent by the Tidal Basin offers games, projects, and puzzles designed to teach kids about the trees, the tree crew that cares for them year-round, and Japan.

In addition to daytime guided tours, park rangers give evening lantern-lit walks, illuminating the blossoms as they share the story of how the trees came to the Tidal Basin. Washington Walks experts lead "Blossom Secrets Strolls" that highlight special trees on the Mall and on the Smithsonian Institution's grounds while revealing the cherry blossom trees' history and significance.

Cherry blossoms create a flowery canopy beneath the spring sky.

For joggers, park rangers offer "Cherry Chit-Chat Runs" throughout the day, a unique way to enjoy the beauty of the trees, get exercise, and learn fun facts. Joggers and runners also can participate in the Credit Union Cherry Blossom Ten Mile Run, which attracts international running stars and has become so popular that entrants must use a lottery system for registration.

Bicycling is another great way to enjoy the cherry blossoms, and a smart idea for traveling to and from events. Complimentary bike valet stations are set up near the Tidal Basin, allowing bike riders the freedom to join the crowds unencumbered. Bike rentals are available at special stations too. Companies also offer group biking excursions, like the multidistance "Blossoms by Bike" tours. Shorter trips starting in Washington, D.C., circumnavigate the Tidal Basin and Hains Point. More intrepid riders can embark on three-hour rides launched in Old Town Alexandria. These follow the Mount Vernon Trail and feature superb views of the blossoms from the Virginia side of the Potomac River.

There are tours for photographers and there have been photo contests, which called for entries in different categories: landscape, people, and festivities.

Winners received a prize and their work was often highlighted in Festival publications or on its website. Some winners' photographs are in the pages of this book.

A most entertaining way to enjoy the cherry blossoms from the water is by taking a paddleboat around the Tidal Basin to enjoy unique vistas of the Washington Monument and Jefferson Memorial. Television crews have been known to do their live cherry blossom broadcasts from the middle of the Tidal Basin stationed in a paddleboat!

Other waterborne blossom-viewing opportunities delight the palate as well as the eye. Dinner cruises offer guests dinner, dancing, and live entertainment; fireworks cruises provide unobstructed viewing of the nighttime pyrotechnics; and river tea cruises feature traditional full-service English "high teas" with classic tea sandwiches, pastries, and scones.

The City in Bloom program spreads the Festival spirit throughout the region with blossoms by day and pink lighting at night. Pink blossom decals festoon windows, public transportation, taxicabs, and cars all around town. And after dark, some of the area's major buildings—including the local airports, theaters, museums, office buildings, stores, government

Randy Mays designed the illustration seen in the Festival's 1993 marketing materials.

buildings, and restaurants—are bathed in pink lighting and blossom projections.

In the minds of sports fans, nothing says spring like the start of baseball season, and the Festival and the Washington Nationals celebrate with special deals on tickets for fans. The Festival encompasses many other sports events as well, including rugby, soccer, and lacrosse matches.

Many people are inspired by the blossoms to be creative. Just as they did after the first gift of the trees were newly planted in 1912, throngs of artists sit under the blooming trees to sketch or paint, especially finding inspiration at dawn or dusk, when crowds are thinner.

The city's museums and cultural institutions unveil unique exhibitions to coincide with the Festival. The Freer Gallery of Art and Arthur M. Sackler Gallery celebrate with Asian-related exhibits and activities each year. The National Gallery of Art, Renwick Gallery of the Smithsonian American Art Museum, Hirshhorn Museum and Sculpture Garden, Textile Museum, and Bureau of Engraving and Printing have also mounted exhibits. Many encourage community participation such as the drawing workshops offered by the Corcoran Gallery of Art and College of Art + Design. Special film screenings add to cultural offerings, including the perennial favorite, an *anime* marathon.

The serene beauty of gardens throughout the area offers an appealing way for people to enjoy the Festival away from the Tidal Basin. Many local gardens open to the public are designed to peak in beauty when the cherry blossoms bloom. In the city, Hillwood Estate, Museum and Gardens provides special tours of its Japanese-style garden, and the U.S. Botanic Garden Conservatory showcases how to train bonsai plants and trees. In Fairfax County, Virginia, visitors can admire more than 100 cherry trees at Meadowlark Botanical Garden, and Green Spring Gardens offers cherry blossom–themed events. The U.S. National Arboretum invites people to go "beyond the Tidal Basin" to see the more than 75 different varieties of flowering cherry trees there.

From time-honored to creative, the Festival's events reward residents looking for something new; visitors seeing the blossoms for the first time; the actively inclined; and the artist within. ▪

The 2010 official Festival artwork was a rice paper collage created by Junko Yamada.
FOLLOWING PAGES: *Cherry blossoms reveal subtle color shadings as they unfurl.*

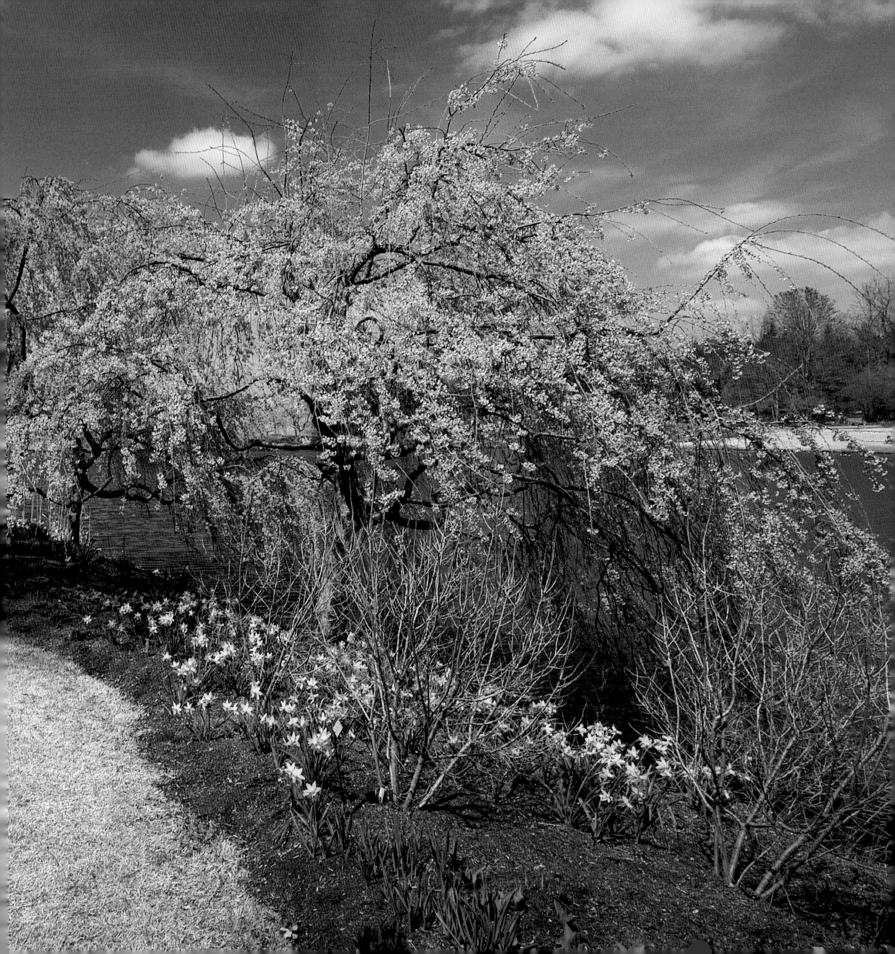

TOURING THE BLOSSOMS

THE BEST WAY TO ENJOY THE CHERRY BLOSSOMS is to be out and about, under and around them. There is so much to see—discovering the different varieties of trees and enjoying the blooming progression on each branch and tree—people quickly realize that visiting just one time is not enough. Many choose to wander on their own among the trees while others take advantage of guided tours. ∞ Active? Leisurely? Night owl? Early bird? There is a tour for everyone. The best part about tours led by experts is that they teach fun facts and tidbits about the famed blossoms and the Festival that others do not know. For instance, a park ranger might point out to visitors the blooming progression on a tree limb, the difference between Yoshinos and Akebonos, or where to see the aged flowering cherry trees on Hains Point that might be from the ill-fated shipment of 1910. ∞ For those with cameras, the vibrant Festival events and beautiful blossoms provide endless photo opportunities. Photographers can perfect their techniques with hands-on guidance from professionals on Washington Photo Safaris. These tours are timed to take advantage of the "golden hours" at dawn or late in the day to make the most of the blossoms' beauty. ∎

Idyllic Meadowlark Botanical Garden in Northern Virginia has more than 100 cherry trees.

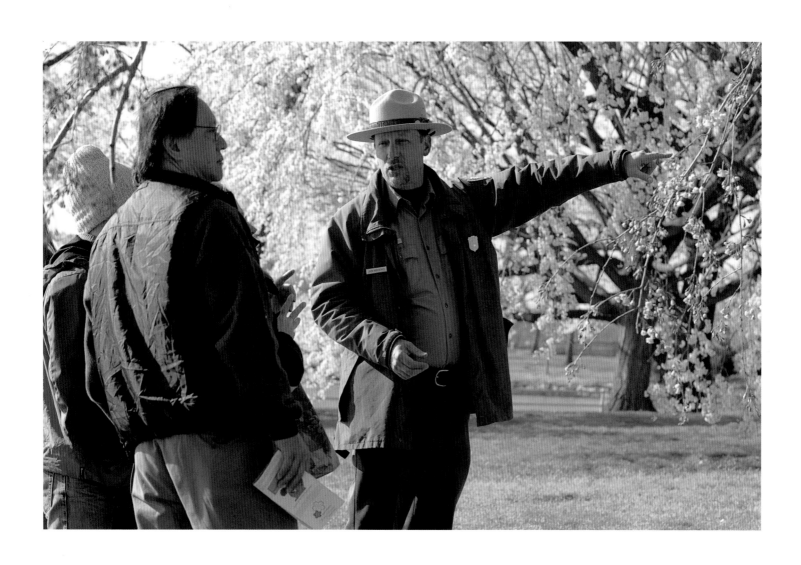

ABOVE: *A National Park Service ranger guides visitors to Festival activities and events.*
OPPOSITE: *A young girl finds her way through a maze of pink, fluffy blossoms.*

"The best way
to enjoy
the
cherry blossoms
is to be out
and about,
under and
around them."

Bike riders take to the road to explore the blossoms around Hains Point.

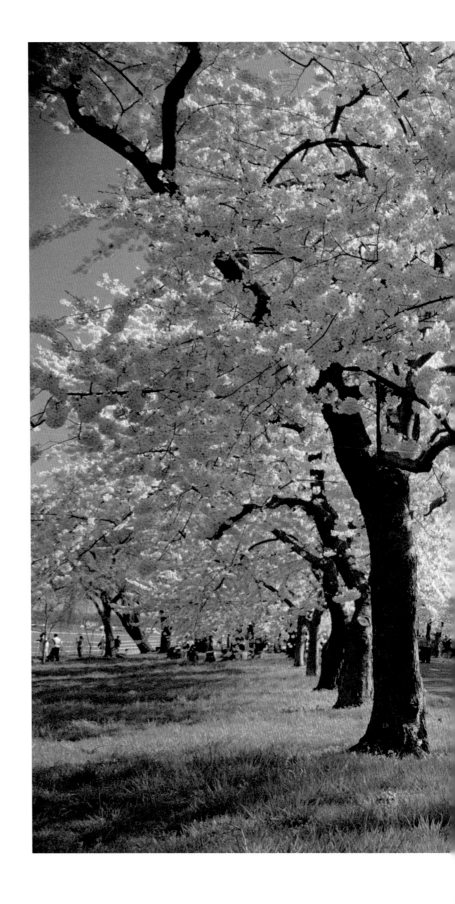

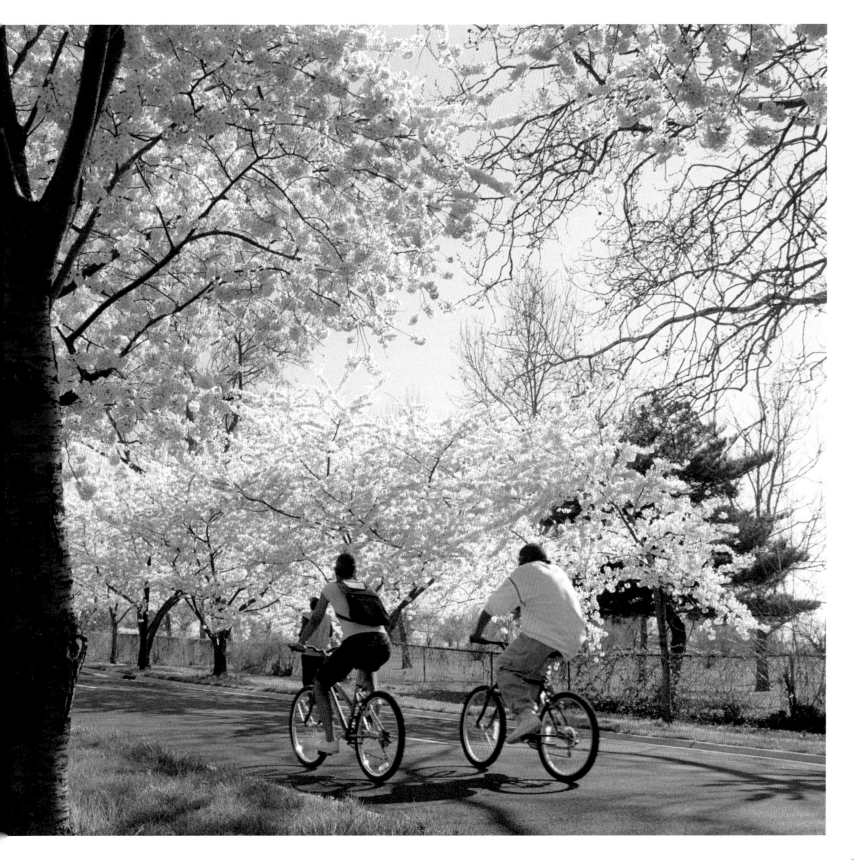

New Varieties of Cherry Blossom Trees

MORE THAN 2,000 ornamental cherry blossom trees grow at the National Arboretum, a research and education facility with gorgeous gardens located in northeast Washington, D.C. Arboretum experts have successfully grown cuttings from Yoshino cherry trees from the original 1912 gift to replace dying trees around the Tidal Basin, ensuring their genetic continuation.

Arboretum experts also develop new varieties of cherry blossom trees for landscape use, sold through the nursery trade. Two offspring of the Okame (*Prunus* 'Okame') variety were developed at the Arboretum: 'First Lady' and 'Dream Catcher'. 'Dream Catcher' was the first to be developed and released. It grows to 25 feet tall with a vase-shaped winter silhouette, and its large blooms are medium-pink single flowers. 'First Lady' is the second release. Its flowers are dark pink and it, too, grows to a height of 25 feet with a more upright shape.

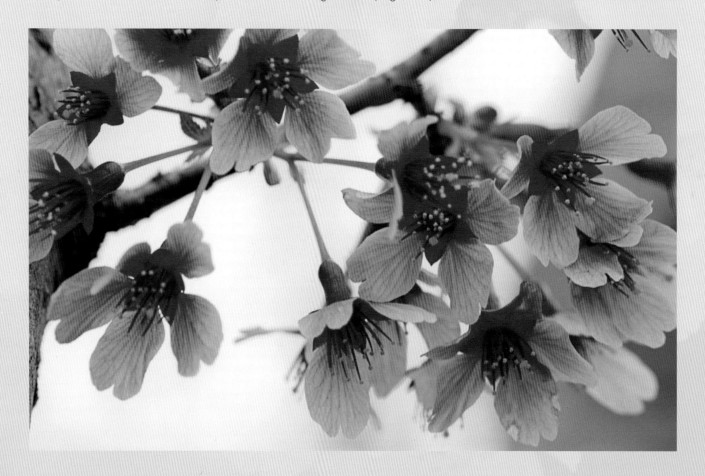

The Okame parent variety is prized for its early-blooming, pink blossoms.

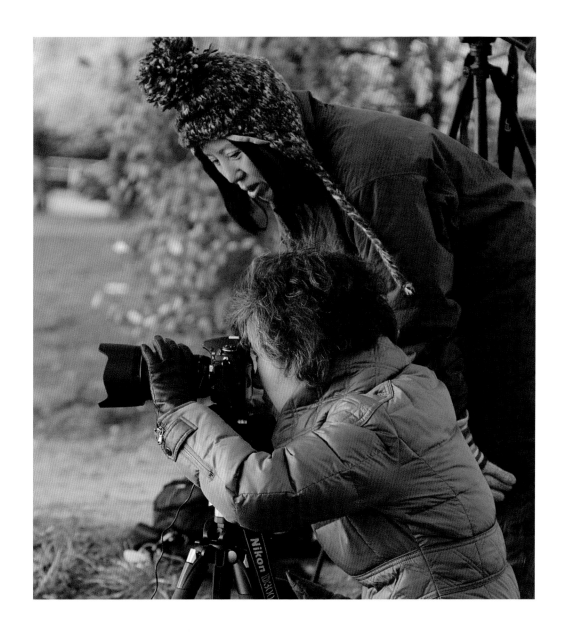

Amateurs and professionals alike are inspired to photograph the trees.
FOLLOWING PAGES: *A woman pauses to photograph a sunny, blossom-filled day at the Tidal Basin.*

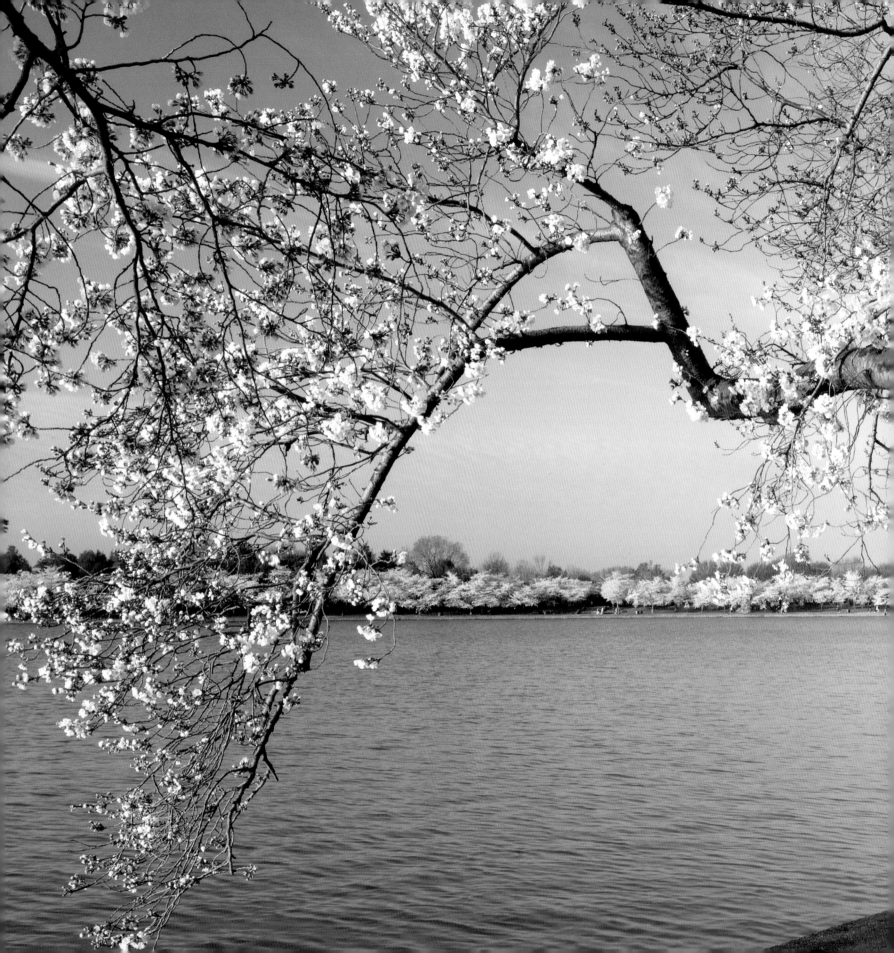

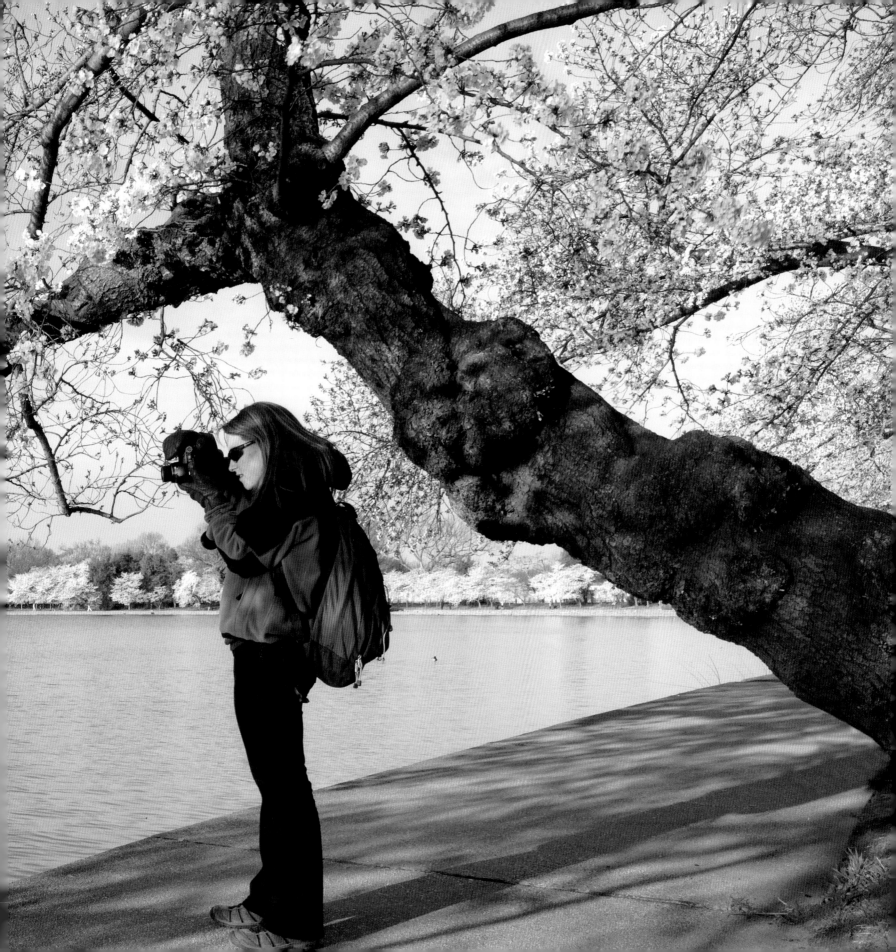

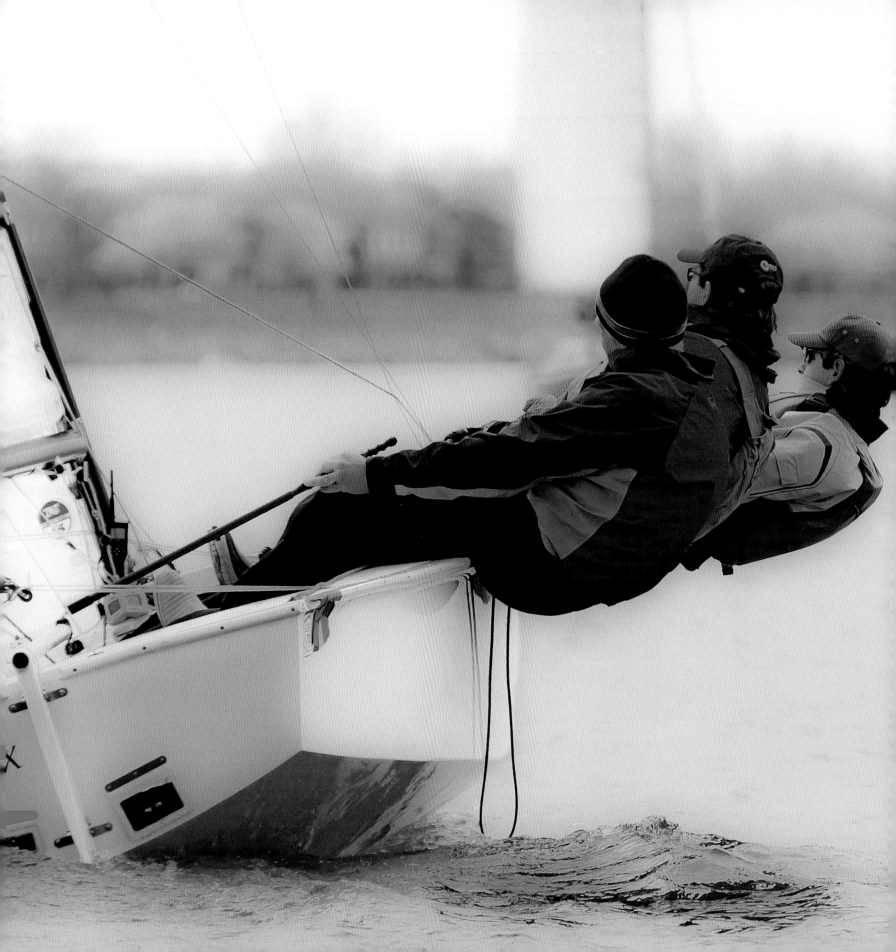

CRUISING THE BLOSSOMS

A S EXHILARATING AS THE BLOSSOMS ARE WHEN SEEN UP CLOSE, the view from the water is sublime. Out in the middle of the Tidal Basin or far from shore on the Potomac River, the clouds of pink and white lining the water's edge take on a magical quality. The most popular way to view the cherry blossom trees from the water is by paddleboat on the Tidal Basin. As the boat leaves the dock, the city beyond the blooming trees seems to disappear. ∾ As its spring tradition, marking the end of winter's deep freeze, the U.S. Navy Memorial hosts the Blessing of the Fleets Ceremony. Sailors from the Navy's Ceremonial Guard pour water from the world's oceans and the Great Lakes into the four fountains on the plaza of the U.S. Navy Memorial, "charging" them to life, celebrating the new season. ∾ The sailing regatta at Daingerfield Island heralds the start of the spring racing season. Many years, crew teams also converge on the Potomac River to compete in the area's largest rowing event. ∾ For those seeking a more leisurely experience on the water, a number of river cruises offer elegant dining and dancing options. There are even nighttime cruises to enjoy the blossoms from the water at dusk and others to view the fireworks. ∎

Shadowfax, a 19-foot Lightning racing sailboat, competes in the regatta.

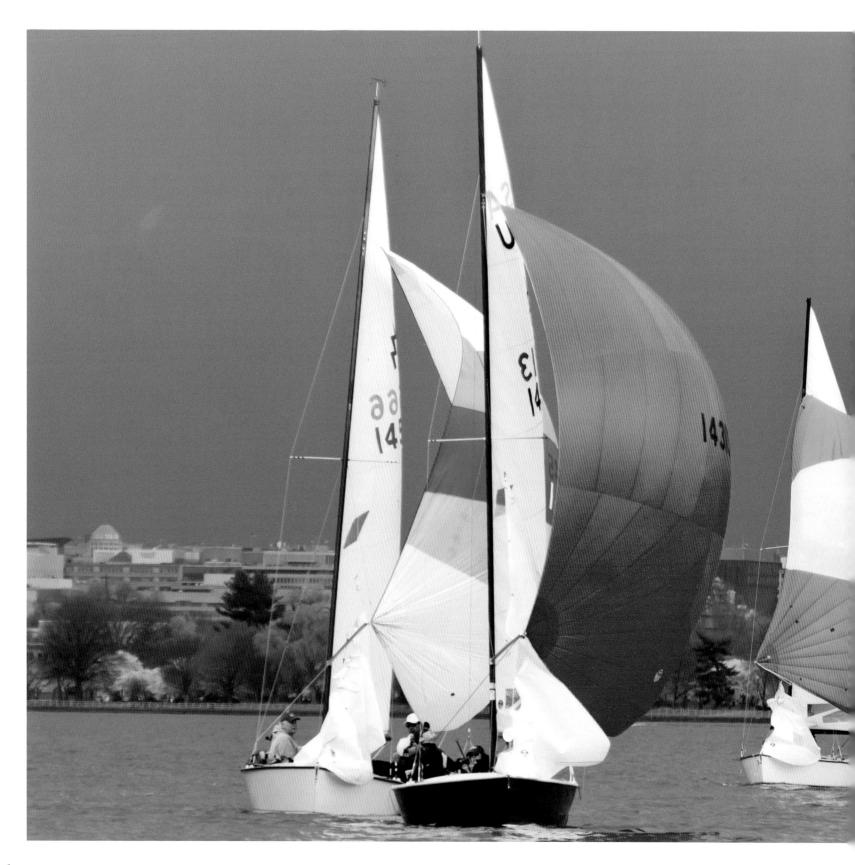

"Nearly anywhere
you go—
on land, on water,
or even indoors—
there is another
Festival activity
to participate in . . ."

River views of the blossoms reward racers in the annual Cherry Blossom Regatta.

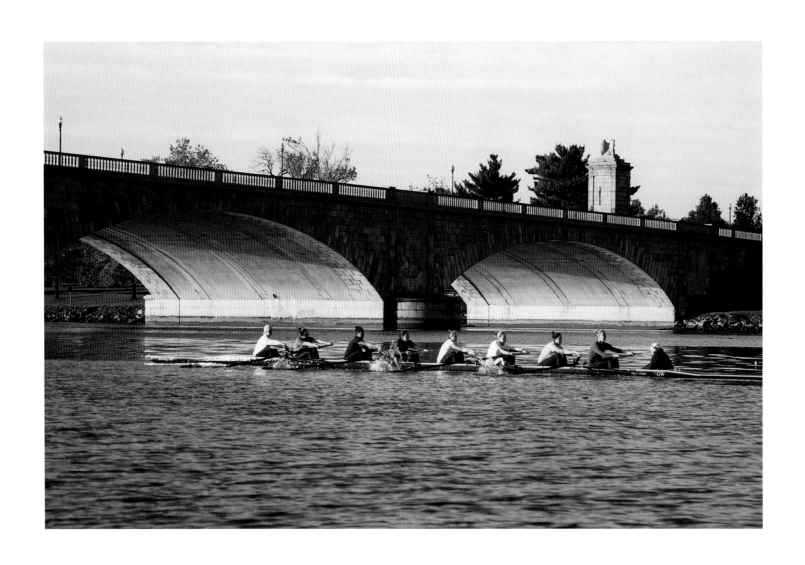

ABOVE: *Rowers from George Washington University have participated in Festival sports.*
OPPOSITE: *People line up to take a coveted paddleboat out on the Tidal Basin.*
PAGES 180-181: *The branch of a cherry blossom tree hangs over the Tidal Basin.*

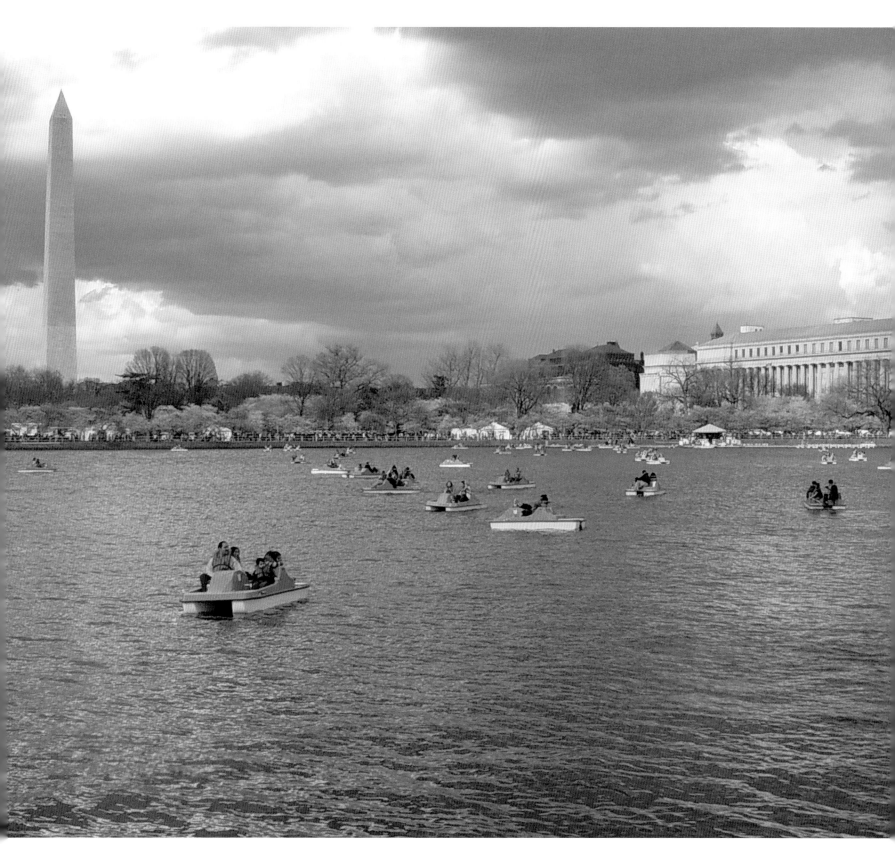

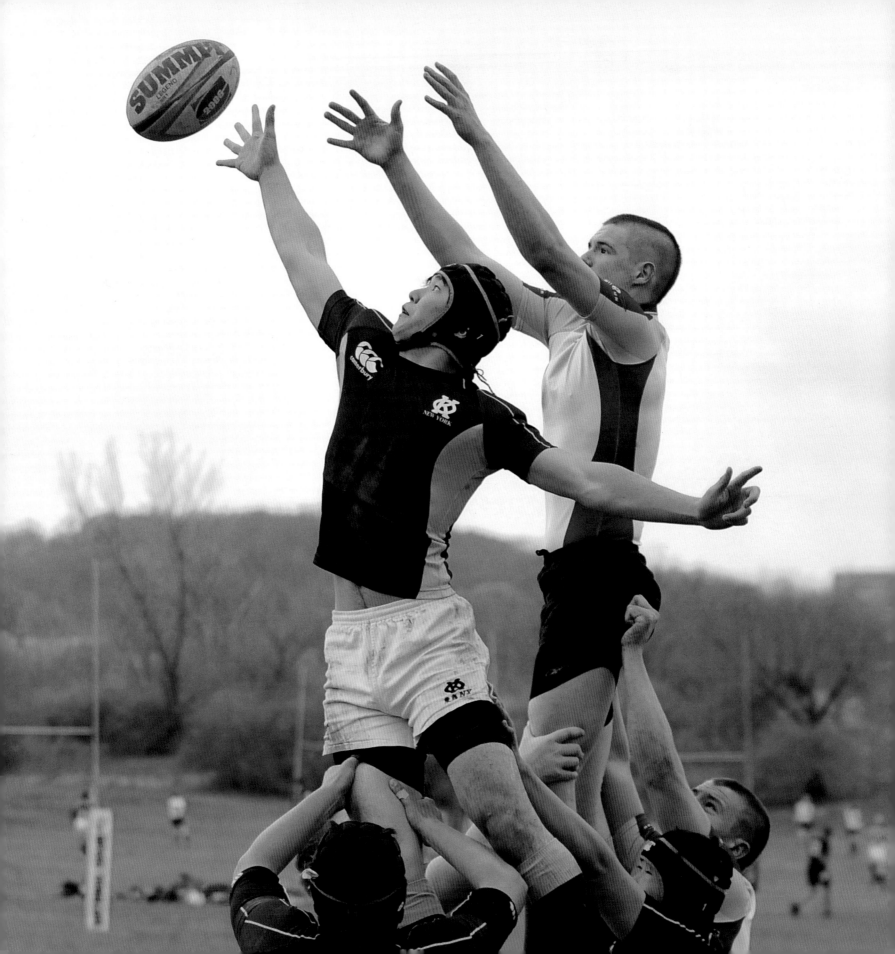

SPORTS UNDER THE BLOSSOMS

THERE IS SOMETHING ABOUT SPRINGTIME THAT INSPIRES physical exertion. Washingtonians and visitors want to be outside, playing sports, during the Festival and in view of the blossoms. Numerous events appeal to amateurs and professionals, testing their strength and skills and providing excitement for their fans and spectators. ≈ The Cherry Blossom Rugby Tournament is a selective two-day competition featuring some of the top-ranked college and high school teams in the United States. The Cherry Blossom Soccer Tournament gives coed adult soccer teams a chance to vie for a Cherry Blossom Cup, building camaraderie while benefiting various community groups. Many years, lacrosse teams have competed in a tournament. Even yogis get into the cherry blossom spirit! More than 1,000 people have practiced their yoga outdoors on the grounds of the Washington Monument in a free class during the Festival. ≈ Each year, joggers and runners anticipate the Credit Union Cherry Blossom Ten Mile Run. World-class professional athletes come from around the globe to compete to win some of the pot of $50,000 prize money. Those who are more comfortable running shorter distances and at a slower pace can participate in the 5K Run-Walk, and there is a half-mile Cherry Blossom Kids' Run too. ∎

Rugby players vie for the ball in an annual tournament that began in 1967.

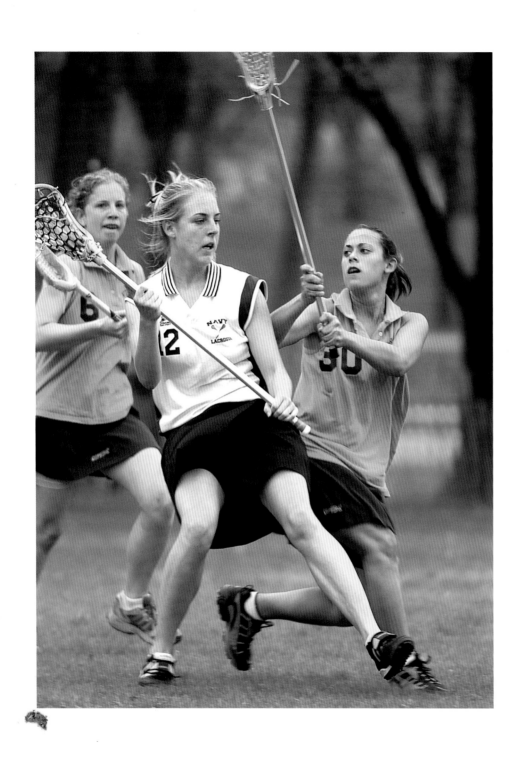

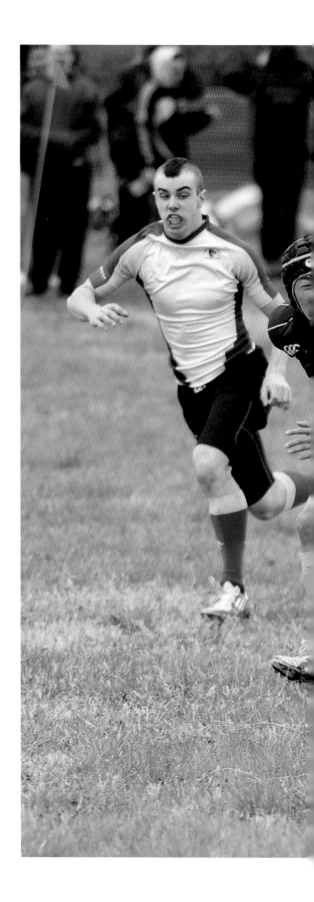

ABOVE: *Women's lacrosse teams have competed in cherry blossom tournaments.*
OPPOSITE: *The annual rugby tournament typically has more than 40 teams and 700 participants.*

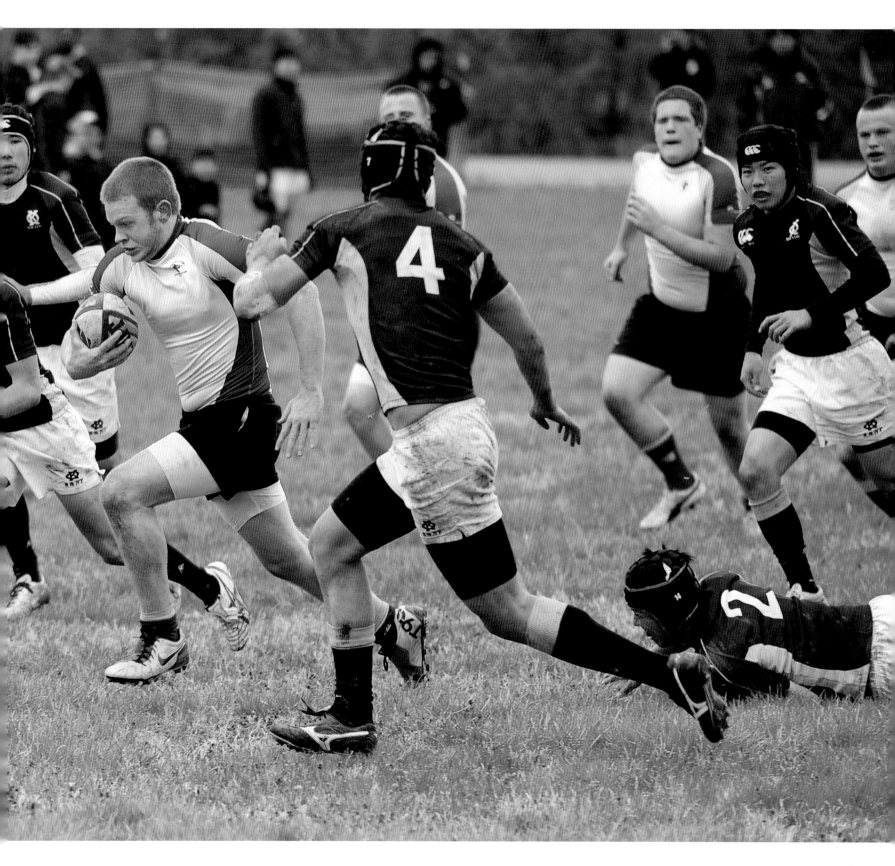

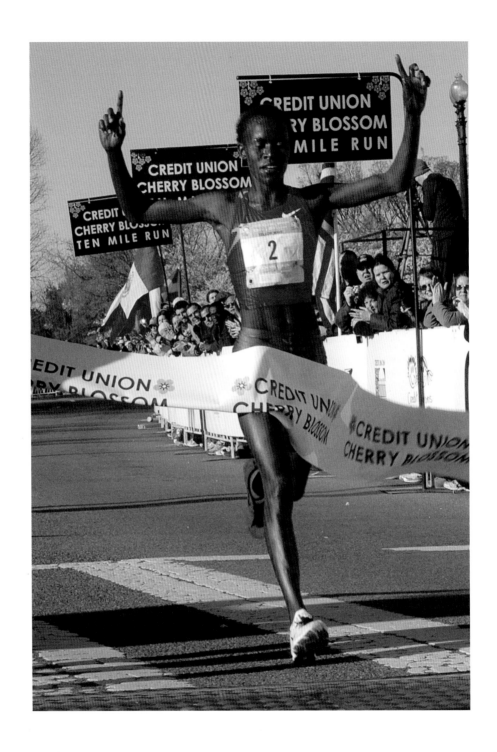

ABOVE: *Three-time women's winner Lineth Chepkurui won the Cherry Blossom Ten Mile Run in 2009.*
OPPOSITE: *World-class runners set a fast pace for the ten-mile race competitors.*

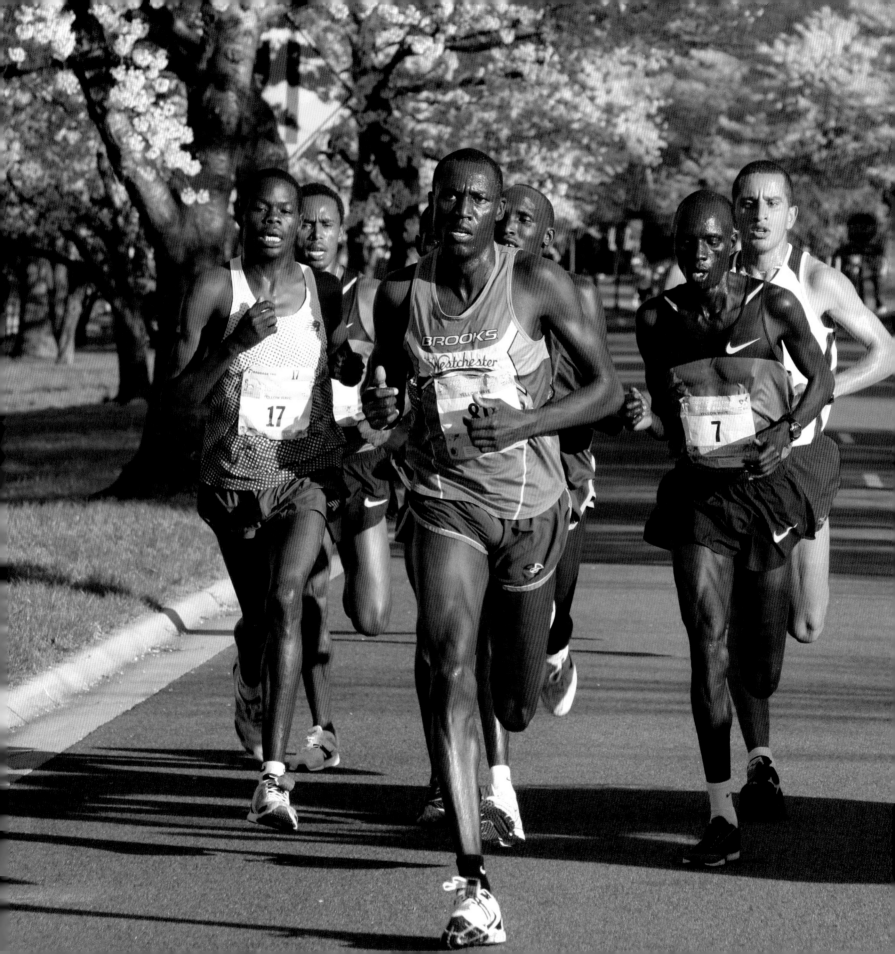

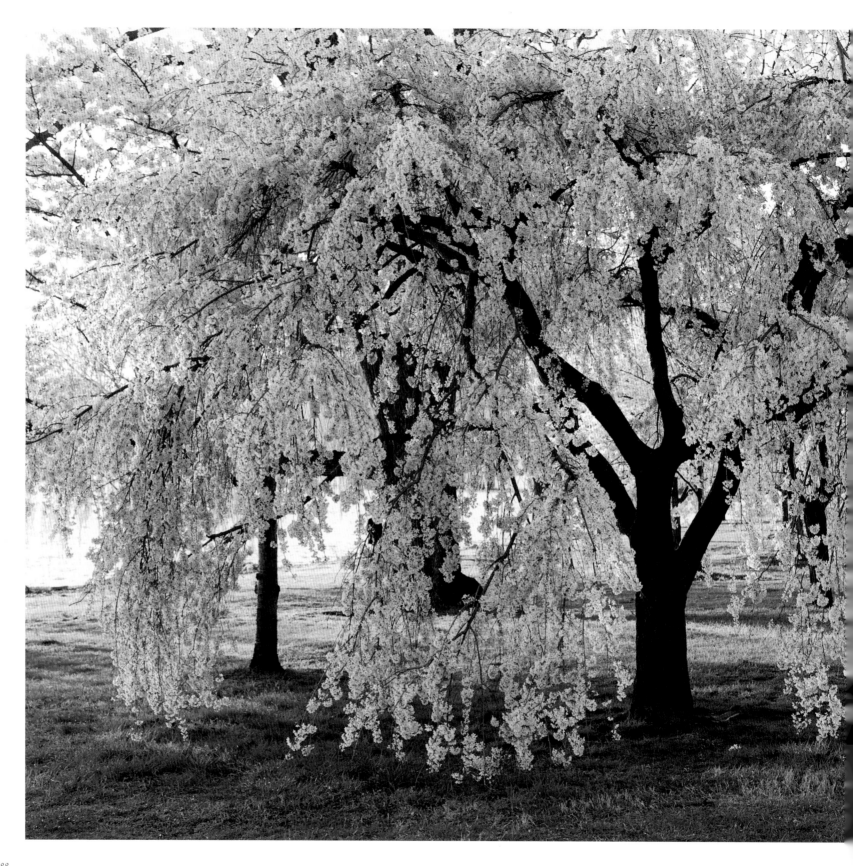

" . . . the
'golden hours'
at dawn
or late
in the day . . .
make the most
of the
blossoms' beauty."

Cascades of blossoms add graceful shapes to the springtime landscape.

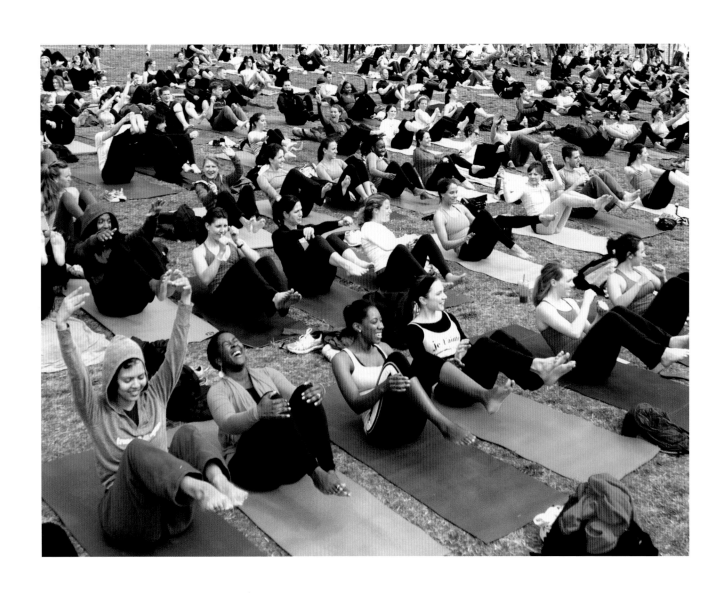

Yogis bring their mats to the Washington Monument for a free yoga session.

Kwanzan Cherry Trees

KWANZAN TREES (*Prunus serrulata* 'Kwanzan') bloom about two weeks after the Yoshino and Akebono cherry blossom trees around the Tidal Basin. There are more than 480 Kwanzans throughout Potomac Park and on the Washington Monument grounds. Easily recognized by their solid pink, "pom-pom" blossoms comprising about 30 petals each, Kwanzans' green leaves emerge at the same time as the blossoms.

Kwanzans, named for a mountain in Japan, are upright-spreading trees, as opposed to weeping varieties whose branches arc toward the ground, and grow to 30 feet. They have relatively short life spans of 15 to 25 years, and they tend to be wider than they are tall when mature. Kwanzans, like all varieties of cherry blossom trees, drop their petals unwithered, and nearly all at the same time. Because of the Kwanzan blossom's many petals, there are wide swaths of pink around the trees after the petals fall.

Kwanzan trees, also known as Kanzan, are named after a mountain in Japan.

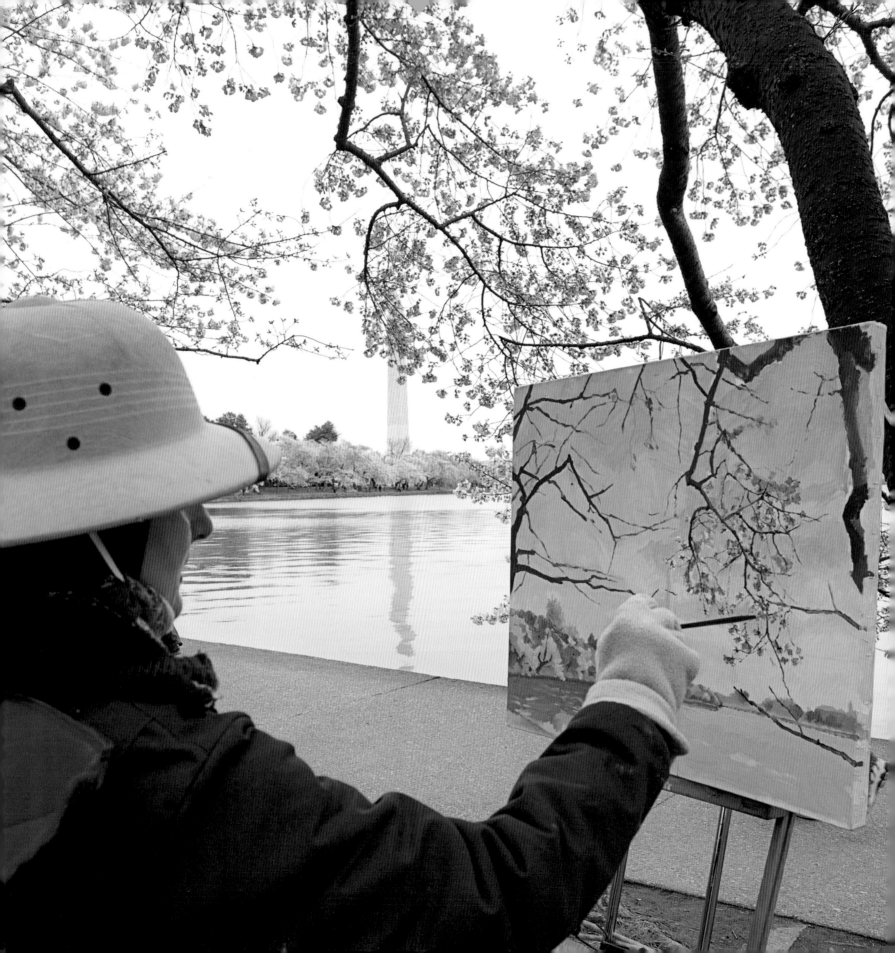

ARTISTIC EXPRESSION

THE FESTIVAL INSPIRES ARTISTS TO BE CREATIVE and museums and galleries to feature related art in every shape and form. Through the years, Festival exhibits have showcased rare and renowned works of art, and pop-up art installations have provided surprises everywhere in the city. ∽ In 2007, Yoko Ono brought her "Wish Tree" exhibit to the Tidal Basin. The installation encouraged people to write wishes on a piece of paper, attaching them to potted trees at the Tidal Basin, creating a blooming effect. Also in 2007, the National Geographic Museum hosted a master gardener from Kyoto, Japan, who created a warrior's garden in the Society's Washington headquarters. In 2011, shoppers were astonished to discover 30 living cherry blossom trees in the Macy's department store in downtown Washington, D.C. ∽ The Freer Gallery of Art and Arthur M. Sackler Gallery presented "Hokusai" in 2006, which included more than 180 paintings, prints, drawings, and printed books by Japanese artist Katsushika Hokusai (1760–1849). In 2005, the Hirshhorn Museum and Sculpture Garden offered "Isamu Noguchi: Master Sculptor." It featured about 55 sculptures and 25 works on paper by Noguchi (1904–1988), focusing on his sculpture as distinct from his commercial designs. ▪

A meticulous painter portrays each branch of a cherry blossom tree.

"*The serene beauty of gardens throughout the area offers an appealing way for people to enjoy the Festival . . .*"

A warrior's garden in 2007 at the National Geographic Museum
inspired meditation.
FOLLOWING PAGES: The Freer Gallery of Art showed "Spring Landscape with
Blossoming Cherries" in its "Seasons" exhibit.

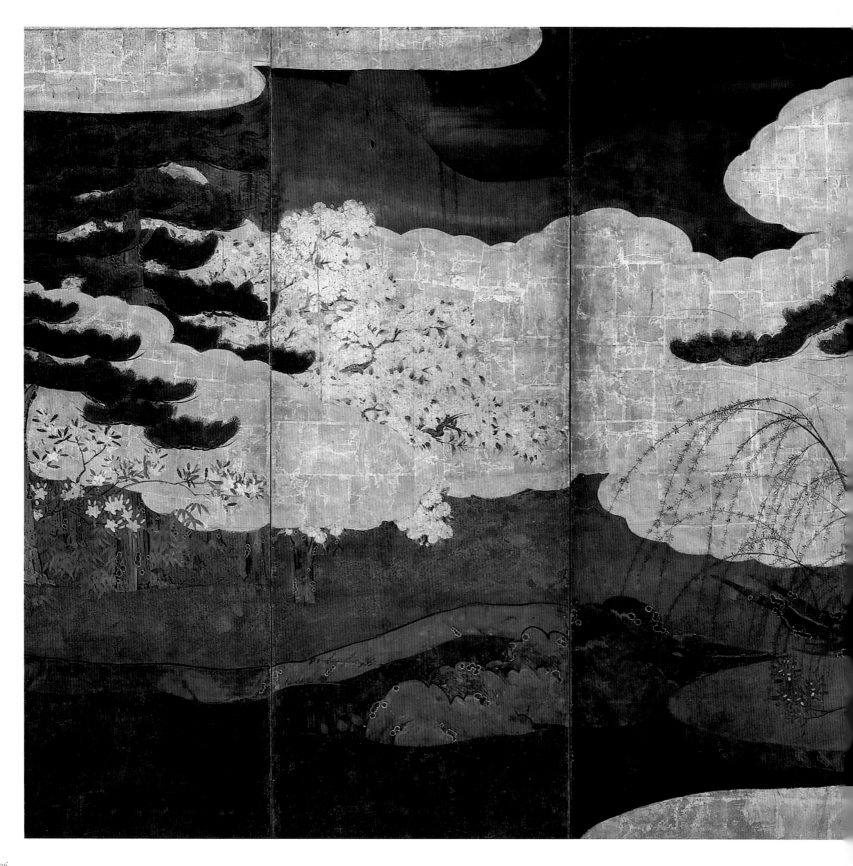

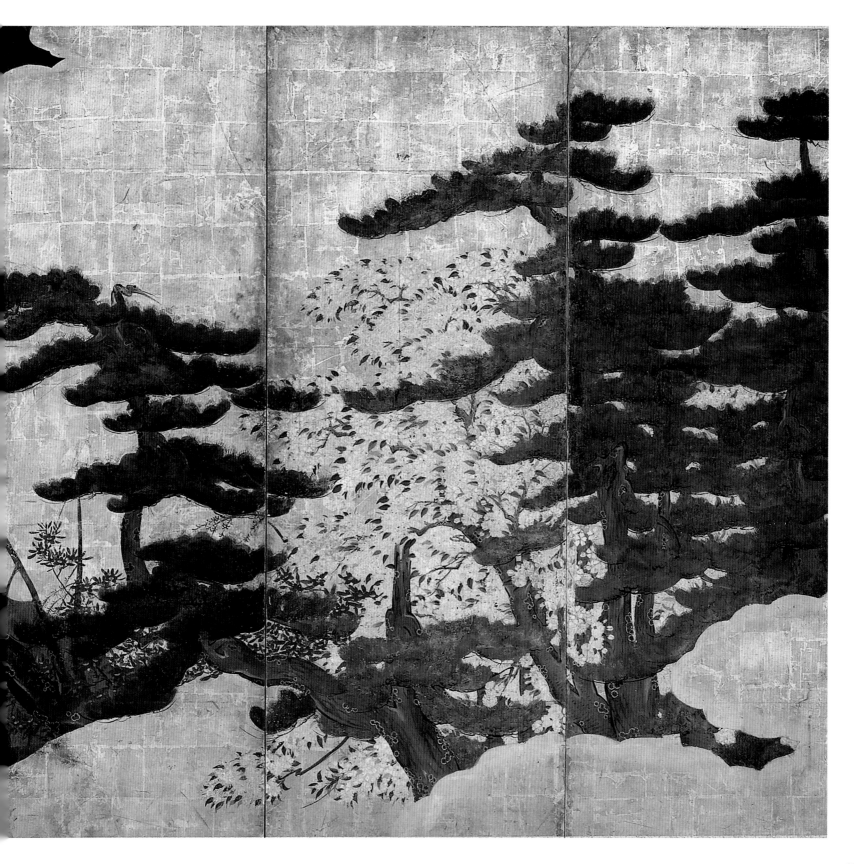

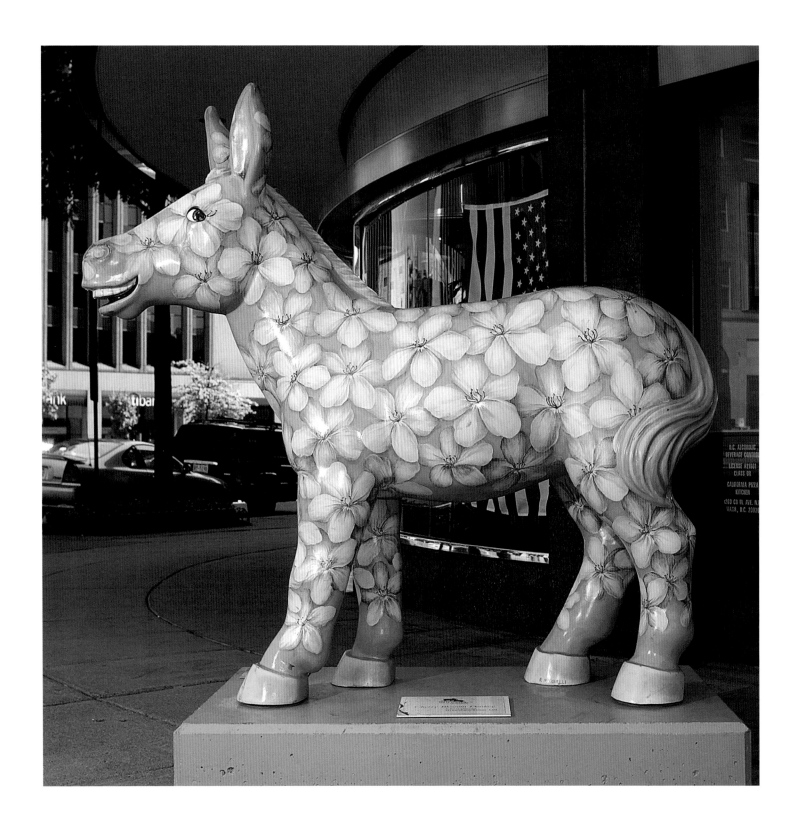

Robert Marovelli's cherry blossom–adorned donkey was in the 2002 Party Animals public art project.

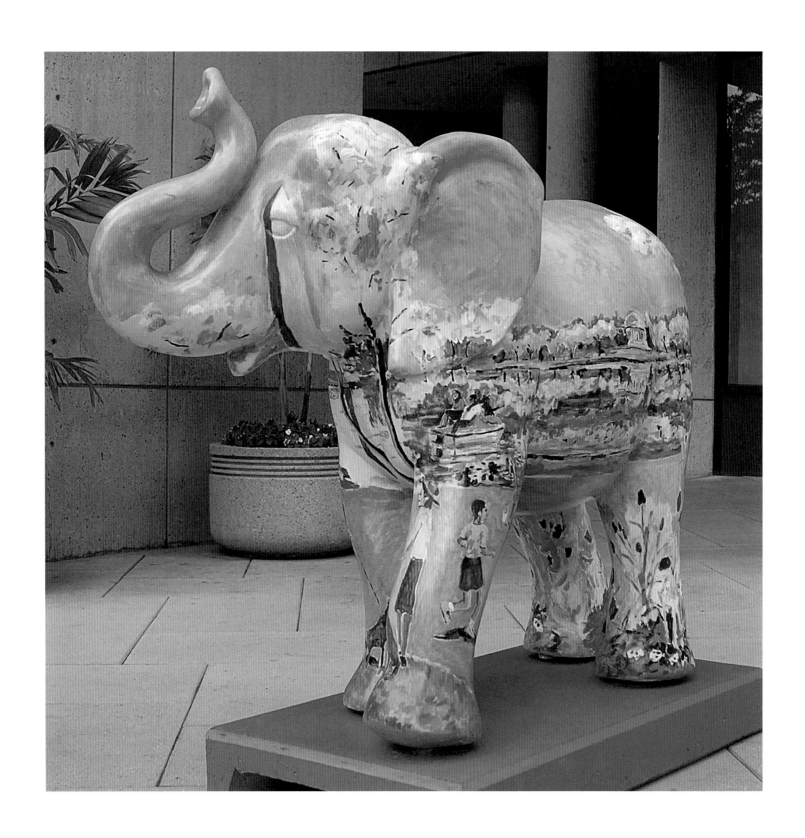

Elizabeth Riordan created a Festival-inspired elephant as one of the Party Animals.

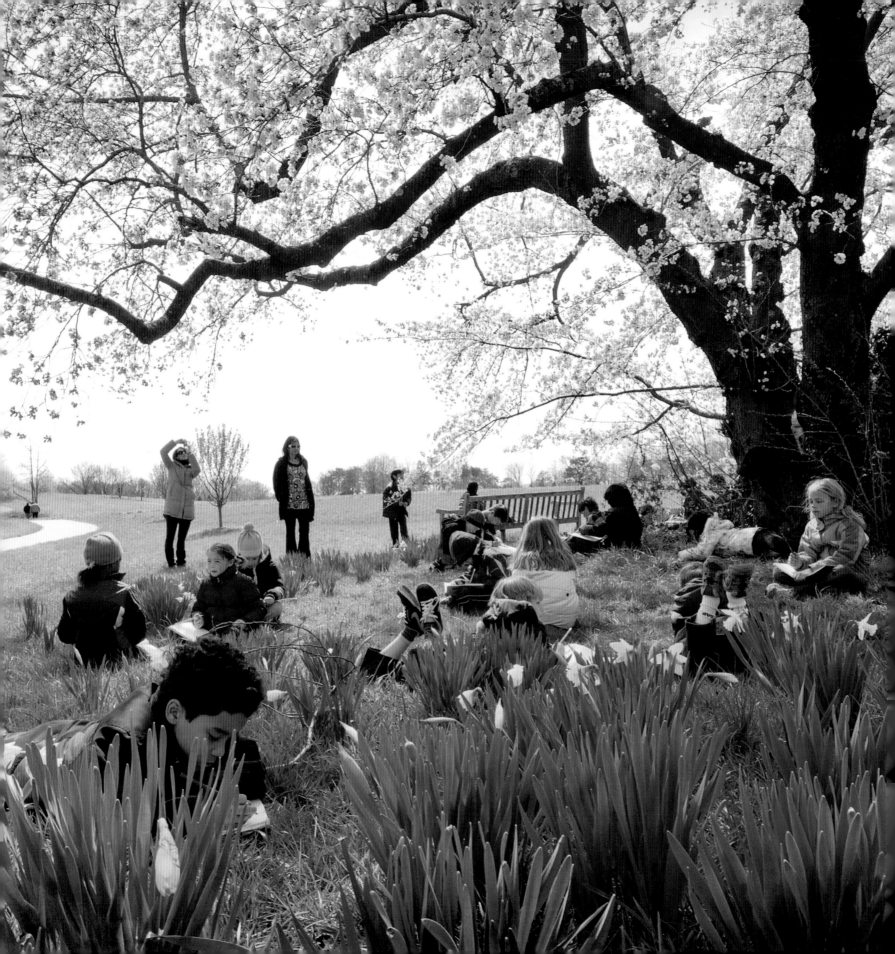

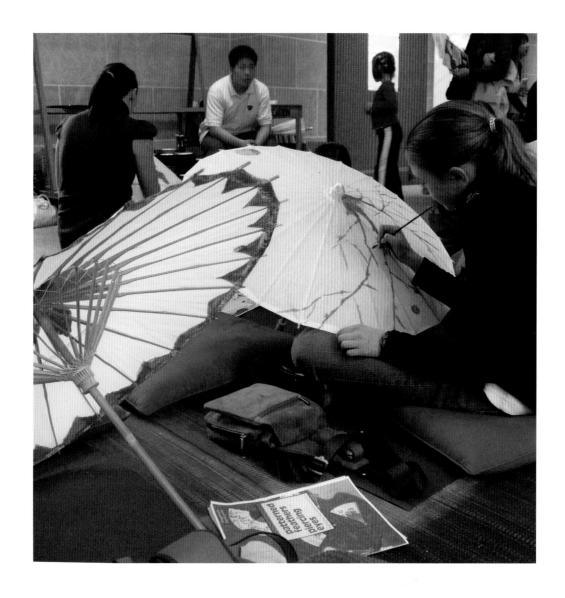

OPPOSITE: *A second-grade class writes haiku underneath a cherry tree at the National Arboretum.*
ABOVE: *ImaginAsia Family Program participants paint paper parasols at the Freer Gallery of Art.*
FOLLOWING PAGES: *Intrepid visitors are not deterred by rain when the blossoms are in full bloom.*

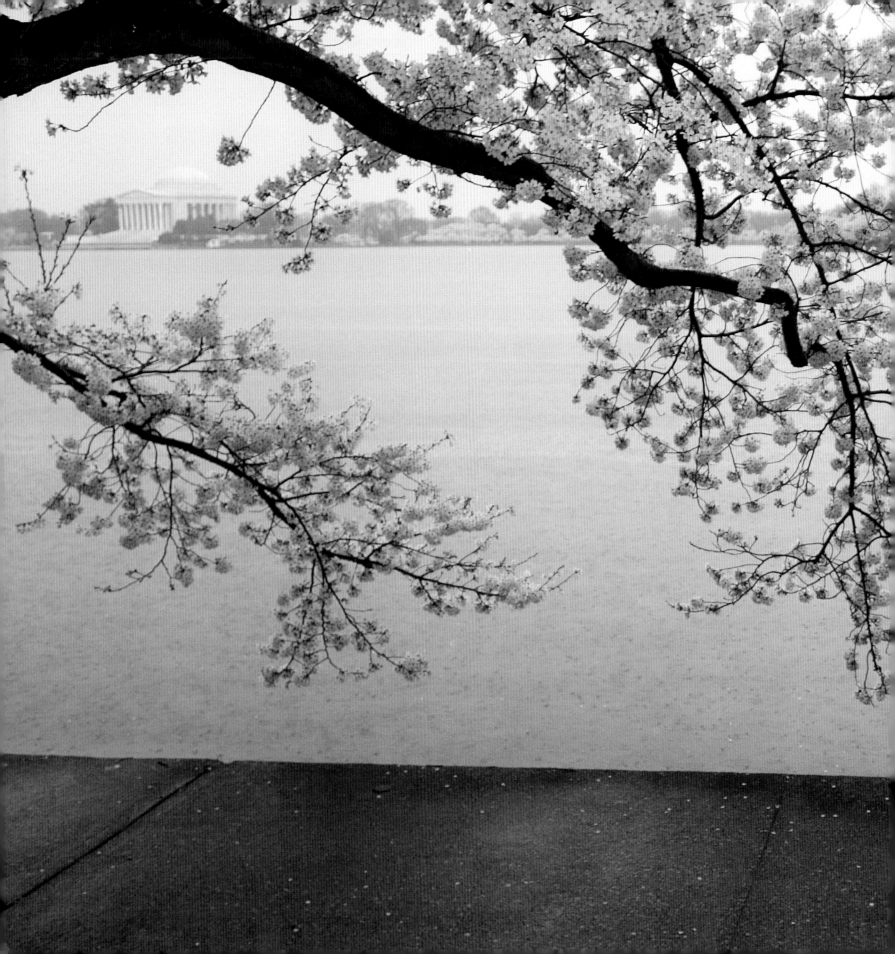

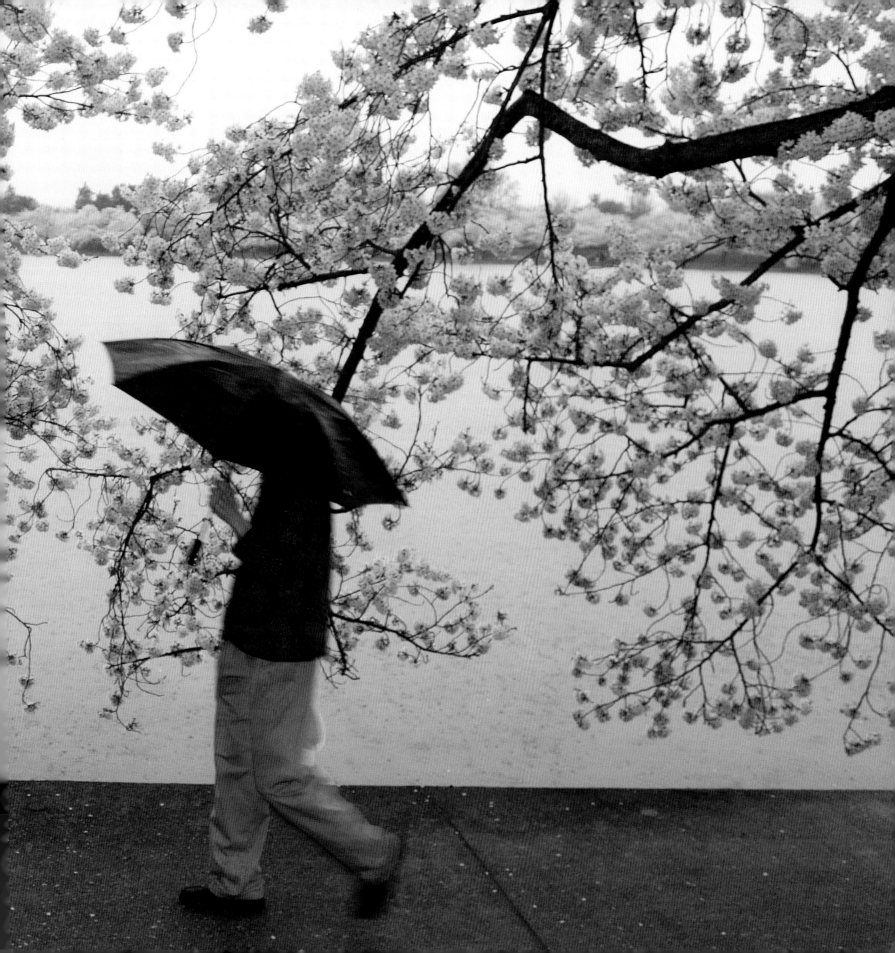

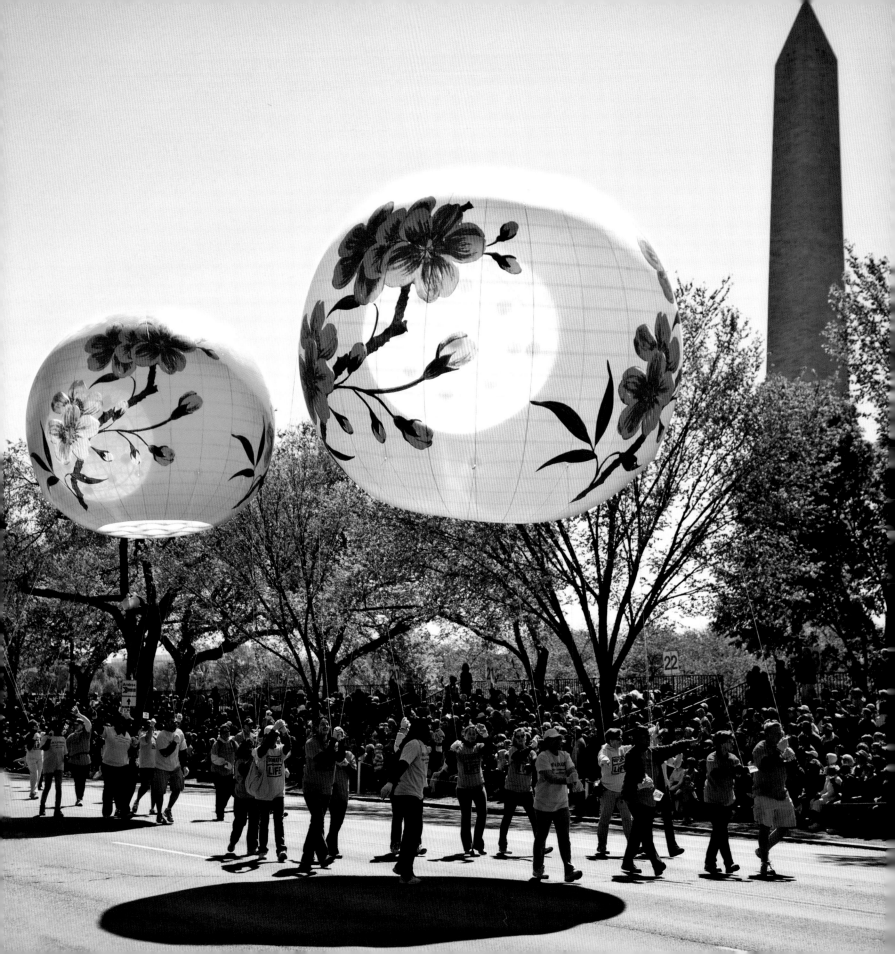

EPILOGUE/LOOKING FORWARD

THE NATIONAL CHERRY BLOSSOM FESTIVAL IS PROUD to produce the nation's greatest springtime celebration. Its important role welcoming spring and establishing traditions in the more than 100 years since the trees arrived in Washington, D.C., has linked family landmark events with the city's springtime revels, creating a trove of shared memories. We look forward to the future as Festivals continue to grow, expanding their reach, engaging the community, celebrating the arts and culture, and preserving natural beauty. ❧ Year-round activities will focus on the environment and education. The Festival's tree-planting program throughout the city will expand, enhancing the environment and continuing the circle of giving. Educational initiatives for today's youth will underscore the value and importance of the trees and the Festival for tomorrow's leaders and their children. ❧ The Festival has grown and evolved—from its beginning as just one afternoon to today's multiweek extravaganza of events, performances, and activities celebrating spring— and it will continue to keep pace with the changing possibilities and expectations of future generations. ■

Enormous Japanese lantern balloons in the parade seem lit from within.

APPENDIX

Cherry Blossom Varieties

Places to Enjoy Cherry Blossom Trees and Festivals

Cherry Blossom Fun Facts

Recipes from Celebrated Chefs

CHERRY BLOSSOM VARIETIES

Afterglow An early-blooming tree, Afterglow has single pink-tinged flowers in clusters of two to five. The blooms hold their color and do not fade, and their foliage turns yellow in the fall. Afterglows (*Prunus* x *yedoensis* 'Afterglow') grow to between 20 and 30 feet with a rounded crown. They are hardy from zones 5 to 8.

Akebonos bloom mid-season with single pale pink flowers, fading to white with a trace of pink, held in clusters of two to five. Akebonos (*Prunus* x *yedoensis* 'Akebono'), also called Daybreak cherries, have round tops. They can reach around 30 feet in height and are wide spreading. They are hardy in zones 5 to 8.

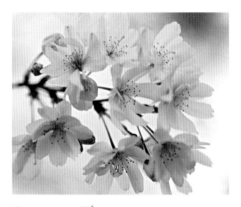

Autumn Flowering blossoms can be single or double and range in color from white to dark pink. Autumn Flowering trees (*Prunus subhirtella* var. *autumnalis*) often bloom during fall warm spells and again in the spring. Reaching heights of around 30 feet, with a spread of 15 to 20 feet, they are hardy to zone 5.

Fugenzo The double flowers of about 20 petals are rose-pink and fade a bit but never become white, hanging in clusters of four to six blossoms. Fugenzos (*Prunus serrulata* 'Fugenzo') can reach 20 feet high and 20 feet wide with flat crowns. One of the oldest cultivated flowering cherries in Japan, it is hardy to zone 6.

Kwanzan The Kwanzans' distinctly pink flowers of about 30 petals hang in clusters of three to five blooms, which emerge with leaves. Kwanzans (*Prunus serrulata* 'Kwanzan') bloom about two weeks after the Yoshinos. They grow to a height of 15 to 30 feet in a broad-spreading shape, and they are hardy in zones 5 to 9.

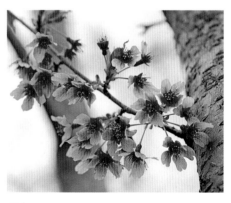

Okame Okames' flowers are single deep pink blossoms. The tree grows to a rounded crown at a height of 15 to 25 feet with a 20-foot spread in a spreading oval shape. Okames (*Prunus* 'Okame') are among the earliest flowering of the cherry trees, with yellow, orange, or red fall foliage. They are hardy from zones 6 to 9.

Sargent The flowers are single, variable pink in color, and grow in clusters. These large trees grow from 40 to 50 feet and can spread as wide. Sargents (*Prunus sargentii*) have late-flowering blossoms in the spring with distinctive bronze- to red-colored fall foliage. Named for an American plant collector, they are hardy to zone 4.

Shirofugen The double pink-tinged white flowers grow in large clusters of 20 to 30 petals, which gradually turn pale pink before falling. The late-blooming Shirofugens (*Prunus serrulata* 'Shirofugen') are flat-topped with a moderate spread of downward-arching branches. They grow 15 to 20 feet tall and are hardy in zones 5 to 9.

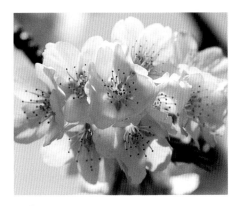

Takesimensis The white flowers grow in clusters, and the broad-spreading tree can reach 30 to 40 feet. Native to an island in the Sea of Japan, Takesimensis (*Prunus takesimensis*) trees bloom about when the Yoshinos do. They grow well in wet locations and are able to tolerate excessive moisture. They are hardy to zone 6.

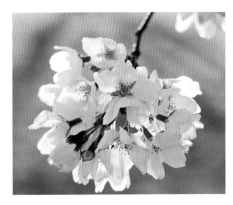

Usuzumi The Usuzumis' single white flowers fade to gray just before falling. Usuzumis (*Prunus spachiana* f. *ascendens*) grow to about 40 feet with a round, graceful crown. The trees in West Potomac Park were propagated from a tree in Japan believed to be the oldest cherry blossom tree in the world. Usuzumis are hardy to zone 6.

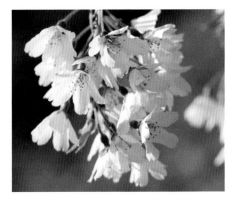

Weeping Japanese Weeping Japanese cherry blossom trees can diverge widely in form and color, with blossoms ranging from pink to white in single or double flowers. Weeping cherry trees (*Prunus subhirtella* var. *pendula*) bloom mid-season and grow to 20 to 40 feet with rounded, gracefully draping crowns. They are hardy to zone 5.

Yoshino With their single white flowers growing in clusters of two to five, the Yoshinos bloom mid-season. Yoshinos (*Prunus* x *yedoensis*) reach heights of around 30 feet and are wide spreading with round tops. A widely cultivated cherry tree in Japan, Yoshinos are hardy to zone 6 and are the most common species in Washington, D.C.

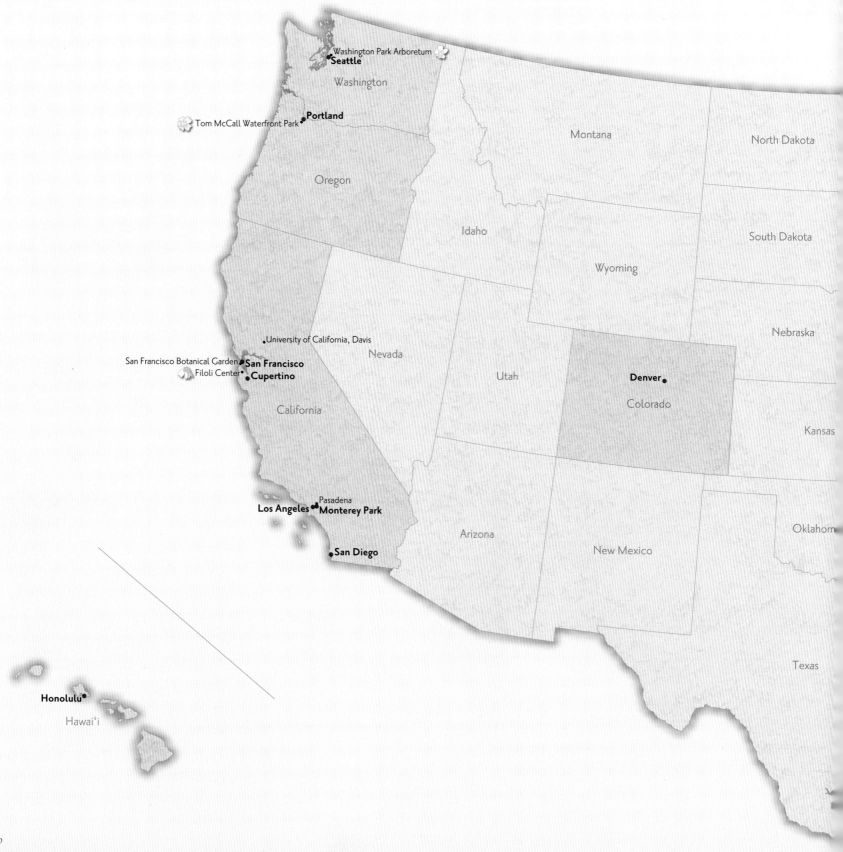

Washington Park Arboretum
Seattle

Washington

Portland
Tom McCall Waterfront Park

Oregon

Montana

North Dakota

Idaho

South Dakota

Wyoming

Nebraska

University of California, Davis

San Francisco Botanical Garden **San Francisco**
Filoli Center **Cupertino**

Nevada

Utah

Colorado
Denver

Kansas

California

Pasadena
Los Angeles **Monterey Park**

Arizona

New Mexico

Oklahoma

San Diego

Texas

Honolulu

Hawai'i

PLACES TO ENJOY
CHERRY BLOSSOM TREES
AND FESTIVALS

Minnesota

Maine

Wisconsin

Vt.

N.H.

Michigan

Botanic Garden
of Smith College

Arnold Arboretum

Mass.

Cornell
Plantations

N.Y.

Conn.

R.I.

Connecticut College Arboretum

Iowa

Bayard Cutting Arboretum

New York Botanical Garden

Brooklyn

N.J.

Brooklyn Botanic Garden

Morton Arboretum

Holden Arboretum

Taltree Arboretum and Gardens

Pa.

Morris Arboretum

Tyler Arboretum

Philadelphia

Longwood Gardens

Scott Arboretum

Indiana

Dawes
Arboretum

Winterthur Gardens

Illinois

Brookside Gardens

Md.

Del.

Ohio

Kenwood

National Arboretum

Meadowlark Botanical Gardens

Washington, D.C.

Dumbarton Oaks

East and West
Potomac Parks

W. Va.

Virginia

Missouri
Botanical Garden

Kentucky

Missouri

Sarah P. Duke Gardens

North Carolina

Tennessee

Arkansas

Furman University

Memphis Botanic Garden

South
Carolina

Georgia

Alabama

Macon

Macon

Mississippi

Louisiana

Florida

KEY

- Cherry blossom festival
- Flowering cherry tree viewing

Featured Cherry Blossom Variety

- Akebono
- Kwanzan
- Okame
- Weeping
- Yoshino

0 300 miles

CHERRY BLOSSOM FUN FACTS

APPROXIMATELY 1.5 MILLION PEOPLE enjoy the National Cherry Blossom Festival each year.

MORE THAN 1,000 INDIVIDUALS volunteer at Festival events, amassing more than 3,000 hours of volunteer service anually.

MORE THAN 200 free performances are presented throughout every Festival.

100 MILLION CHERRY BLOSSOM CENTENNIAL FOREVER® stamps were issued by the U.S. Postal Service on March 24, 2012. For only the third time in recent history, an additional 50 million were printed due to incredible demand.

THE FESTIVAL PLANTS CHERRY TREES throughout the region each spring. In 2012 and 2013, 200 trees were planted in Oxon Run Park in Washington, D.C., creating the largest grove outside the Tidal Basin and Hains Point.

THE NATIONAL MALL, America's magnificent promenade, extends just over two miles from the U.S. Capitol to the Lincoln Memorial.

THE JEFFERSON MEMORIAL was designed in the style of the Pantheon in ancient Rome. The statue of Jefferson inside is 19 feet tall.

IT IS A TWO-MILE WALK around the entire Tidal Basin, a perfect way to get the full effect of the cherry blossoms from every angle.

Cirque-tacular performers use aerial silks to dazzle the crowd.

RECIPES
FROM CELEBRATED CHEFS

Black Forest Cake
CHRIS KUJALA, RIS

The cherries:
1/2 cup port
2 tbsp orange juice
4 black peppercorns (cracked)
1 cinnamon stick
1 strip of lemon zest
6 oz sour cherries

Place all the ingredients except the cherries in a small pot over medium heat. Bring to a boil. Add the cherries, lower the heat to a simmer, and cook two minutes. Remove the pan from the heat and allow the mixture to soak for three hours or overnight. When ready to use, drain the cherries well and discard the zest, spices, and liquid. Pat the cherries dry with paper towels.

Soaking syrup:
1/3 cup sugar
6 tbsp water
2 tbsp kirsch
2 tbsp water

Bring the 1/3 cup sugar and 6 tablespoons of water to a boil in a small pot. Remove from heat and cool. Add the kirsch and 2 tablespoons of water. Reserve.

Chocolate cake:
1 cup all-purpose flour
1/2 cup cocoa powder
1/2 tsp salt
1/4 tsp baking powder
1/4 tsp baking soda
1 1/2 sticks unsalted butter (soft)

1 1/2 cup sugar
3 large eggs
1 tsp vanilla extract
1/2 cup sour cream

Preheat oven to 350°F. Grease a nine-inch cake pan.

Sift together the flour, cocoa powder, salt, baking powder, and baking soda. In a 4 1/2-quart bowl of a electric mixer, using a paddle attachment, beat the butter on medium speed until creamy. Add the sugar and continue to beat until the mixture is light in texture and color. Beat in the eggs, one at a time, beating until smooth. Blend in the vanilla. On slow speed, alternately add the sifted mixture with the sour cream. Beginning and ending with the sifted mixture. Mix until smooth. Scrape the mixture into the cake pan and bake about one hour or until a toothpick placed in the center comes out clean. Cool the cake in the pan.

Mascarpone mousse:
1 cup heavy cream
3 large egg whites
1 cup sugar
1/2 cup cold water
1 cup mascarpone
1 1/2 tbsp cold milk
2 tsp gelatin

Whip the cream in a bowl to soft peaks. Chill. Place the egg whites in a mixing bowl with the whisk of a electric mixer. In a pot, add the sugar and 1/4 cup water. Bring the mixture to a boil. At the same time, start to whisk the egg whites to soft peaks. When the sugar mixture reaches 247°F, slowly add the syrup and the whipped whites, while whisking on

slow speed. When all the syrup is poured in, turn up the machine to high and whisk the mixture until it cools.

In a large bowl, mix the mascarpone with the cold milk to soften the mascarpone. Sprinkle the gelatin over the other ¼ cup water. Let soak until softened. Melt the gelatin in a microwave to dissolve. While the gelatin is still warm, whisk it into the mascarpone quickly until smooth. Whisk in the meringue, and then fold in the whipped cream until smooth.

To assemble:
Line a nine-inch springform pan with plastic wrap. Trim the top off the cake. Place the cake in the springform pan, and coat the top of the cake with the kirsch syrup. Place half of the mascarpone mousse over the cake, top with the cherries, and then add the rest of the mousse. Tap the pan to settle the mixture. Chill overnight until set. Remove the springform pan. Dust the top with cocoa powder and shaved dark chocolate.

The Cherry Blossom
MICHAEL CHERNER & VICTORIA GRAHAM,
Mie N Yu Restaurant

1½ oz Effen Black Cherry Vodka
½ oz orange juice
¼ oz grenadine
2 oz Red Bull

Mix first three ingredients in a cocktail shaker with ice.

Shake.

Strain into glass filled with ice.

Fill with Red Bull.

Add maraschino cherry for garnish.

Stir three times with stirrer.

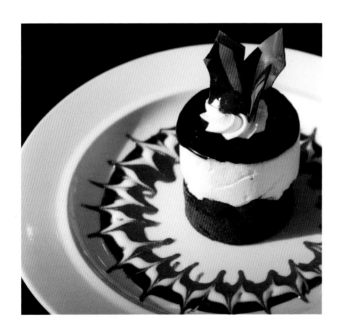

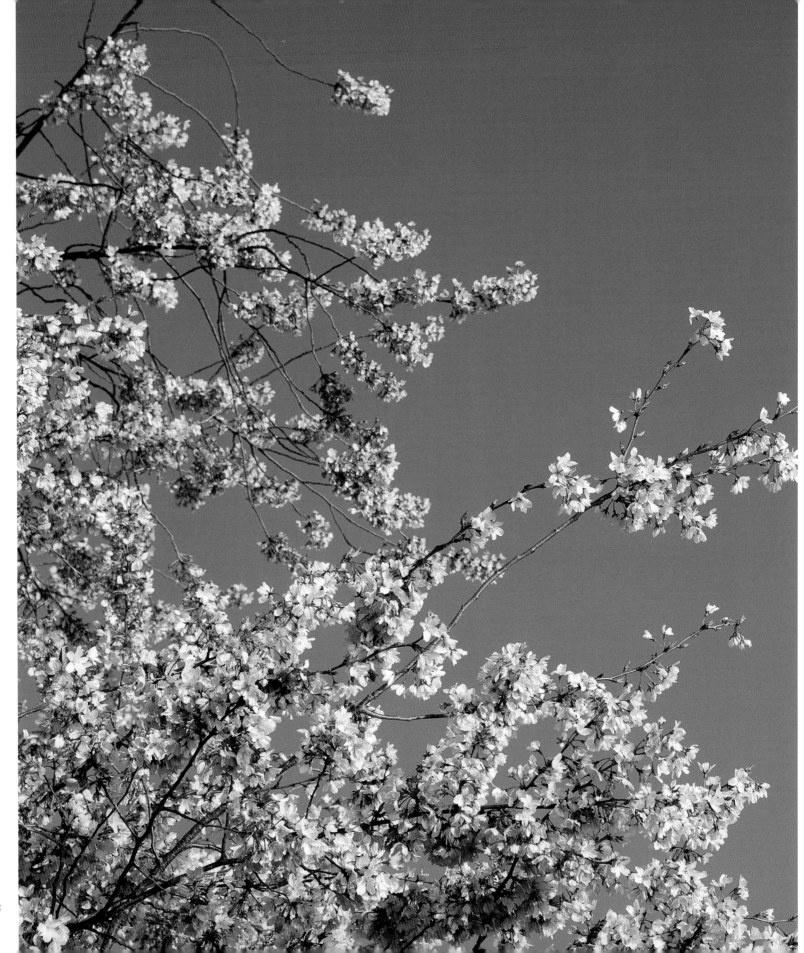

WHO WE ARE

DIANA MAYHEW became executive director of the National Cherry Blossom Festival in 2000, and president in 2007. Under her leadership, the Festival has grown from an all-volunteer, seasonal organization to a fully staffed, year-round 501(c)(3) nonprofit. Her success as a "connector" has led to developing strong partnerships with business, media, government, and industry leaders, resulting in the Festival's growth in programming, funding, and staff support.

Today, the strengthened brand of the Festival receives local, national, and international recognition, attracting more than one million visitors to Washington, D.C., each year and generating over $150 million annually for the nation's capital.

Mayhew currently serves on the Foundation Board of the International Festivals & Events Association (IFEA) and is a member of Leadership Greater Washington, the Destination DC Marketing Advisory Committee, and the Women's Leadership Group of the Boys & Girls Club of Greater Washington. She was recognized by the *Washington Business Journal* as one of the 2012 Women Who Mean Business. Mayhew and her husband, Kerry, are longtime residents of suburban Maryland and have four children.

KRISTIN ROHR, director of marketing and communications for Guest Services, Inc. since 2007, is chair of the board of the National Cherry Blossom Festival. She has been a marketing communications professional for more than 30 years, with experience in both the public and private sectors. Rohr has worked in advertising agencies, as principal of her own consulting firm, as a contractor to the federal government, and as senior director of communications for an independent government agency. Her work with Guest Services encompasses creative direction, public relations, and advertising development; she supervises graphic design and social media activities, in addition to the development and execution of marketing promotions.

Rohr is also an active volunteer, having served on the Board of Trustees of Woodley House, Inc. (president, 2003–2006). She currently sits on the Board of Directors of the Restaurant Association Metropolitan Washington (RAMMY chair 2010–2011) and the Edes Home Foundation.

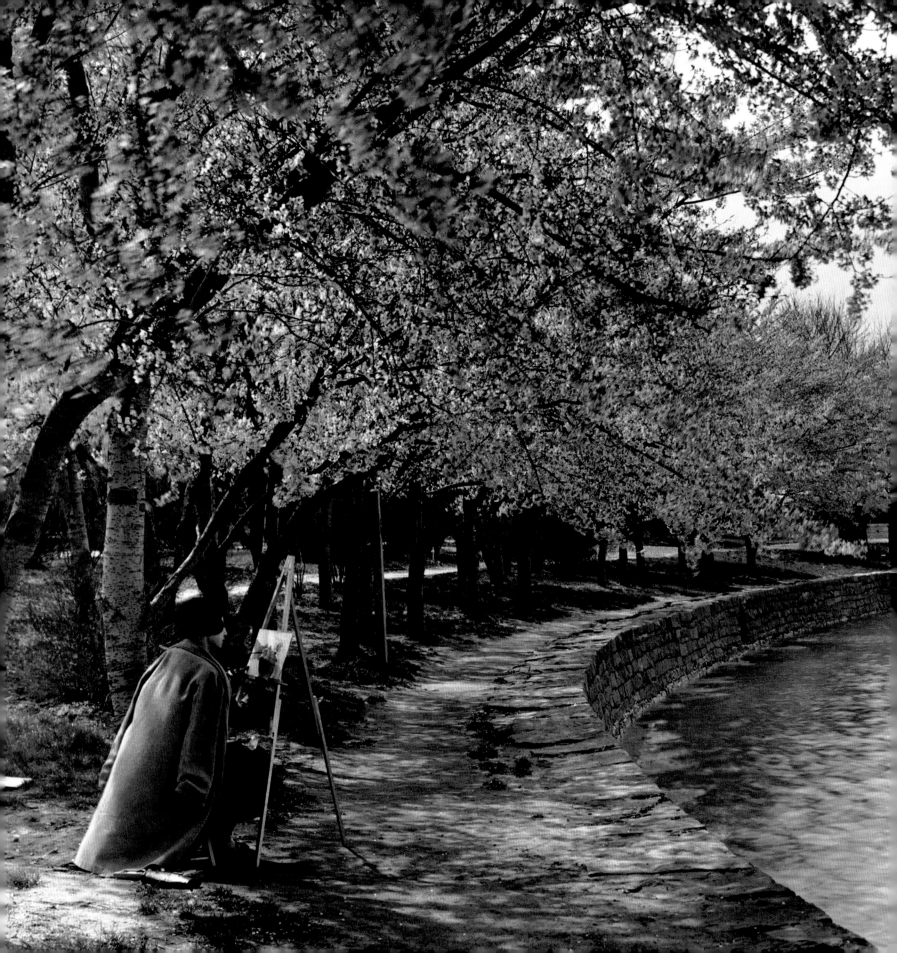

AUTHOR AND PHOTOGRAPHER ACKNOWLEDGMENTS

ANN MCCLELLAN: I thank Diana Mayhew and the Festival board and staff for the opportunity to participate in the Festival's Centennial Celebration through this joy-filled book. Special thanks to Lindsay Robbins for orchestrating the project, and gratitude beyond words to Danielle Piacente, whose enthusiasm, good-humored guidance, photo research, and significant contributions in every dimension were invaluable.

I am grateful to Margaret Pooler of the U.S. National Arboretum, and to Rob deFeo, Bob Grogg, and Bill Line of the National Park Service for sharing their respective expertise.

My thanks to the National Geographic Books team for their hard work on this project. I am especially grateful to Susan Straight for her patient, comprehensive, and dedicated oversight and editing; to Jane Menyawi for her expert photo selection; and to Cinda Rose for her spirited design.

I thank my family and friends for their support and their encouragement of my commitment to the cherry blossom trees and the National Cherry Blossom Festival.

I dedicate this work to the memory of Helen Calvert Bergman, whose too-short life well lived inspires me, just like the cherry blossoms.

RON BLUNT: My work would not have been possible without the men and women of the National Park Service and their skillful care of the cherry trees depicted in this book. Their expertise and dedication is critical for the continued presence of this beautiful feature of Washington, D.C.

I would especially like to honor Keleigh Sherrod whose support, energy, and creative vision was pivotal in bringing my photographs in this book to fruition. I dedicate my work in these pages to her.

NATIONAL CHERRY BLOSSOM FESTIVAL ACKNOWLEDGMENTS

The National Cherry Blossom Festival is grateful to our partners, whose support and involvement has helped make the nation's greatest springtime celebration a reality.

Events DC

Downtown DC Business Improvement District

National Park Service

The Japan-America Society of Washington, D.C.

Special thanks and appreciation to the Embassy of Japan in Washington, D.C., for their continued support and engagement.

The National Cherry Blossom Festival is grateful for the support and participation of our board of directors, sponsors, participating organizations, staff, and the government of the District of Columbia.

The Festival thanks board members of the National Cherry Blossom Festival, who provide strategic guidance, and spend countless hours offering their support. Thanks also to the Festival's core staff, along with its teams of consultants, who work diligently to produce and coordinate events and programs millions have enjoyed in the past, and who are setting the stage for the Festival's next 100 years.

The Festival is grateful for the support of its sponsors, ensuring that events are free and accessible to all, and for the organizations whose participation provides a robust and diverse lineup of Festival activities.

The Festival thanks each and every one of the thousands of volunteers who make the annual celebration possible, from handling balloons in the parade to working with kids on arts and crafts activities throughout Family Day. Volunteers stationed at the Tidal Basin greet visitors with a smile each Festival day, making an invaluable contribution to enhancing visitor experiences.

Finally, the Festival thanks National Geographic Society for its involvement, including serving as publisher of this book.

SPECIAL THANKS TO DAIICHI SANKYO

LIKE THE CHERRY BLOSSOM TREES that circle the Tidal Basin, Daiichi Sankyo has been blooming for 100 years, making a difference by improving people's health and well-being every day. We salute Dr. Jokichi Takamine, a world-famous chemist and the first president of global pharmaceutical company Daiichi Sankyo, and his pivotal role in the gift of the trees from Japan in 1912.

Daiichi Sankyo's legacy of innovation began in 1899, when their scientists first isolated the hormone adrenaline and then later discovered vitamin B_1, establishing the basis for the theory of vitamins. Later, scientists developed the first glitazone and pioneered the development of the first statin class of medicines, revolutionizing long-term control of type-2 diabetes and treatment of heart disease.

Today the company is proud of its innovative medicines and philanthropic initiatives that support critical medical and health care services, and important worldwide artistic, educational, and cultural activities. Together, the Festival and Daiichi Sankyo celebrate 100 years of global collaboration.

Daiichi-Sankyo

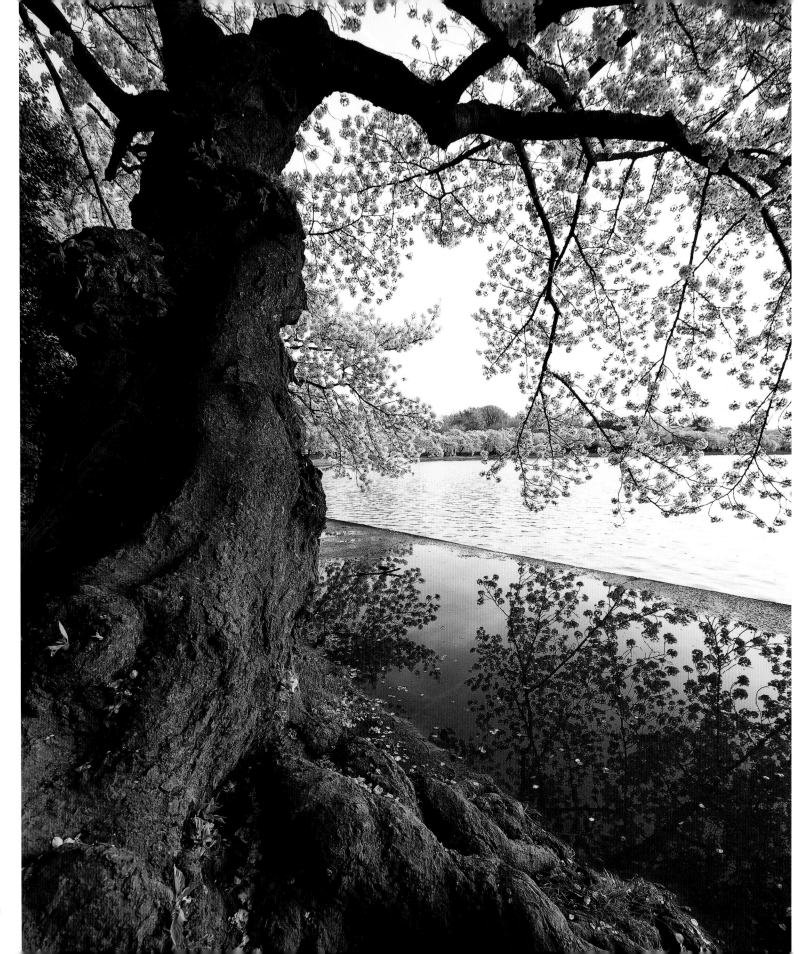

ILLUSTRATIONS CREDITS

All images by Ron Blunt, Ron Blunt Photography, unless otherwise noted below:

1, Sucha Snidvongs/National Cherry Blossom Festival; 2-3 Sam Kittner/National Geographic Stock; 6, Playtime Design/National Cherry Blossom Festival; 8-9 Paul Sutherland/National Geographic Stock; 10, Buddy Secor; 14-15 Ron Engle; 16, Jeff Simpson Photography; 18-19, Ron Engle; 22 National Photo Company; 24, Jerry Arnold/National Cherry Blossom Festival; 25, Ann Marie Williams/National Cherry Blossom Festival; 26-27, Library of Congress; 28, Courtesy of the Museum Resource Center, National Park Service; 30, Courtesy D.C. Public Library, Washingtonian Division; 31, Courtesy of the Fairchild Tropical Garden–Fairchild Estate; 32-33, Courtesy of the Museum Resource Center, National Park Service; 34-35 Courtesy of the Museum Resource Center, National Park Service; 36, Courtesy of the Museum Resource Center, National Park Service; 37, Courtesy of the Museum Resource Center, National Park Service; 38-39, Courtesy of the Museum Resource Center, National Park Service; 40, courtesy Daiichi Sankyo, Co., Ltd.; 42, Courtesy of the Museum Resource Center, National Park Service; 44-45, Jacob Gayer; 46-47, Ernest L. Crandall; 48, Underwood & Underwood/Corbis; 49, Library of Congress; 50, Courtesy of the Museum Resource Center, National Park Service; 52-53 Volkmar Wentzel; 54, Abbie Rowe, courtesy National Park Service; 55, Courtesy of the Museum Resource Center, National Park Service; 56-57, Bettmann/Corbis; 59, Abbie Rowe, courtesy National Park Service; 60, AP Photo/Tsugufumi Matsumoto; 61, Bettmann/Corbis; 62-63, Volkmar Wentzel; 68, Phyllis Saroff/National Cherry Blossom Festival; 69, Carol Tomasik/National Cherry Blossom Festival; 73, K. Rico; 74, Carol Pratt; 76, Lulu.com/National Cherry Blossom Festival; 77, The Smithso-nian Associates; 78, Ron Engle; 79, Terry J. Adams/National Park Service; 84, Nick Eckert; 86, Courtesy of the Museum Resource Center, National Park Service; 88, (left) Jeff Song, (right) Nick Eckert; 89, Eric Gushee; 90, Nick Eckert; 94, Simon Williams; 96, Laura Padgett; 98, (top) Ron Engle, (bottom) Michael Cherner & Victoria Graham; 99, Alfredo Flores/Metromix; 100, Dakota Fine Y Photography; 102, Lillian Iversen; 103, Fredde Lieberman; 108-109, E. David Luria; 110, Kevin A. Koski; 112, Lulu.com/National Cherry Blossom Festival; 116, Nick Eckert; 118, Jim Starr/National Cherry Blossom Festival; 119 Steven S. Walker/National Cherry Blossom Festival; 124, Ron Engle; 126, Ron Engle; 130, Terry J. Adams/National Park Service; 132, AP Photo/Susan Walsh; 136, Eric Matern; 137, Emily Todd; 146, Lavanya Jaganathan/LJ Creaations; 150, Lavanya Jaganathan/LJ Creaations; 151, Sue Murphy; 160, Randy Mays/National Cherry Blossom Festival; 161, Junko Yamada/National Cherry Blossom Festival; 164, William B. Folsom; 168, Simon Williams; 174, Carl G. Schaefer, Jr.; 176, Carl G. Schaefer, Jr.; 178, The George Washington University Athletic Association; 179, National Cherry Blossom Festival; 183, Kent Miller; 184, U.S. Lacrosse-Potomac Chapter; 185, Kent Miller; 186, MarathonFoto; 187, Bob Burgess; 190, Christopher Gindlesperger; 194, Becky Hale/National Geographic; 196, Freer Gallery of Art; 198-199, John Woo/courtesy DC Commission on the Arts and Humanities; 200, USDA photo/Lance Cheung; 201, courtesy of the Smithsonian's Freer and Sackler Galleries; 204, An Truong; 212, Dennis Kan/ImageLinkPhoto.com; 215, (top) Michael Cherner & Victoria Graham, (bottom) Laura Padgett; 217, (top) Downtown D.C. Business Improvement District, (bottom) National Geographic; 219, (top) Robert Epstein, (bottom) Mike Olliver 2010; 220, Daiichi Sankyo, Co., Ltd.; 222, Bernard Chen Photography.

CHERRY BLOSSOMS
THE OFFICIAL BOOK OF THE NATIONAL CHERRY BLOSSOM FESTIVAL

Ann McClellan, photographs by Ron Blunt

Published by the National Geographic Society

John M. Fahey, Jr., *Chairman of the Board and Chief Executive Officer*

Timothy T. Kelly, *President*

Declan Moore, *Executive Vice President; President, Publishing*

Melina Gerosa Bellows, *Executive Vice President; Chief Creative Officer, Books, Kids, and Family*

Prepared by the Book Division

Hector Sierra, *Senior Vice President and General Manager*

Barbara Brownell Grogan, *Vice President and Editor in Chief*

Jonathan Halling, *Design Director, Books and Children's Publishing*

Marianne R. Koszorus, *Design Director, Books*

Lisa Thomas, *Senior Editor*

Carl Mehler, *Director of Maps*

R. Gary Colbert, *Production Director*

Jennifer A. Thornton, *Managing Editor*

Meredith C. Wilcox, *Administrative Director, Illustrations*

Staff for This Book

Susan Straight, *Editor*

Cinda Rose, *Art Director*

Jane Menyawi, *Illustrations Editor*

XNR Productions, *Map Production*

Judith Klein, *Production Editor*

William W. Cline, *Asst. Production Manager*

Robert Waymouth, *Illustrations Specialist*

Jodie Morris, *Design Assistant*

Manufacturing and Quality Management

Christopher A. Liedel, *Chief Financial Officer*

Phillip L. Schlosser, *Senior Vice President*

Chris Brown, *Technical Director*

Nicole Elliott, *Manager*

Rachel Faulise, *Manager*

Robert L. Barr, *Manager*

The National Geographic Society is one of the world's largest nonprofit scientific and educational organizations. Founded in 1888 to "increase and diffuse geographic knowledge," the Society's mission is to inspire people to care about the planet. It reaches more than 400 million people worldwide each month through its official journal, *National Geographic,* and other magazines; National Geographic Channel; television documentaries; music; radio; films; books; DVDs; maps; exhibitions; live events; school publishing programs; interactive media; and merchandise. National Geographic has funded more than 9,600 scientific research, conservation and exploration projects and supports an education program promoting geographic literacy. For more information, visit www.nationalgeographic.com.

For more information, please call 1-800-NGS LINE (647-5463) or write to the following address:

National Geographic Society 1145 17th Street N.W. Washington, D.C. 20036-4688 U.S.A.

For information about special discounts for bulk purchases, please contact National Geographic Books Special Sales: ngspecsales@ngs.org

For rights or permissions inquiries, please contact National Geographic Books Subsidiary Rights: ngbookrights@ngs.org

ISBN: 978-1-4262-1343-4

Printed in China

13/PPS/1